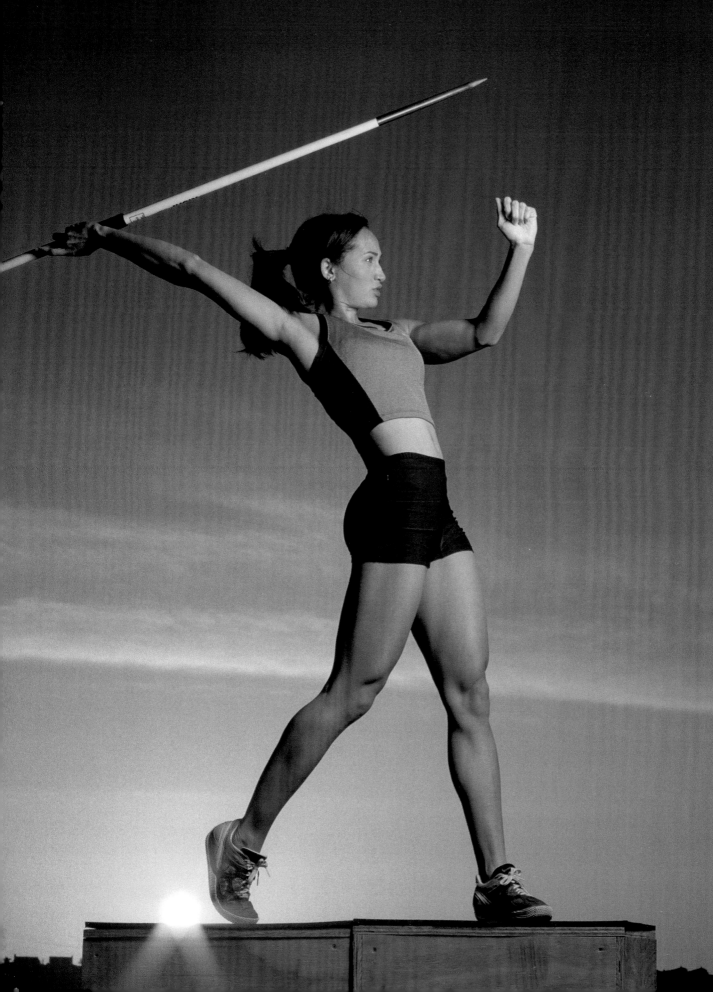

superwomen

100 women · **100** sports

Jodi Buren

with **Donna Lopiano,**
Chief Executive Officer,
Women's Sports Foundation

FOREWORD BY
Billie Jean King

BULFINCH PRESS
New York · Boston

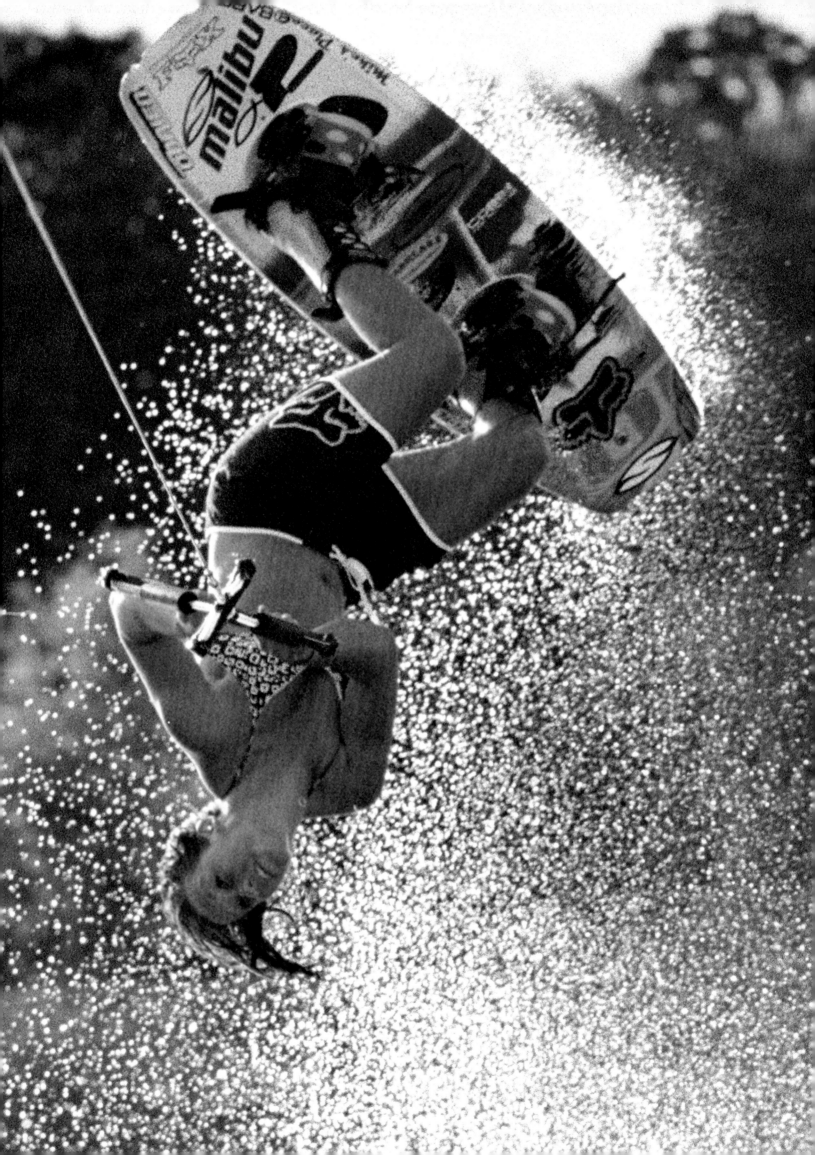

Bulfinch Press
Time Warner Book Group
1271 Avenue of the Americas
New York, NY 10020
Visit our Web site at www.bulfinchpress.com

First Edition

Photographs on page 10 are by Ronnie Smith.

Library of Congress Cataloging-in-Publication Data
Buren, Jodi.
 Superwomen : 100 women, 100 sports / Jodi Buren with Donna Lopiano; foreword by Billie Jean King.—1st ed.
 p. cm.
 ISBN 0-8212-2891-9 (hc) / ISBN 0-8212-2896-X (pb)
 1. Women athletes—United States. 2. Women athletes—United States—Portraits.
I. Title: Superwomen. II. Lopiano, Donna A. III. Title.

GV709.18.U6B87 2003
796'.082—dc22 2003060652
(WSF Special Edition ISBN 0-8212-6186-X)

Design by Laura Lindgren

Printed in Singapore

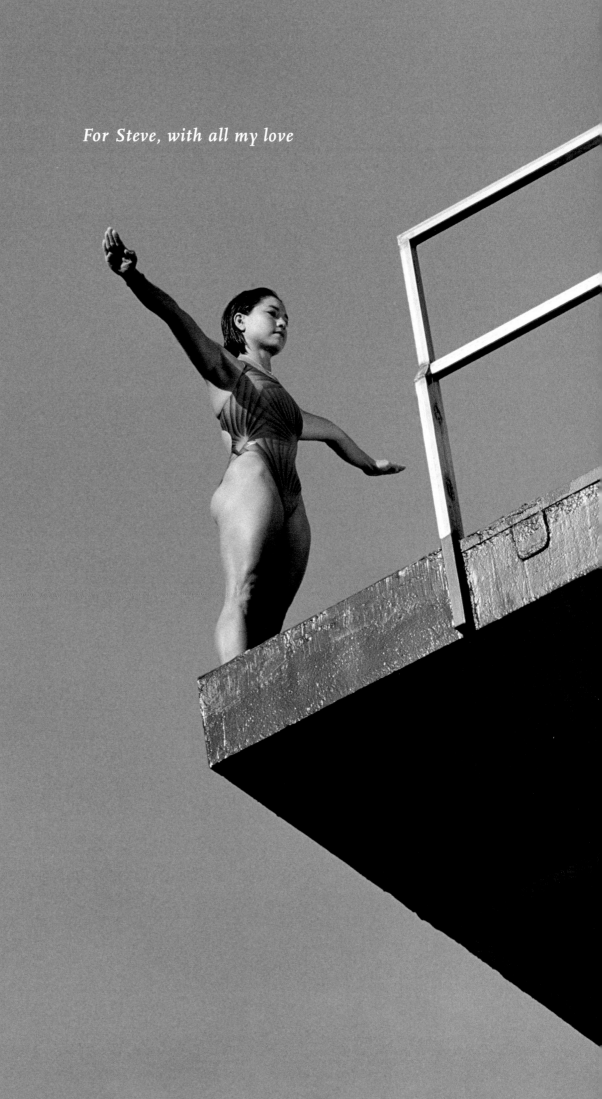

For Steve, with all my love

Contents

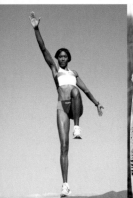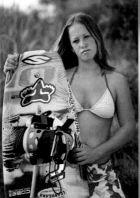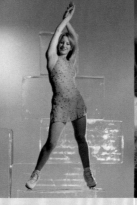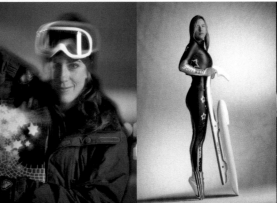

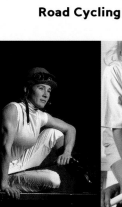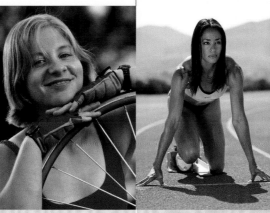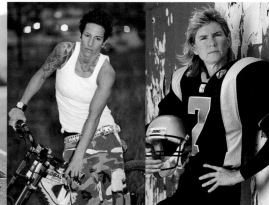

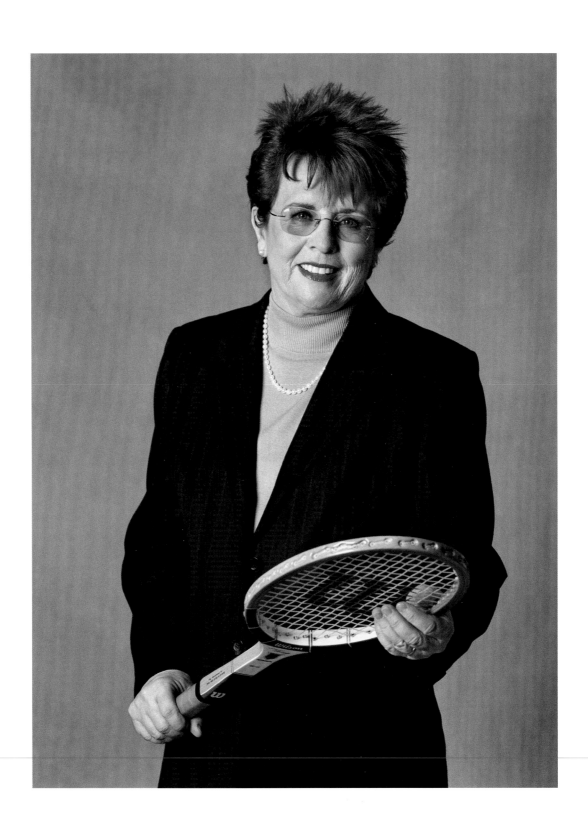

Foreword

Everyone remembers their first superwoman moment. Mine played out not on the tennis court, like many to follow, but on the diamond. Picture a scrappy nine-year-old tomboy—the youngest on the team. It's the bottom of the ninth inning, runners on second and third, our team is up by one. Shifting my weight to the balls of my feet, I hunker over at shortstop and punch a fist into my mitt. Charged with adrenaline, I stand at the intersection of fear and hope, anticipating the ball coming my way. The pitch flies. The bat cracks, and a line drive is sent with gusto just out of my reach. Diving to the ground, I snag the ball, spin, throw to third to double off the runner. That's it. Last out. The team goes berserk. We had done it. I savor my first taste of being part of a championship team.

All women can benefit from feeling the power that comes from those moments of achievement. Thirty years ago, I worked with a group of talented and dedicated people to start the Women's Sports Foundation. At that time, access to athletics was limited for women. Our goal was to afford every girl and woman the opportunity to embrace their own superwoman. We wanted to make sure that everyone, from Olympians to playground prodigies, had a chance to fall in love with sports. Seeds for women's success on and off the court needed to be planted, sowed, and protected.

To this day, the Women's Sports Foundation has been working to make sure that girls have an opportunity to dream about sports. As a team we've come to understand winning means something different to everyone. Winning is not just about championship rings and trophies. It's about loving the game so much that you keep coming back to compete—day after day, throughout your life. It's an attitude that bleeds into everything you do.

The pages of this book are graced with reflections of one hundred athletes in search of the superwoman that lives inside of them. Each one defines winning on her own terms. These are women who have seized the opportunities they have been given. When there was no space for a female, they created one. They have taken risks. They've failed and flailed and found a way to get back up. Look in their eyes. Study their bodies and you will find maps of perseverance and determination. As you flip through the pages, allow yourself to be moved by both the incredible athletic achievements as well as the real stories of women behind those achievements. Most important, keep in mind that there is a superwoman living inside all of us. Find her and let her fly.

Billie Jean King

Founder, Women's Sports Foundation

Preface

Eight months ago, I set out to photograph and interview one hundred women from one hundred different sports. I wanted to document the beauty of the woman athlete—to remove her helmet and focus on her spirit. I wanted to find the person inside the athlete, to discover her thoughts, her dreams, her goals, and her desires. I wanted to give girls across America an opportunity to learn about sports and the women who do them.

It has been an incredible journey.

I have met one hundred extraordinary women.

With each shoot, the momentum and excitement for the project escalated. The athletes were eager to share their stories and seemed honored to be recognized. I was an audience of one, and as I sat on track fields, in parking lots, and in kitchens around the country, I laughed and cried and was forever changed. I saw what sport can do for women. I saw this over and over again in women who were confident, driven, powerful, determined, who were in control of their bodies and their lives. I am in awe of these women. I am inspired and humbled by them.

I left each interview wanting to achieve more, wanting to be a better person, wife, mother, photographer. It was no longer just about sport; it was about being a woman, about giving all that you can, about fulfilling your dreams.

Jodi Buren

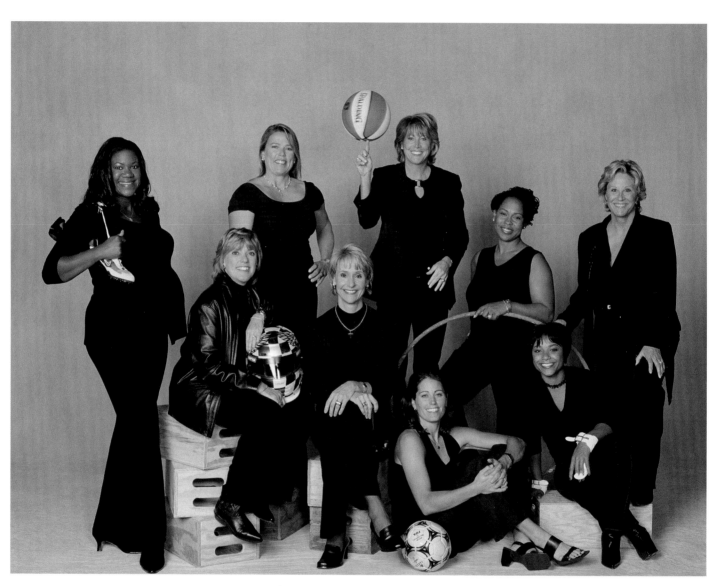

Past presidents (BACK ROW, FROM LEFT TO RIGHT) Benita Fitzgerald Mosley, Dawn Riley, Nancy Lieberman, Wendy Hilliard, and Donna de Varona. (FRONT ROW) Lyn St. James, Nancy Hogshead-Makar, Julie Foudy, and current president Dominique Dawes (not pictured: Carol Mann).

Icons. Activists. Leaders. Legends. The women who have served as president of the Women's Sports Foundation are truly larger than life. Together, these nine athletes have captured thirteen Olympic medals, earned more than seventy-five professional and collegiate national titles, and are members of eleven different sports halls of fame. These extraordinary women are also published authors, coaches, professors, media analysts, and social advocates. Renowned in athletics and honored for their commitment to women's sports, they exemplify the power of women as leaders.

Introduction

You are holding the spirit of sport in your hand. This is not a book about stats and facts. In these pages you will not find wordy research or political jargon. What you will find is a mosaic of vivid photographs and interviews of one hundred extraordinary women who live and play with fervor. These pages will take you on an exploration of the extremities of passion, determination, and an athlete's quest for her personal best. *SuperWomen*, most simply put, is a testament to the soul that lies at the core of the female athlete.

Each athlete featured in this book has a unique story. In a labor-of-love effort to create this journey for you, author/photographer Jodi Buren traveled around the country in search of tales of exceptional women. Her goal was to compile a series of verbal and visual images that convey the beauty and power of the female athlete. The focus was never fixed on what an athlete had accomplished, but rather who she was. The women she photographed and interviewed all embody incredible confidence, strength, poise, and purpose.

No one athlete's story is like the next, but all are apt to move you. Some are tales of world champions, others of master recreators. Some are grandmothers, others are grandchildren. Race, religion, education, ability, background, wins, and losses are just a few of the things that differentiate these athletes. What unites them all is the fact that every woman possesses the tools of excellence. At some point, each woman has touched that elusive thing we call perfection. We call them superwomen.

We present *SuperWomen* to you as a celebration of the Women's Sports Foundation's thirtieth anniversary. Each athlete in this book is a living, breathing affirmation of why the Women's Sports Foundation has spent three decades working to ensure equal opportunity to sports for females.

By now we all know that sports are vital to the health and well-being of girls and women. The reports have been published. The laws have been passed. The evidence is irrefutable. An evolution is in the works—the by-product of which is presented in this chronicle. Thirty years ago, one hundred vignettes of elite female athletes in one hundred different sports would have been hard to come by. Today... well, see for yourself!

Donna A. Lopiano, Ph.D.
CEO, Women's Sports Foundation

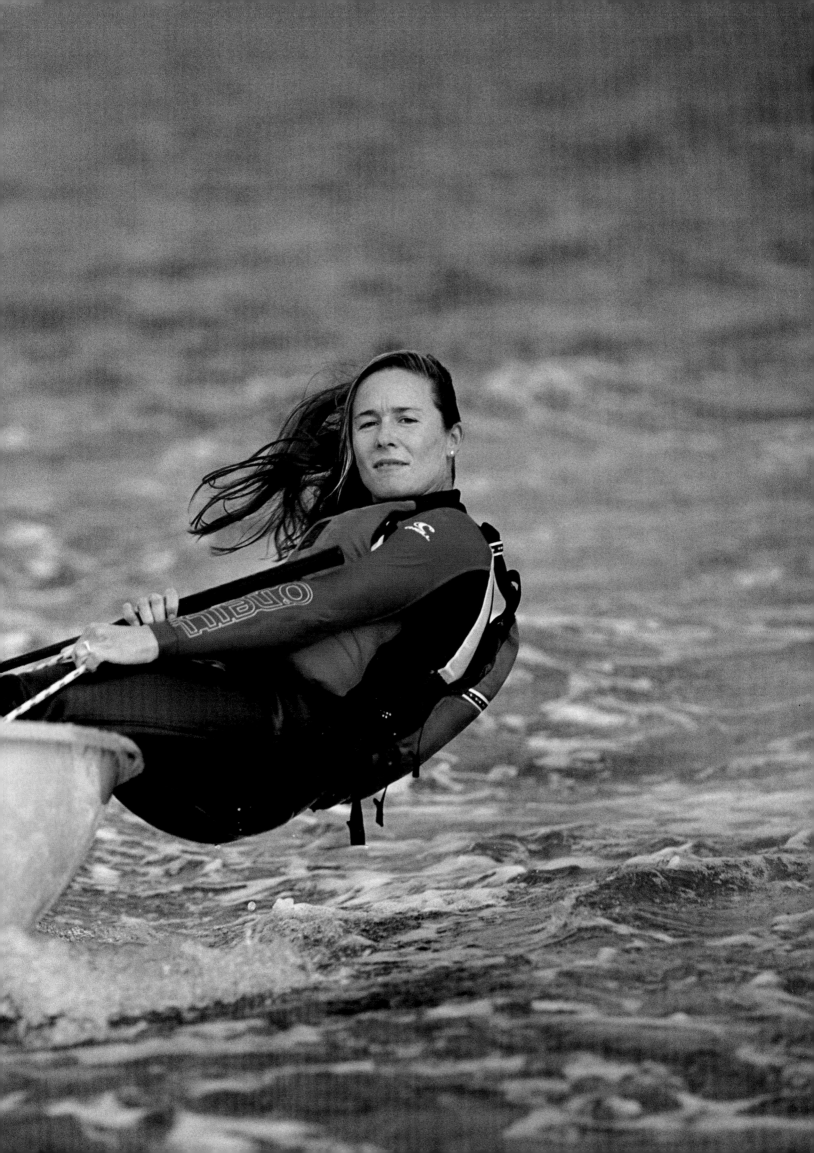

1 Adventure Racing

Robyn Benincasa

Adventure racing is like life—all the highs and lows you experience over the years compressed into a one-week period.

Adventure racing is the ultimate in physical endurance and teamwork skills. You have a team of four people who are given a map, a compass, a set of rules, and a start line. You travel together, day and night, nonstop, for up to 500 miles, over seven days, doing whatever it takes to get from point A to point B. You run, bike, and paddle. In Morocco, we rode camels. In Borneo, we rappelled into bat-infested caves. In Ecuador, we scaled a 20,000-foot volcano.

You're either laughing, crying, throwing up, or sleeping. It's the most intense life experience possible.

In endurance races of this length, I believe that there really is no difference between men and women. Men and women compete on an absolutely even playing field. It really is an equal opportunity sport. You have to have a woman on your team and you have to have a man. In my world, it's not even a question that the girls play with the boys.

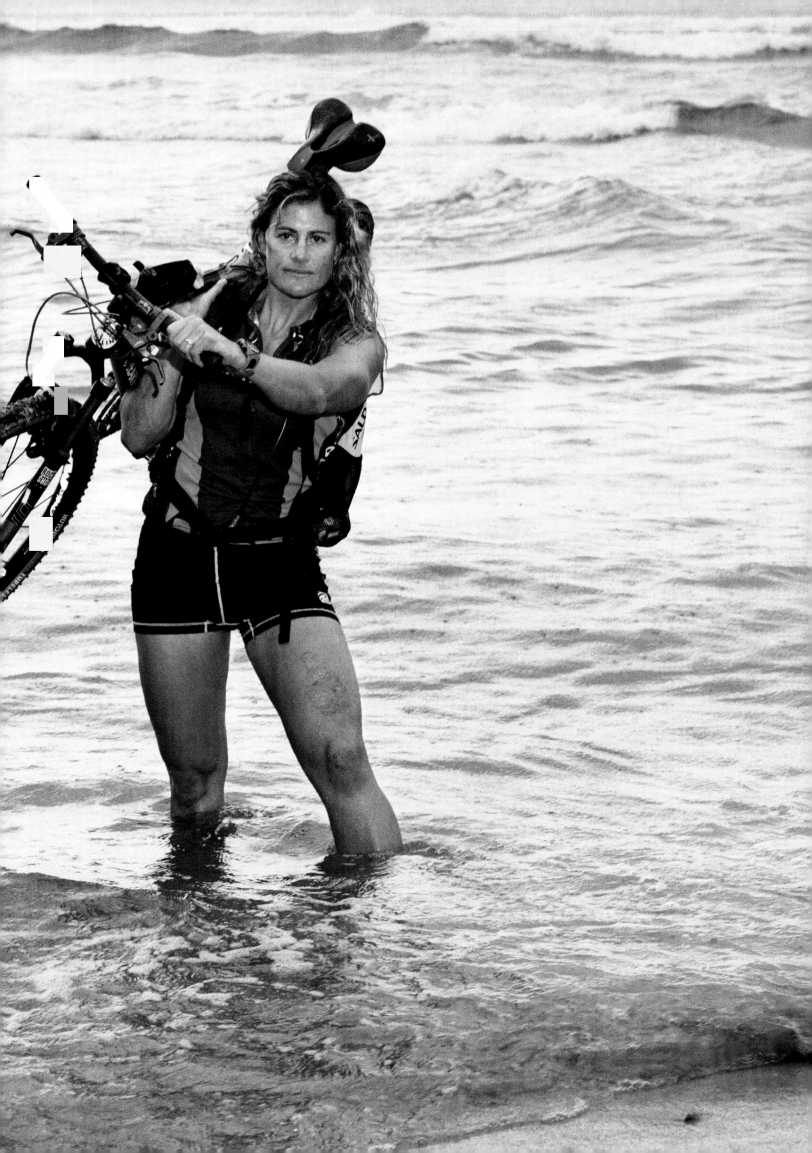

Picabo Street
Alpine Skiing

Oftentimes I looked at my career and thought, Wow, I have experienced some really wonderful moments, but they've all happened away from home. They could have been so much more inspiring had they happened in America, and in front of a large crowd. The kids would have felt that magnitude, been attracted and turned on by it. That's what made having the Olympics in America so special. And the Games were wonderful, they were fun, they came off great, the weather was beautiful. The only thing missing was the cherry on top, which would have been me winning the gold medal.

was seven years old when I found a bow in a haystack and brought it home. My dad got me two wood arrows and I started shooting. I had this make-believe Robin Hood thing going on in the backyard where I had to prove myself by shooting the arrow into the middle of the target. I had a wagon and went up and down the street collecting papers from the neighbors to buy my first real bow. It was not something that was handed to me. I had to earn my equipment.

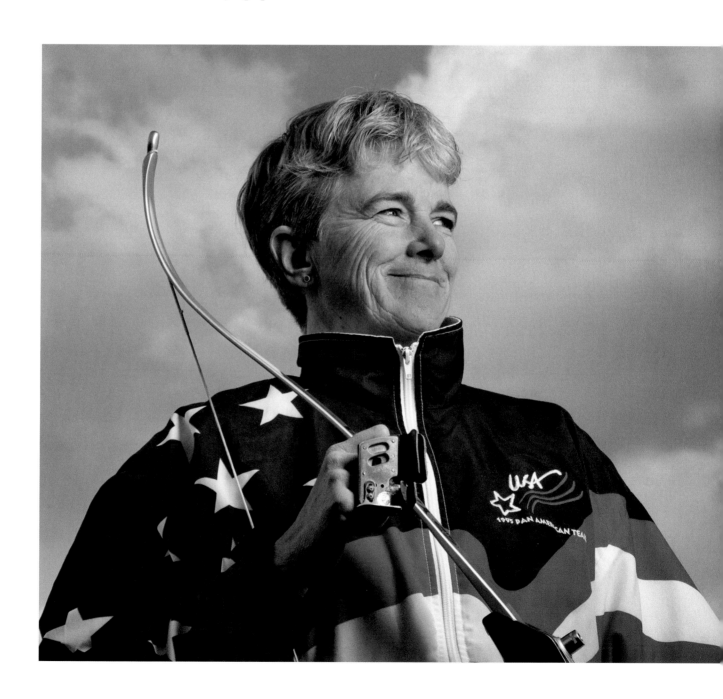

Kathy Zimmerman

Badminton

My grandfather played, my dad played, and then my father passed it on to his kids. My dad was my coach from the age I could hold a racket. I actually played in tournaments with him until I was about eighteen. He was one of the best players in the state, but I was still pretty weak. He didn't care, he just wanted to play with me.

I'll never forget when I won my first national championship. I remember looking up at the stands and seeing Dad. He's got his fists clenched and he's biting his nails. When the winning point comes, I hear my parents scream. As I'm hugging my partner, I turn around and there's my dad on the court. And I just jump into his arms, and my mom was right behind him. It was really cool, a really unique moment.

Now that I have retired, my father and I are playing mixed doubles again. It's such a joy. We've won every tournament we've entered. Dad is a Senior Olympic three-time gold medalist. The neat thing is that now when he competes, I get to coach.

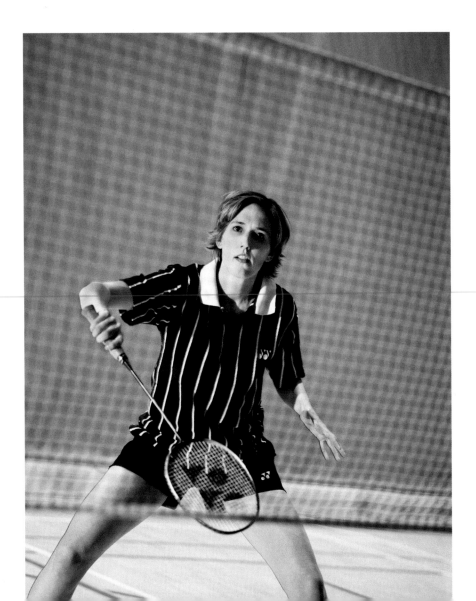

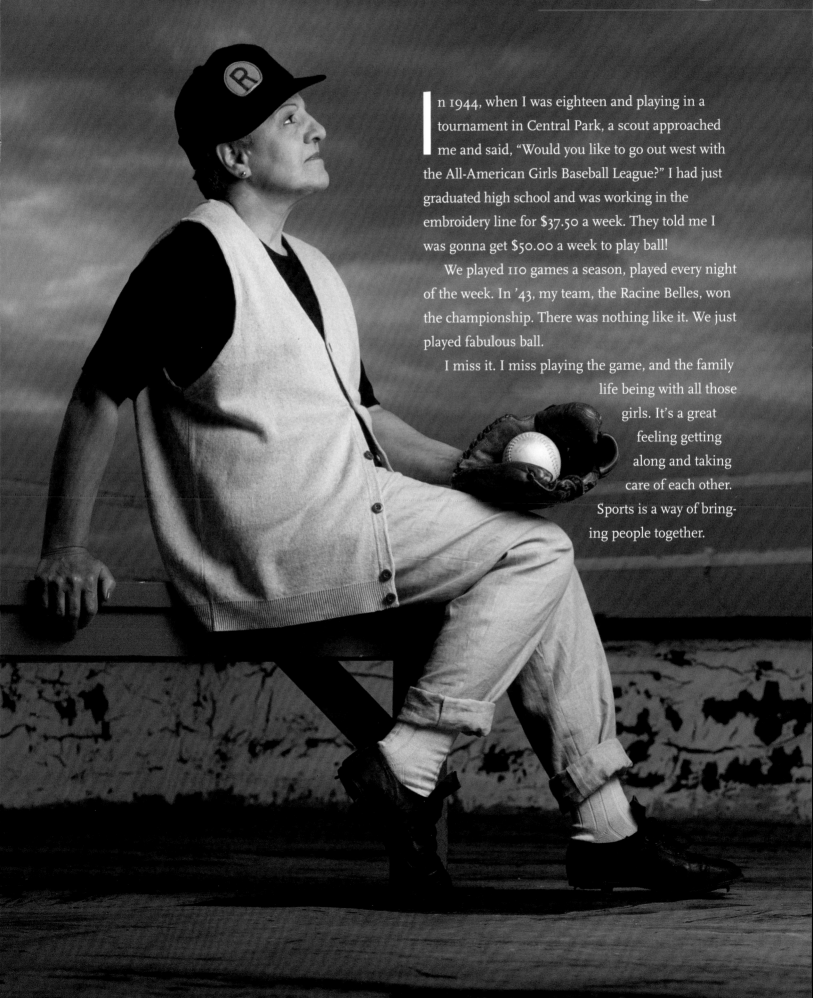

In 1944, when I was eighteen and playing in a tournament in Central Park, a scout approached me and said, "Would you like to go out west with the All-American Girls Baseball League?" I had just graduated high school and was working in the embroidery line for $37.50 a week. They told me I was gonna get $50.00 a week to play ball!

We played 110 games a season, played every night of the week. In '43, my team, the Racine Belles, won the championship. There was nothing like it. We just played fabulous ball.

I miss it. I miss playing the game, and the family life being with all those girls. It's a great feeling getting along and taking care of each other. Sports is a way of bringing people together.

Accept your differences and move on.

I was born with a hearing loss, and my first pair of hearing aids were real big, the behind-the-ears kind. It was a struggle going through school and always getting made fun of and being different from all the other kids. But when I was playing basketball, I didn't have to fit in. How are you going to make fun of me on the basketball court if I'm beating you or if I'm scoring on you or stealing the ball from you? Just stepping onto the basketball court made me feel so much better. And that's when everything started turning around because people were like, Oh, man, she can play basketball, forget about the hearing aids, just look at what she does on the court.

Ever since seventh grade I knew that I wanted to be a basketball player. I wanted to be in the NBA. I got drafted straight out of college. I've worked my butt off, and I've made a lot of sacrifices. And here I am now, at age twenty-three, in the WNBA. I'm playing in the greatest league with the greatest players ever. Sometimes I can't believe I'm actually doing this. I was always Tamika Catchings, daughter of former NBA player Harvey Catchings. Now people say, Harvey Catchings, father of WNBA player Tamika Catchings.

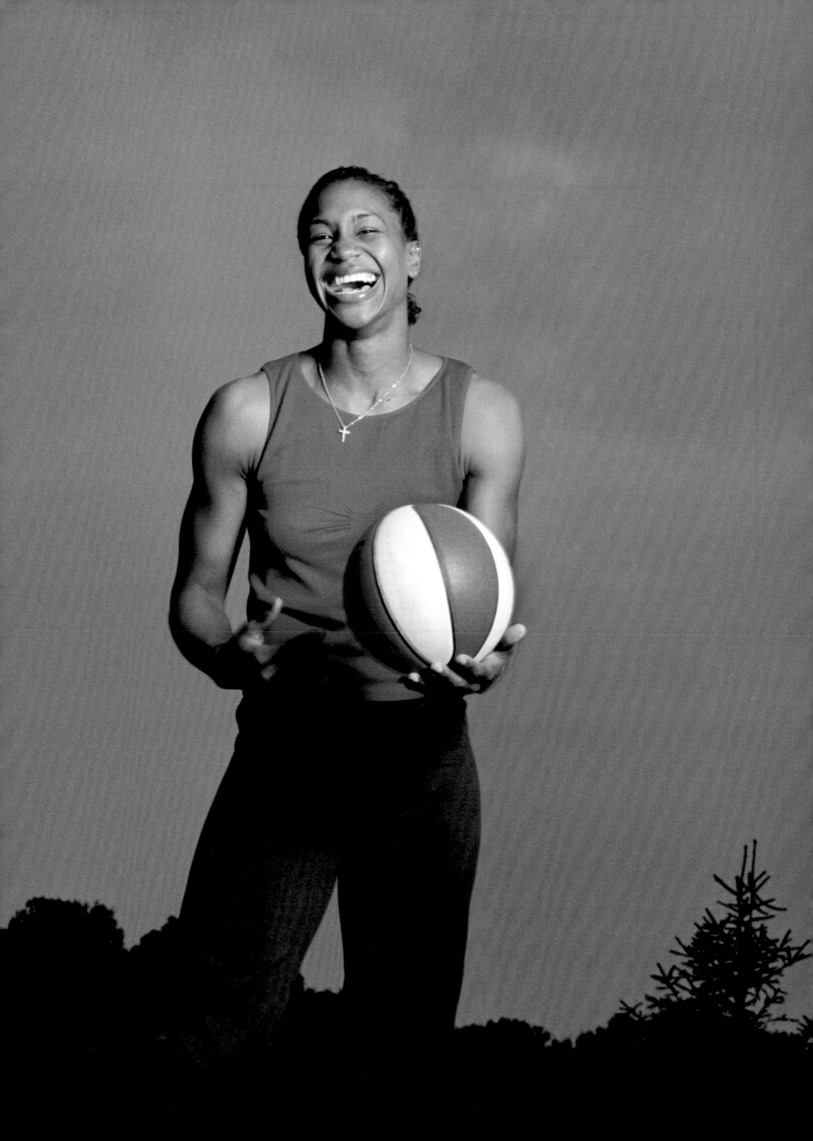

Misty May

7 Beach Volleyball

My mom passed away last May. Then I had knee surgery; it was a tough road for me. Mentally, I was just played. Touring gets tiring, living out of a suitcase, being away for months, in a different country each week. And wanting to call home but knowing my mom's not going to answer. I think that was ultimately the worst.

Losing my mom taught me that volleyball is not my life. It put winning and losing in perspective. It is not the end of the world. There are so many more things to do. And a lot of athletes don't realize that. They get so wrapped up in their sport. You never know what's going to happen tomorrow, so you have to live each day to the fullest.

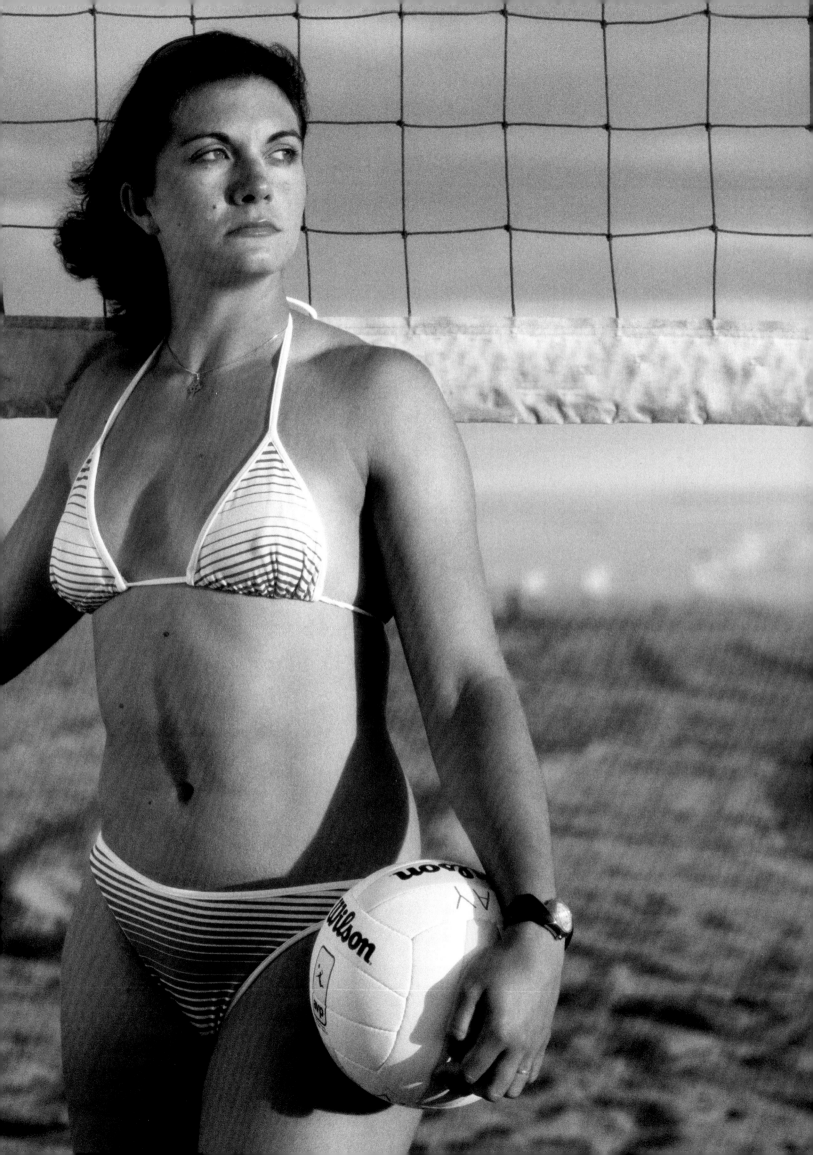

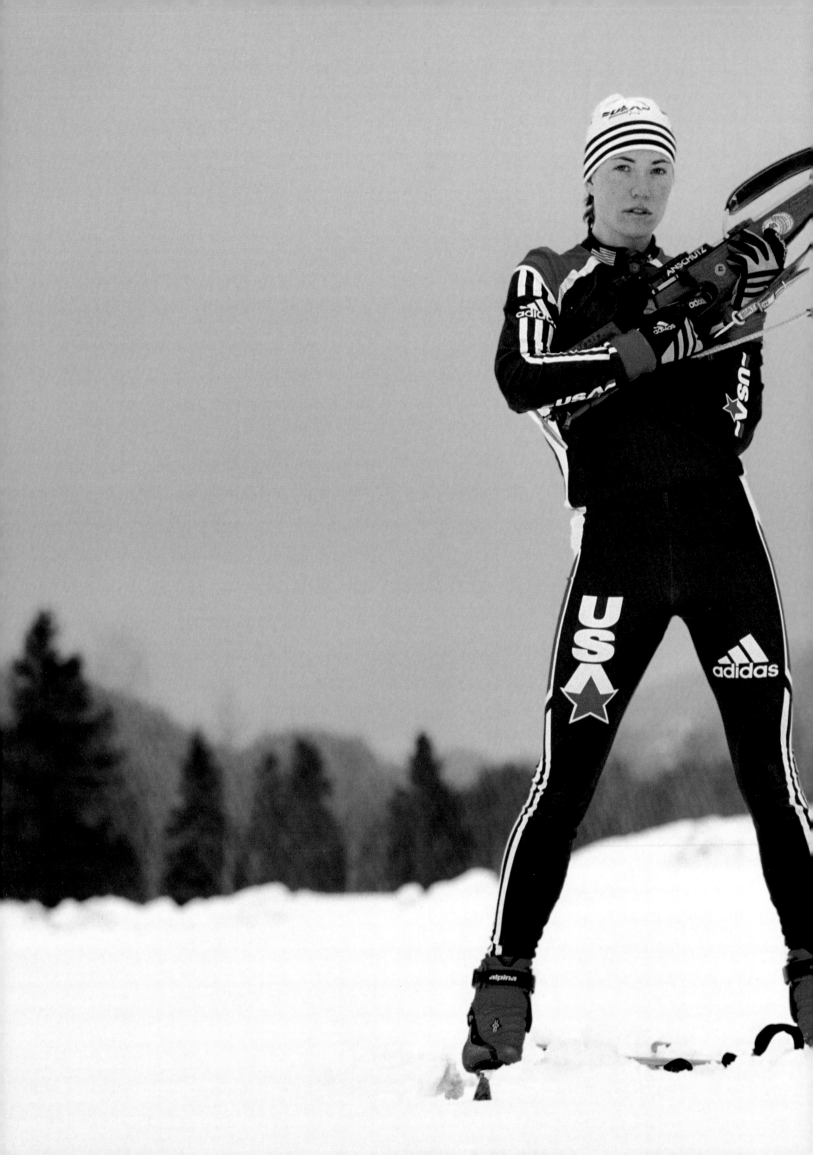

Denise Whitten-Teela

Biathlon

I like guns a lot. I grew up around them. Where I'm from, in Alaska, every woman owns a gun. It's normal. My father shoots, my brother shoots. Of course I was going to shoot.

The National Guard has a wonderful program in which you can be both a soldier and an athlete. I'll be going to basic training for four months. I'm excited. I think it will bring a new challenge to my life and will help me to be more mentally capable of handling any type of problem that I might face. It's worth it, because for the next eight years I'll have biathlon paid for. For however long I'm in the military, all I'll have to do is keep signing a contract and the paycheck will keep coming.

There's always a chance that you may get called up for war. There's nothing you can do about it. It's pointless to lose sleep over it. And I think anybody would be excited to serve their country. That's what we originally signed up for.

Kim Hayashi

Bicycle Motocross Racing

You have to be able to take that risk, go that extra mile, and put all your fears away to succeed. If you're not going to use yourself to your ability, you might as well just walk away and go home.

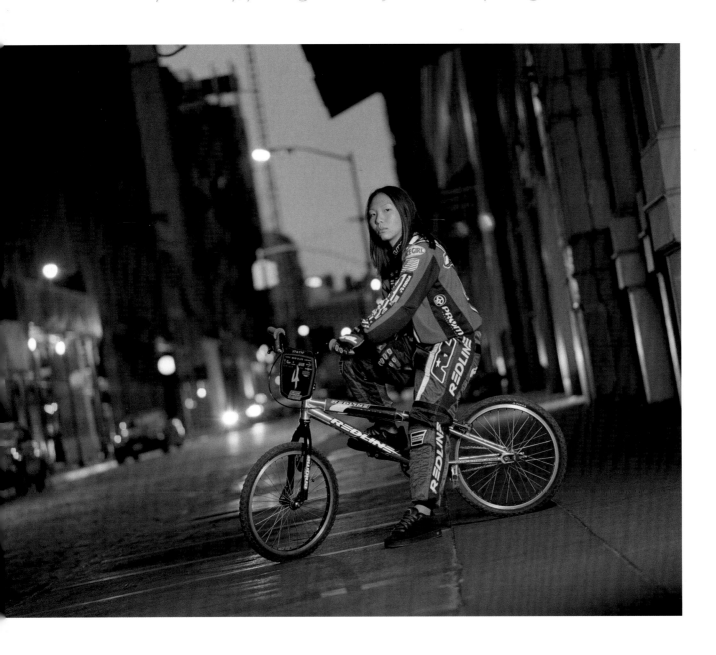

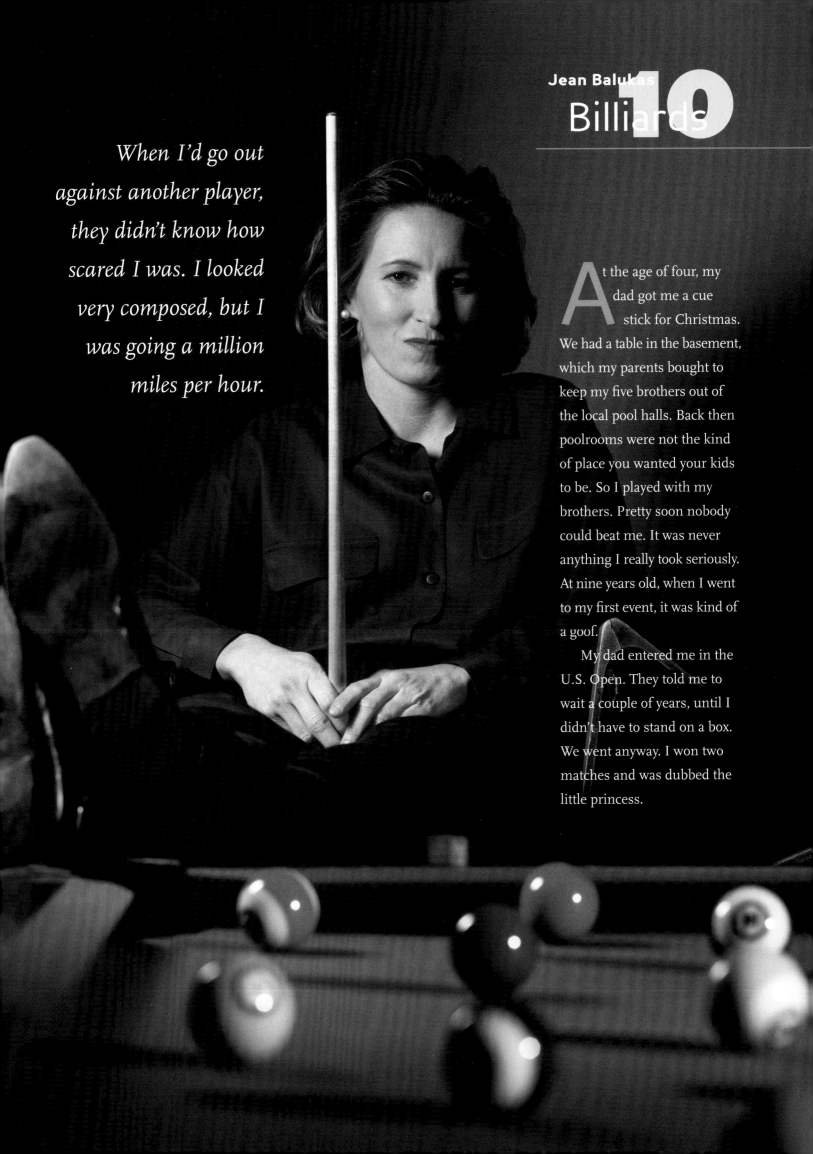

When I'd go out against another player, they didn't know how scared I was. I looked very composed, but I was going a million miles per hour.

Billiards 10

At the age of four, my dad got me a cue stick for Christmas. We had a table in the basement, which my parents bought to keep my five brothers out of the local pool halls. Back then poolrooms were not the kind of place you wanted your kids to be. So I played with my brothers. Pretty soon nobody could beat me. It was never anything I really took seriously. At nine years old, when I went to my first event, it was kind of a goof.

My dad entered me in the U.S. Open. They told me to wait a couple of years, until I didn't have to stand on a box. We went anyway. I won two matches and was dubbed the little princess.

11 Jill Bakken
Bobsledding

The hardest part was getting

bobsledding into the Olympics.

Then came making the Olympic team.

Winning the gold was the easiest.

I didn't know what I was getting into when I decided to commit to bobsledding. It wasn't an Olympic event, didn't have a lot of support, and most people didn't want women involved anyway. I think we were frowned upon because it was such a male-dominated sport. I'm sure they were thinking that women couldn't drive, that we were going to kill ourselves on the track. I was coming from a school where I'd had the same opportunities as men. I didn't know any better.

If there is something that you want to do, don't let other people tell you that you can't. It was a pretty rough road for me. It was easy to want to give up. I thought about it tons of times. We crash, we get pounded by g forces, we constantly get beat up. What keeps bringing me back to bobsledding is my wanting to go down just one more time, wanting to push faster, wanting to do better. It's all for those sixty seconds that I'm on the track.

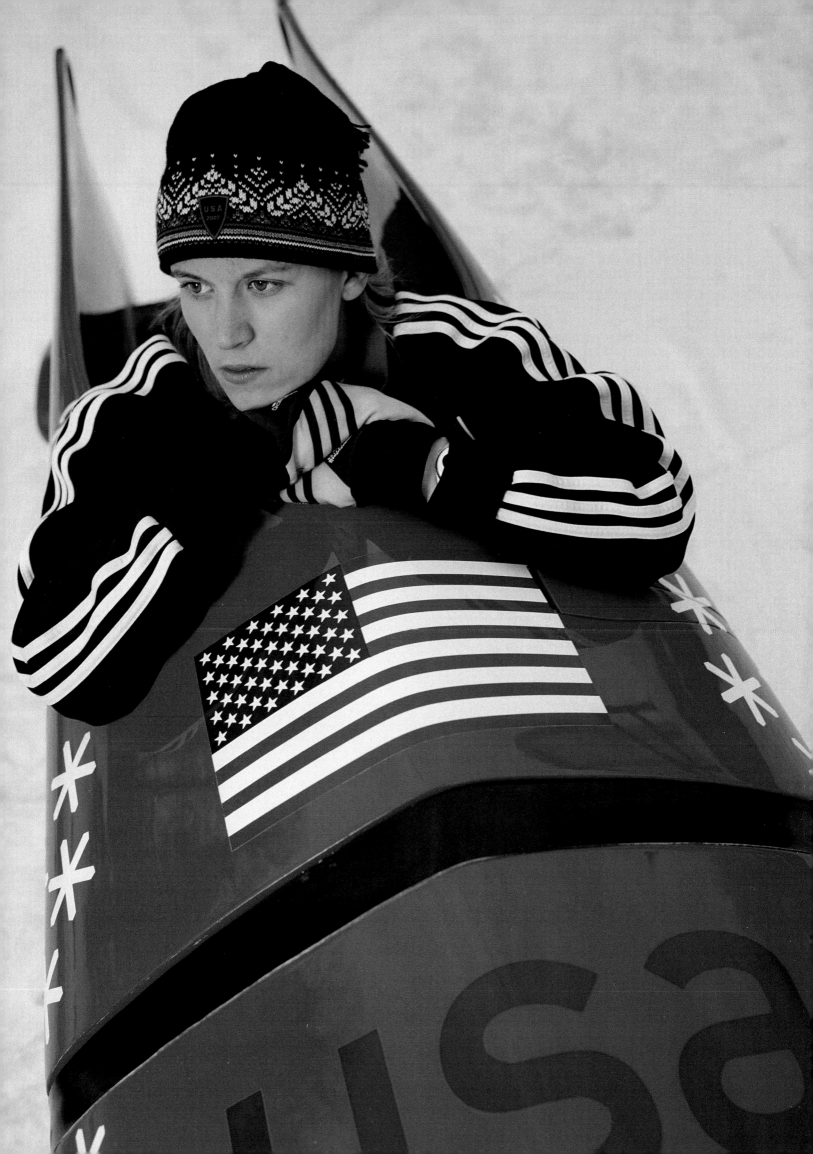

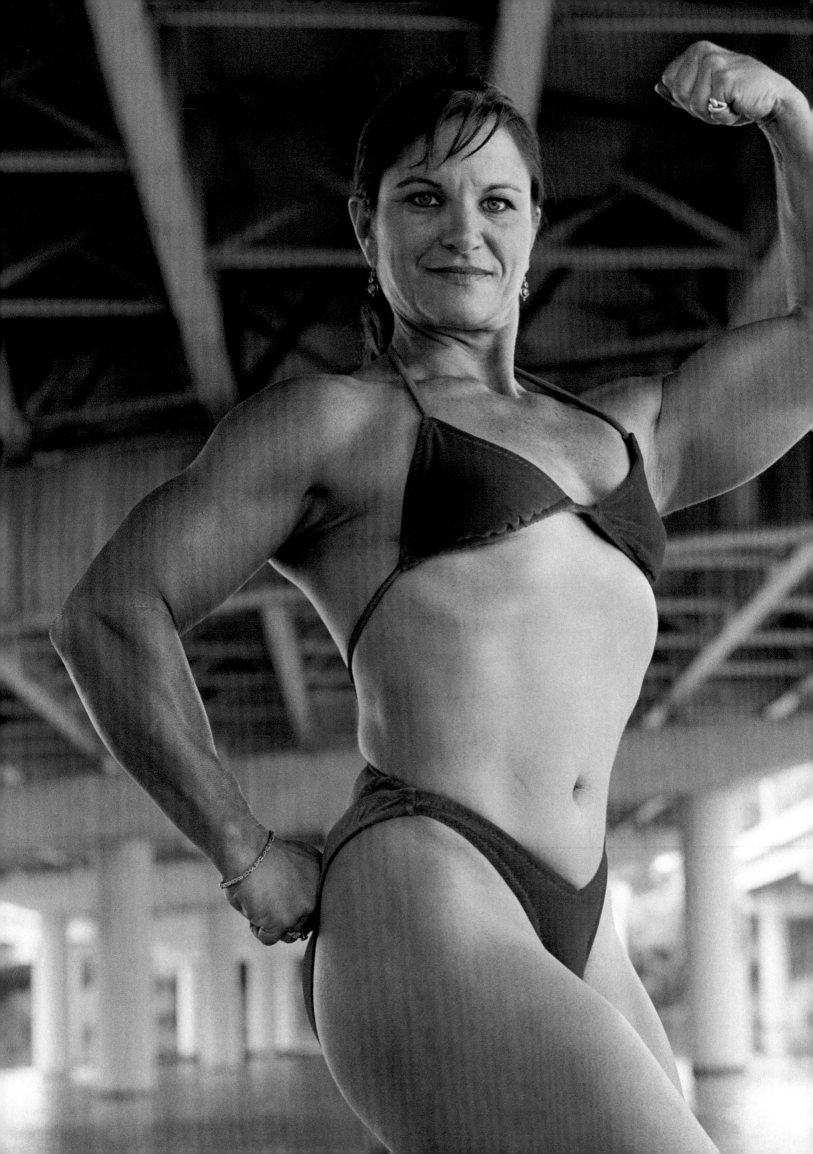

*I'm a lifetime natural athlete.
Natural meaning no drugs or
steroids or anything like that.*

Bodybuilding is like any other major sport that involves scoring the athlete. You train, you lift weights, and you do aerobics. And then you pose. You're being judged on muscularity, symmetry, and your routine. That was the hardest part for me. Not the training or the dieting. It was getting up on stage. I'm at a point now where I feel confident when I'm up there in a little two-piece. I've been pretty successful overcoming those fears.

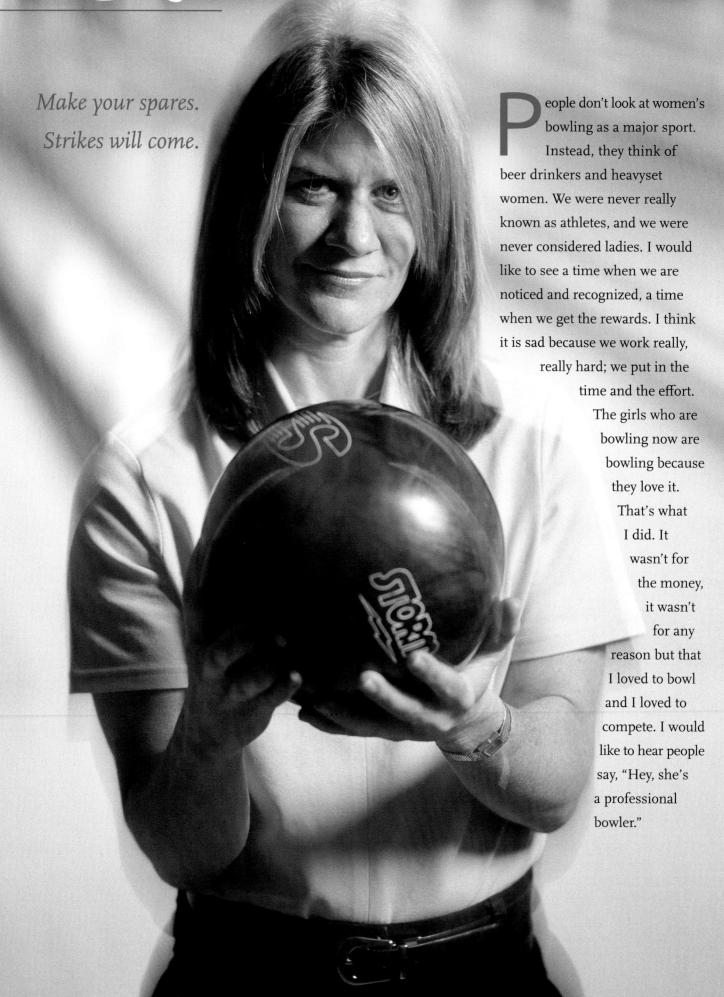

13 Bowling

Robin Mossontte

Make your spares.
Strikes will come.

People don't look at women's bowling as a major sport. Instead, they think of beer drinkers and heavyset women. We were never really known as athletes, and we were never considered ladies. I would like to see a time when we are noticed and recognized, a time when we get the rewards. I think it is sad because we work really, really hard; we put in the time and the effort. The girls who are bowling now are bowling because they love it. That's what I did. It wasn't for the money, it wasn't for any reason but that I loved to bowl and I loved to compete. I would like to hear people say, "Hey, she's a professional bowler."

Box Lacrosse

I played in women's leagues. They weren't competitive. They weren't making me any better. I figured you have to play against the best to be just as good or better than them. I started to look for men's leagues. I did research. I was sneaky about it. I called and asked when the men's open league was. I figured: I lifted, I ran, I stayed in shape, I played all the time; I would just show up. They're always short a goalie. People would do double takes. They thought I showed up the wrong night.

I saw there was an open tryout for men's box lacrosse in Colorado. There were about a hundred guys there. The general manager pulled me aside, and said, "I want you to come, but we have three goalies signed already." I sent him a resume: Let me come to the camp, I promise you won't be sorry, I know how to play. So I got to go to rookie camp and on to the training camp. It was hard at first. They were afraid to play me in the scrimmages. When they [the New Jersey Storm] offered me a rookie salary, I became the first woman in league history to gain a regular-season roster spot.

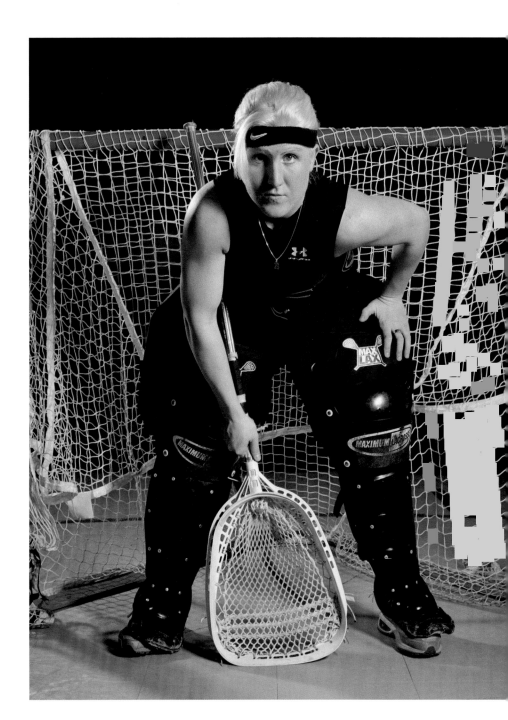

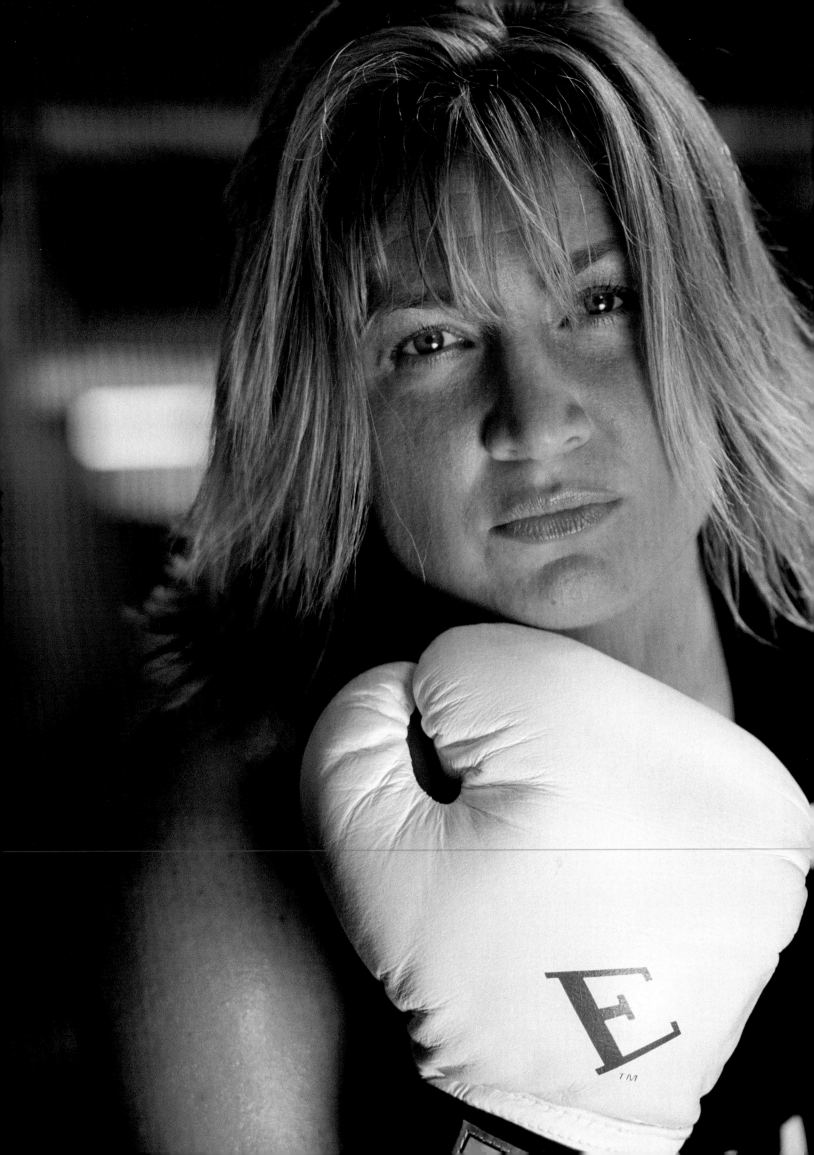

Boxing 15

As horribly painful as my childhood was, it made me who I am. It taught me that overall I'm a survivor, no matter what happens, and I'm going to come out on top.

I was 240 pounds, a size 26, and smoked two packs a day. I was watching *Rocky* on TV, had seen women's boxing, and I thought, Bingo, that's it. I need to go to a boxing gym, not to fight, but just to get in there and do that workout. I knew that was the place for me. I had a lot of personal anguish from a really troubled childhood. My mom was a single mom. I had a stepdad who wasn't good to me. I was a very abused child. I had a lot of resentment, a lot of anger, and boxing was perfect. The fact that I'm even standing here before you with four world titles is a miracle in and of itself.

16 Car Racing

Janet Guthrie

My job as an aerospace engineer supported my racing for the first seven years. My next job as a technical editor supported my second bout of racing for about five years. And then I went racing full time again for a couple of years. At that point I was thirty-eight years old and had no job, no savings, no house, no husband, no jewelry, no insurance, and was saying to myself that I must come to my senses and give this up. And that was the moment at which someone asked if I would like to test a car for the Indianapolis 500. Well, I didn't believe it at first. Until 1971 women were not allowed in the pits, the garage area, or the press box at the Indianapolis 500 for any reason whatsoever. It was a major ban. A woman could own the race car, but she couldn't get close to it. And it had always been that way. But by the late '70s the women's movement had made a great deal of progress. When the time became right for a woman to get the opportunity to drive in Indianapolis, I was the woman whose name came to everybody's mind. I had at that time the biggest reputation and the most recent record of success at the national level.

I would have walked over hot coals barefoot from coast to coast to get that opportunity as a driver.

I drove only eleven Indy car races. Had I been able to drive even a full season, I would have bettered what I did. And there have been other talented women who had the same problem I had: no money. No money just makes you a fast pedestrian.

The good news about women in racing is that you don't have to have the broad shoulders and the big muscles. The bad news is that the machinery is very, very expensive. And so, as I've been saying for twenty-five years, what we need is a woman with all the stuff it takes and her own fortune and then we'll see a winner in Winston Cup and Indy cars.

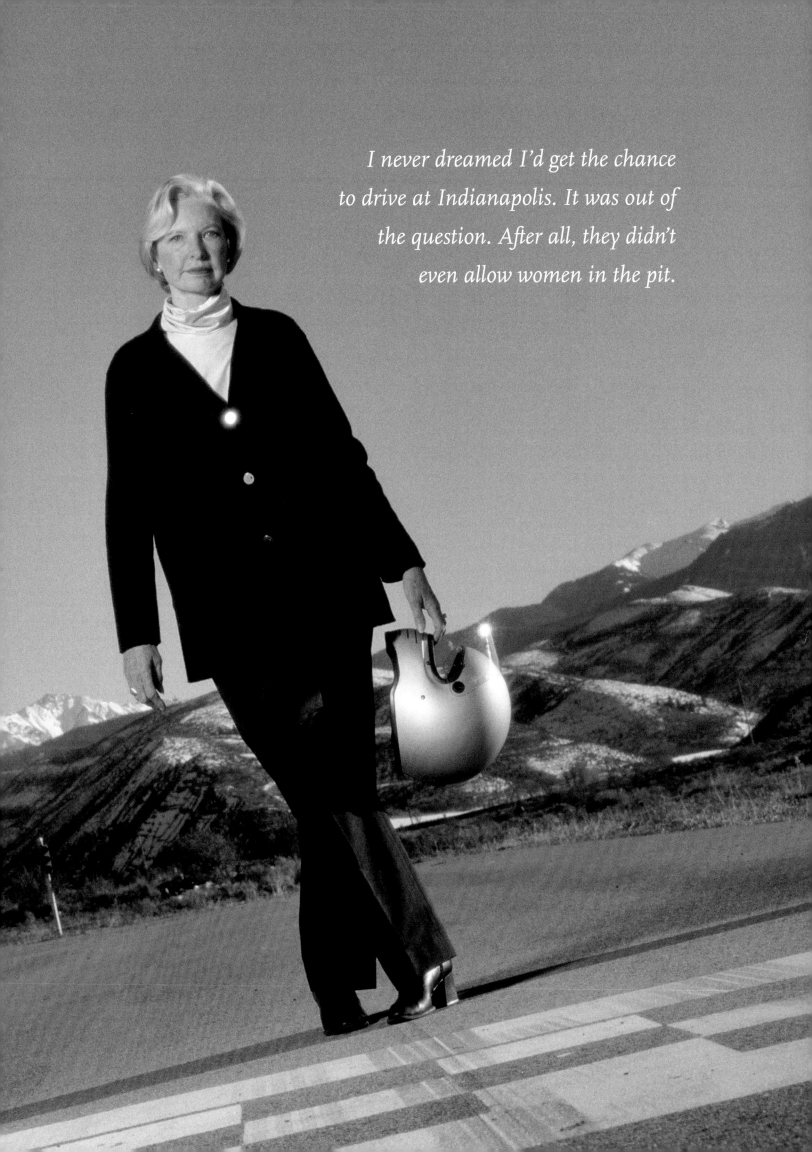

I never dreamed I'd get the chance to drive at Indianapolis. It was out of the question. After all, they didn't even allow women in the pit.

Alison Dunlap

Cross-Country Mountain Biking

When the gun goes off, you're literally at your max heart rate within thirty seconds.

You're racing in ankle-deep mud, it's thirty degrees and snowing, or maybe it's ninety-five degrees and super humid. You may have to ride over a log, or you may have to ride through a rock garden, or a big nasty section of muddy roots that are really slippery, or a stream crossing. You really have to be able to handle anything. You're on your own and you're not allowed to get help from anybody. If you have a flat, if your chain breaks, if your handlebars bend, you have to fix it yourself. No one can touch your bike but you. So it truly is an individual sport.

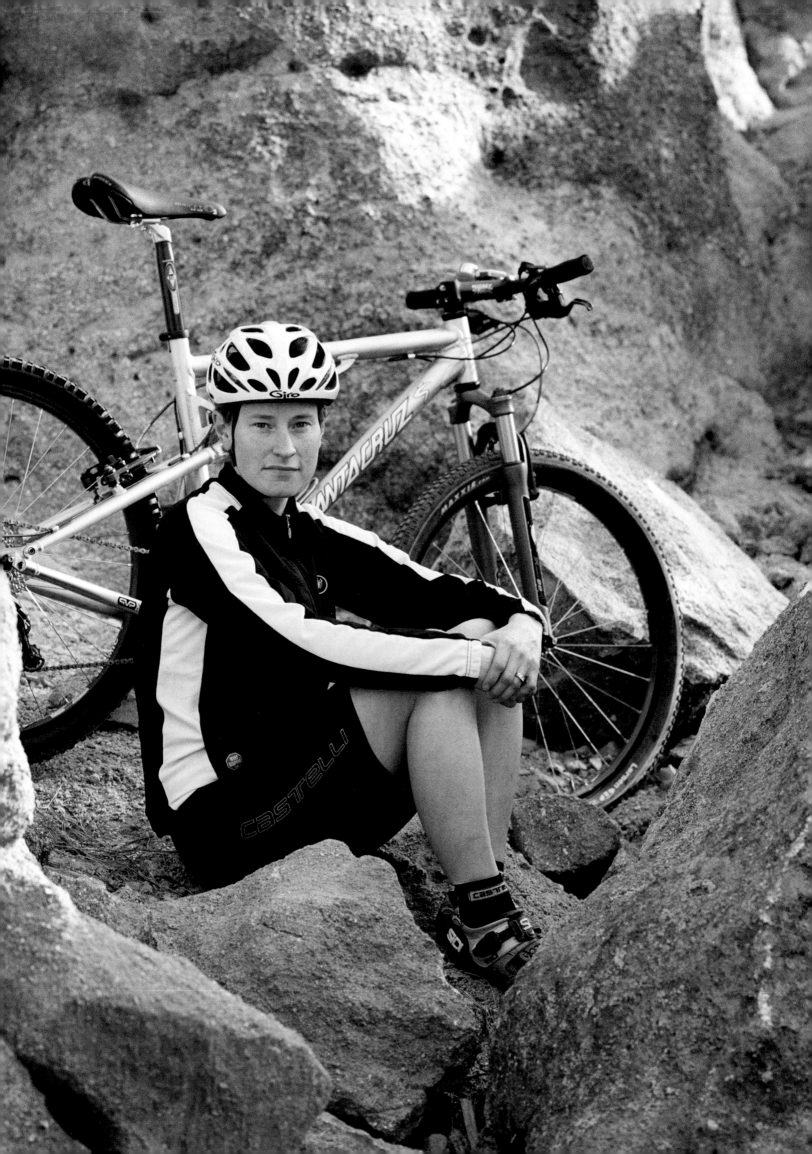

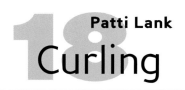

Patti Lank

Curling

*You can have it all. You can follow your dreams,
do your own thing, have a loving family,
and still come home and be a mom.*

Curling is a sport played on ice. You throw a rock at a target. It's called curling because the rock curls on the ice. It came from Scotland, and it's ancient. I think what upsets me the most is when people laugh at our sport: Oh, curling, isn't that for old people?

My ultimate goal is to play in the Olympics with my daughter Madison on my team. She is playing in the Junior Little Rock Program. If she progresses over the next few years, which I think she will, and if we win the next Olympic trials, I will be taking her as my fifth player.

Sports are important for kids. They learn a lot. They learn disappointment, they learn highs and lows, they learn to be challenged, they learn tasks, they learn how to get along with others. Sometimes it's not about you, it's about the team. Learn from your mistakes. It's going to make you a better player. You know, with any sport, everyone is going to miss. Just remember the ones you made and throw the missed ones out of your head.

At our annual family bonspiel, my husband skips, I play lead, Madison plays third, and Mackenzie plays second. We usually win.

Phil Raschker

Decathlon (Senior)

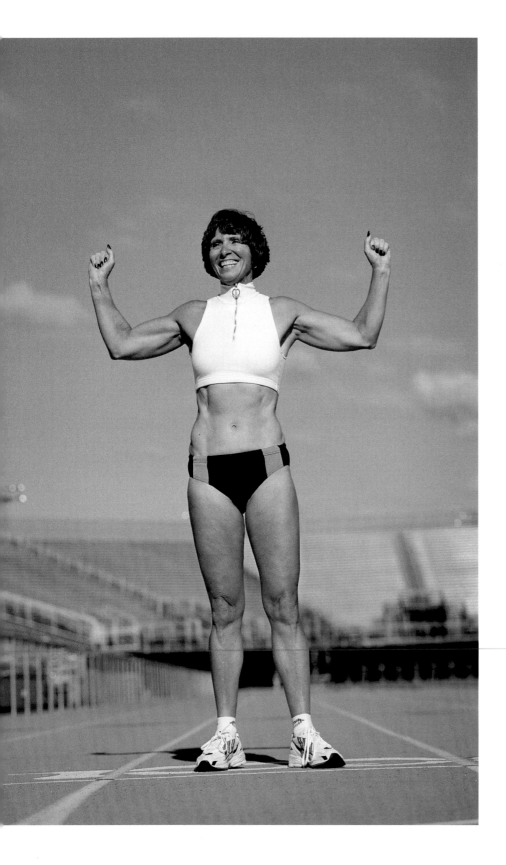

Decathlon:

First day: 100-meter dash, discus, pole vault, javelin, 400-meter run.

Second day: 100-meter hurdle, long jump, shot put, high jump, 1500-meter run.

The winner of the decathlon is the very best all-around athlete in track and field. You have to overcome the events that you are not strong in.

I enjoy the challenge.

Dinghy Sailing

Sailing has gone down the family line. My mother sailed, and both my grandparents. My grandmother was one of the pioneers of women's sailing. At one point I didn't think that I liked it. I was young, I didn't like to get wet, and I was scared. Sailing was work. There's a lot of heavy equipment involved—masts, sails, hulls, all sorts of things.

But sailing has done more for me than I could have ever imagined, especially in terms of self-confidence. I've traveled the entire world, all because of sailing. I may not go to all the museums, but from the water I get the best view in town. Everything is beautiful from the water.

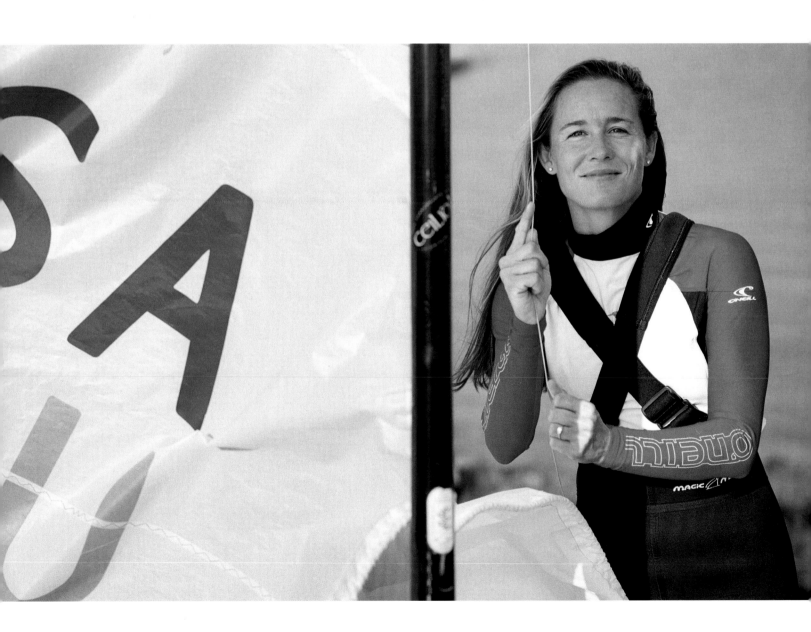

Discus throwing is the perfect combination of grace and power.

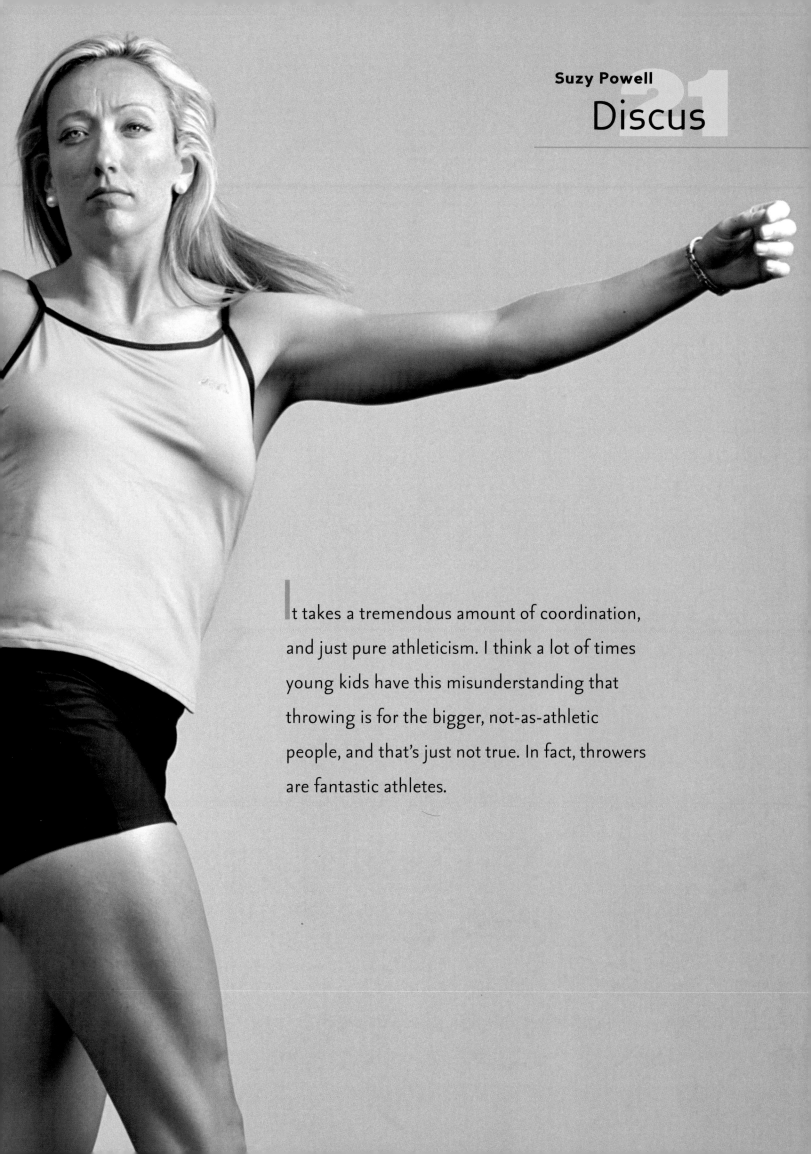

Discus

21

It takes a tremendous amount of coordination, and just pure athleticism. I think a lot of times young kids have this misunderstanding that throwing is for the bigger, not-as-athletic people, and that's just not true. In fact, throwers are fantastic athletes.

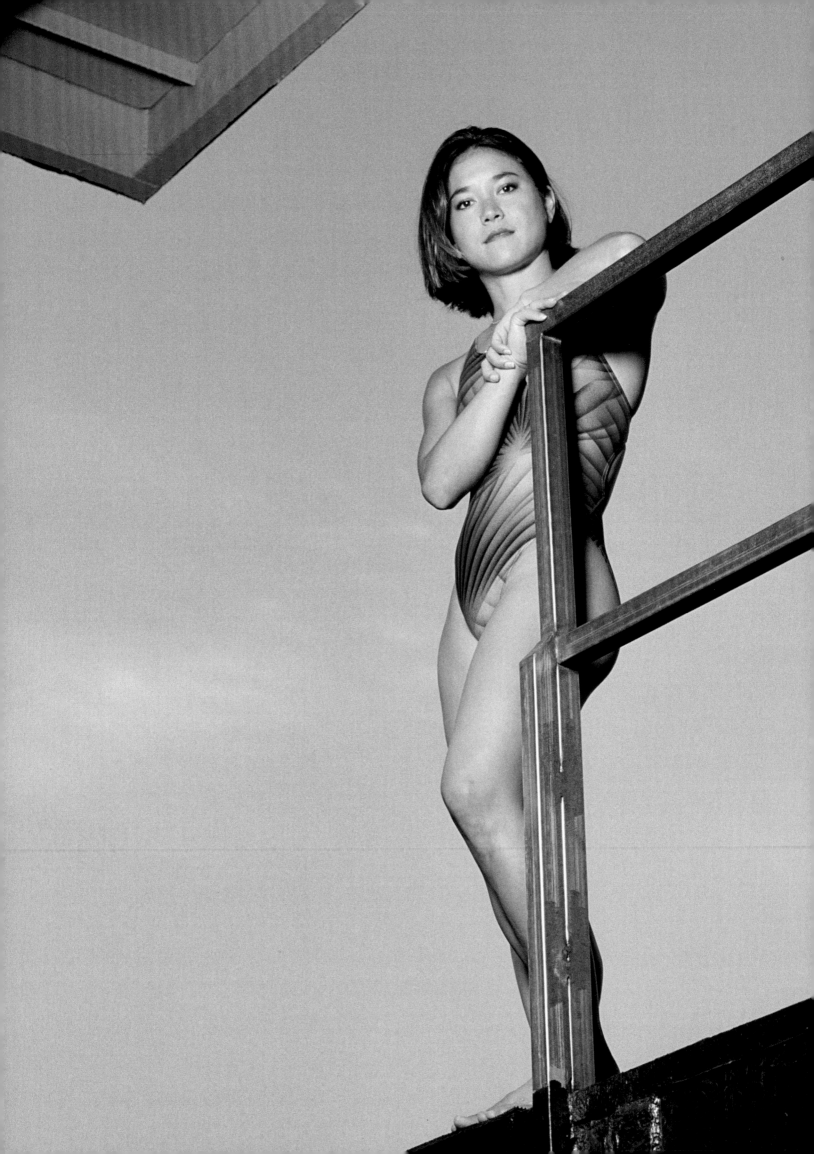

22
Diving

We don't train to make the Olympic team.
We don't train to win a medal. We train for gold,
and that's the mind-set you've got to have.

The beauty of sport is that it teaches you about life. One of the lessons I've learned from diving is that you've got to face your fear. You can't avoid it. You can't turn your back on it. You can't ignore it. You can't pretend it's not there and you can't run from it. When you're standing up there on the ten meter, you're thirty-three feet in the air. You know you're going to hit the water going thirty-five miles an hour. It's scary. But you face that fear, you get through it, and then you overcome it. You learn that you have to take the risks in order to receive the rewards.

Diving teaches you about acceptance and letting go. You can't make a dive happen; you have to let it happen—and that's just a really hard lesson to learn.

When you're on and you're flying through the air, you can hear the wind blowing by your ears and see the world spin around you; it's an incredible feeling. And then to hit the water and know that you nailed the dive, you just ripped it. The silence under the water is awesome.

Missy Giove

Downhill Mountain Biking

I am my
only limitation.

Horseback riding is a team sport.

My teammate is my horse.

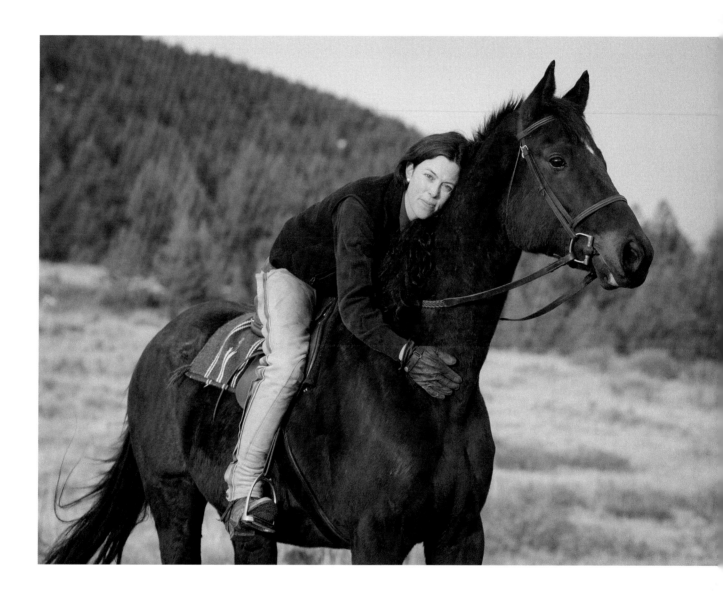

'm not riding a horse to jump big jumps and win. For me, the reward is taking a racehorse that has been mistreated, working through the problems, having the horse become my teammate and really wanting to do the job I'm asking him to do. The reward is in knowing I was the one who created that. So even if I don't win, even if I'm not a champion, I have a horse that can do a jumper course with me. If I do well, then that's just the icing on the cake.

Fencing

*Fencing got me out of the
South Bronx. It was my lifeline.*

knew I didn't want to go home to a dark, cold place with the ceiling falling down. It was no way to live. No heat, hot water, or electricity. I knew I didn't want to become pregnant or a drug addict. My biggest challenge was making sure I didn't live there for the rest of my life.

I was a shy kid, super, super skinny with big glasses. I was picked on because we had no money and I had only one dress. When I was sixteen, I saw a sign that hung on the women's locker room door: "If anyone is interested in fencing, come and try out." It seemed like a way to do something besides going from home to school.

The people on the team were nice to me. They supported each other. I liked the coach. I could talk to him about anything. Whether you won or lost, he still loved you. He became the father figure that I didn't have. I met the right people who showed me the right things at the right time. That changed my life.

Later in life, through fencing, something turned on in me and I started developing, becoming more of a joker. I started laughing. I was a quiet, unhappy kid and eventually, I got released.

I've ended up OK.

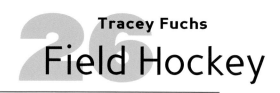

26 Field Hockey

Dream big.

I grew up with three sisters and five boys next door. We would play street hockey around the clock. On Saturdays we played from eight to six until our parents called us in to eat dinner. We played to win. We played for blood. We were as competitive and wanted to win as badly then as I do now. Those backyard games, even with nobody watching, were important to us. They still counted.

I wanted to play ice hockey but we didn't have very many rinks at that point. Girls really couldn't play. When I got to seventh grade, the only sport girls could pick was field hockey. I did not want to wear a kilt or skirt, but I wanted to play.

At eighteen, I got cut from the team. The coach thought I was too small to play in international field hockey. So I went in the weight room and I got stronger and eventually got my chance. You can make up for size with smartness and experience. That's what I've done from there on in. I've been playing for fifteen years. If you want something, you just have to believe in it and keep going after it. You have to dream big.

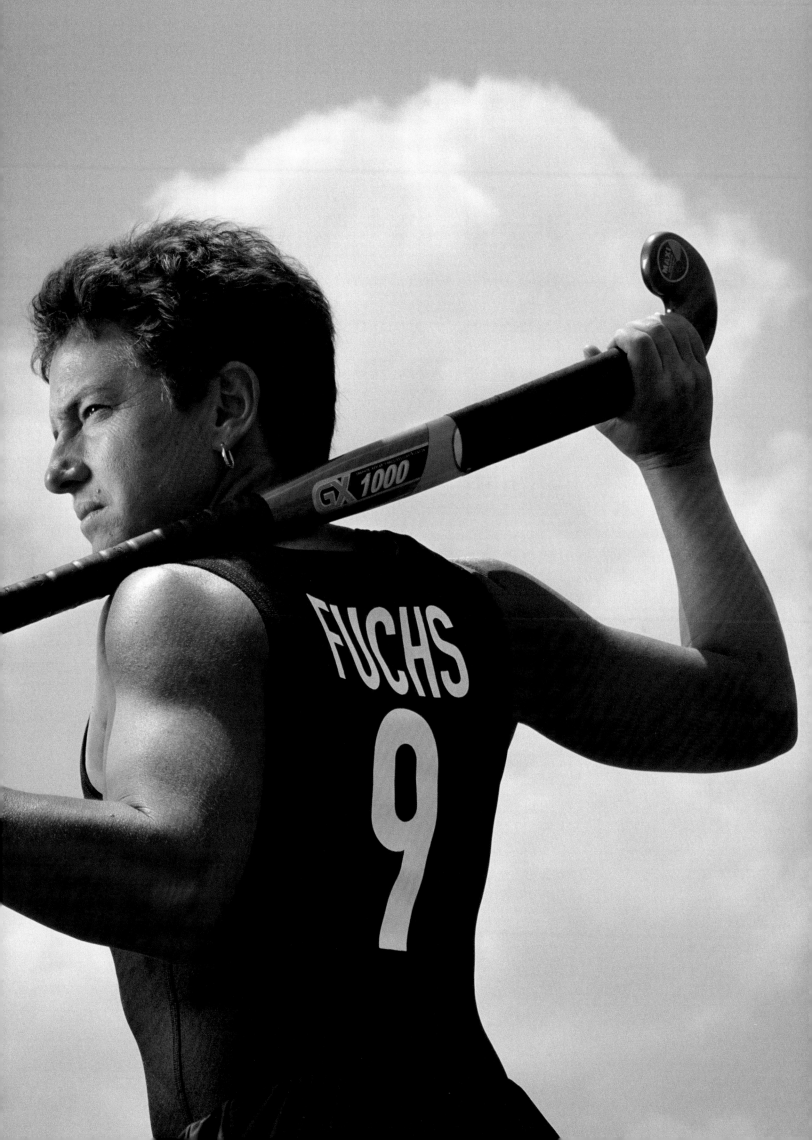

Denise Austin

27 Fitness

I'm truly out there just trying
to get people off the couch.
It's my personal challenge.

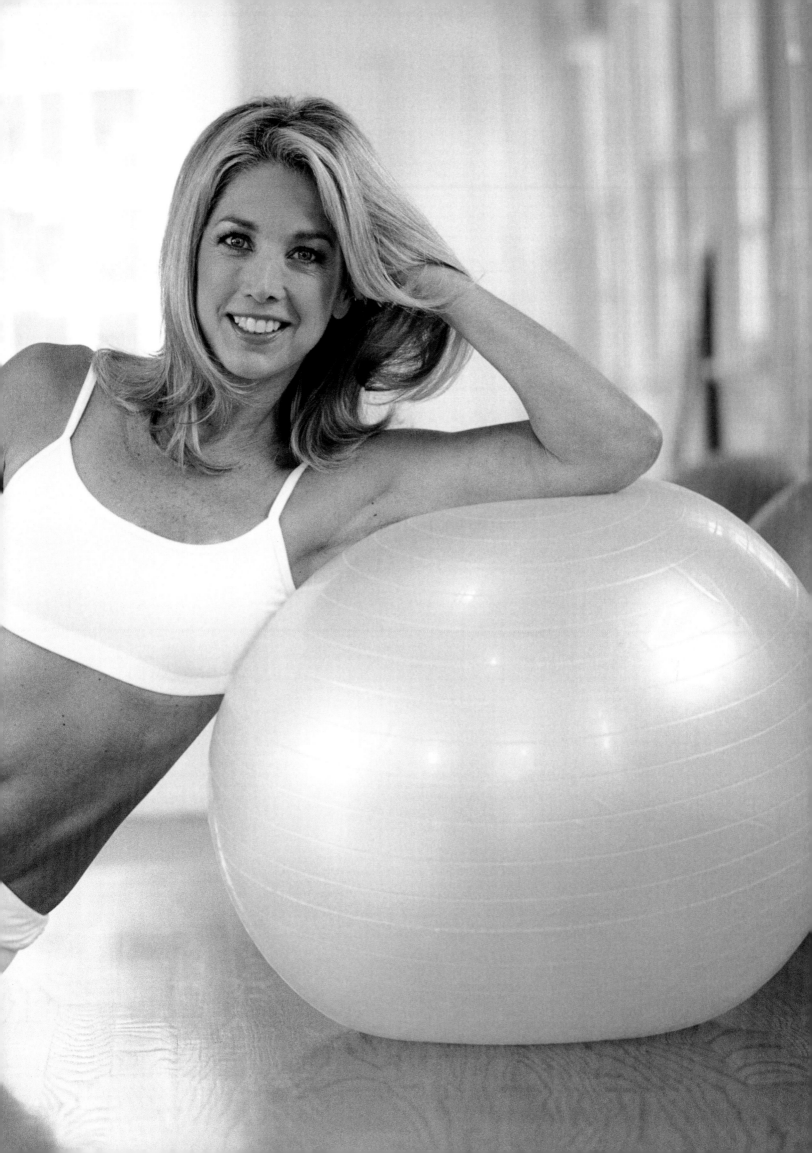

28 Football

Andra Douglas

*To boys it's a birthright, and to girls
the game of football is a privilege.*

Dad loved sports, especially football. He would take me out and teach me how to pass, how to catch. We were staunch Gators fans. We would listen to them on the radio, watch them on TV, and on occasion go to a game.

Not many girls liked football as much as I did. So I played with the neighborhood boys. By the time we were all in high school, I became so much one of the guys that they petitioned the head coach to let me play on the team. But it was the mid-'70s, and girls just weren't supposed to play the sport. The coach flat out said no, absolutely not.

Football was a passion. You play when you can. You cheer for your favorite team. You collect football memorabilia. You just love the game in all the ways you can.

In 1999 a couple of guys started the Women's Professional Football League. And they charged us money to play. They made teams. They started franchises. Women came from everywhere to live out their dreams. Never in my life had I put on football pads and a helmet and gotten out on the field and played the game. This was nirvana.

After one game we had to buy the franchise or we were not allowed in the league. No one wanted us, no sponsors stepped up, nobody cared. It came down to the final hour, and either we anted up or we played no more football. So I withdrew the money from my 401k and bought the New York Sharks. Never in my wildest dreams or even prayers did I ask to own a women's pro football team. Last year we won our first championship. It was a fantastic feeling of success after hard work, but it was an opportunity that should have been afforded me twenty years ago.

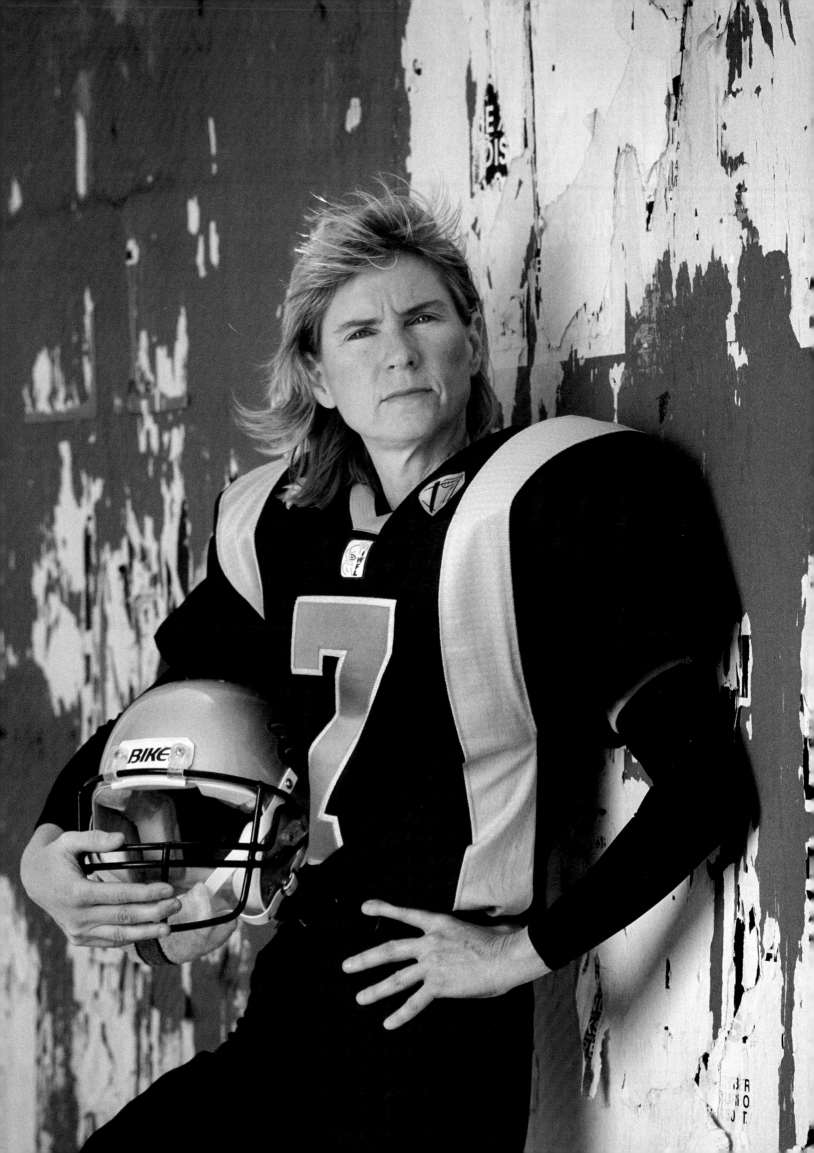

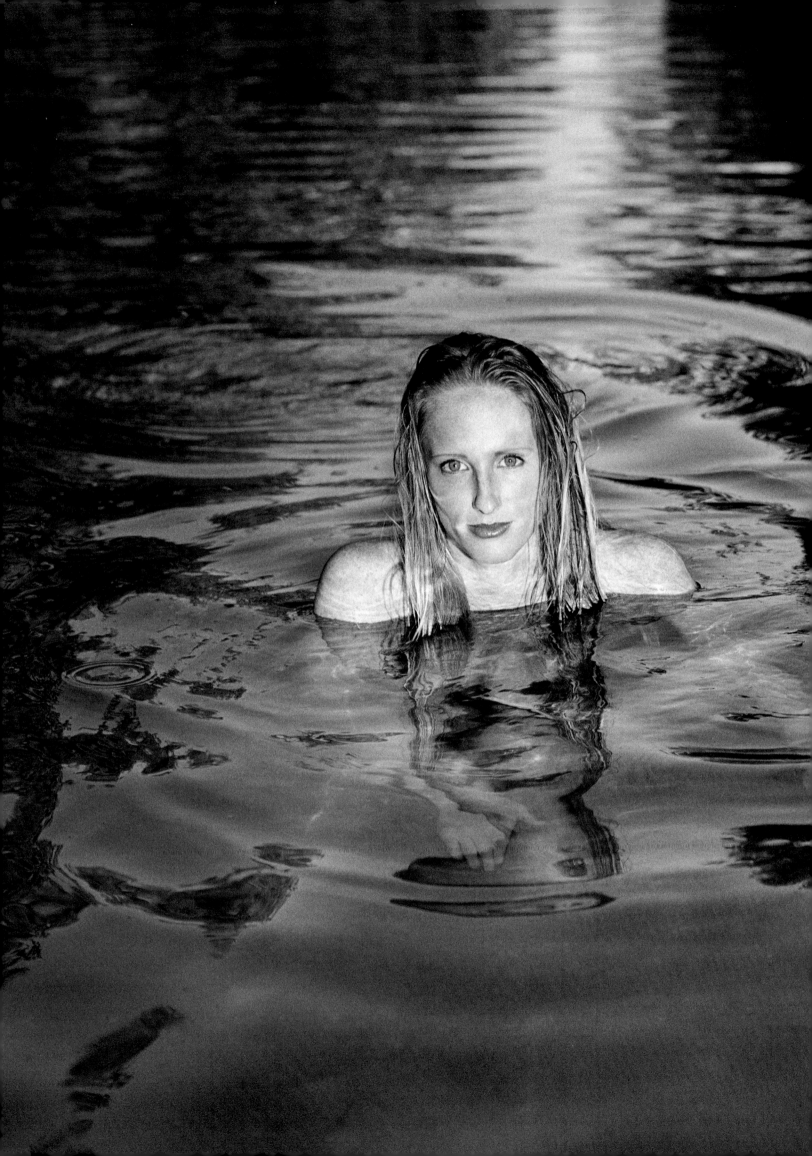

Free diving is nothing if it isn't life affirming.

It is not death defying.

Essentially, the basis of free diving is taking a breath of regular air at the surface, plummeting as deep as you can on that single breath, and returning to the surface with no equipment or assistance. I don't wake up one morning and say, "I think I'll try five hundred feet today." The training predetermines how deep I'm going to go.

I believed there were limits to what I could achieve, but the reality is that my limits are nowhere near where I originally thought they were. I realized that as human beings we all think that we can do only so much. But if we are superhuman for just a moment and try a little bit harder, we do succeed in more than we think we can. So day by day, dive by dive, literally meter by meter, I never let myself back down, I never let myself stop. I redefine my limits.

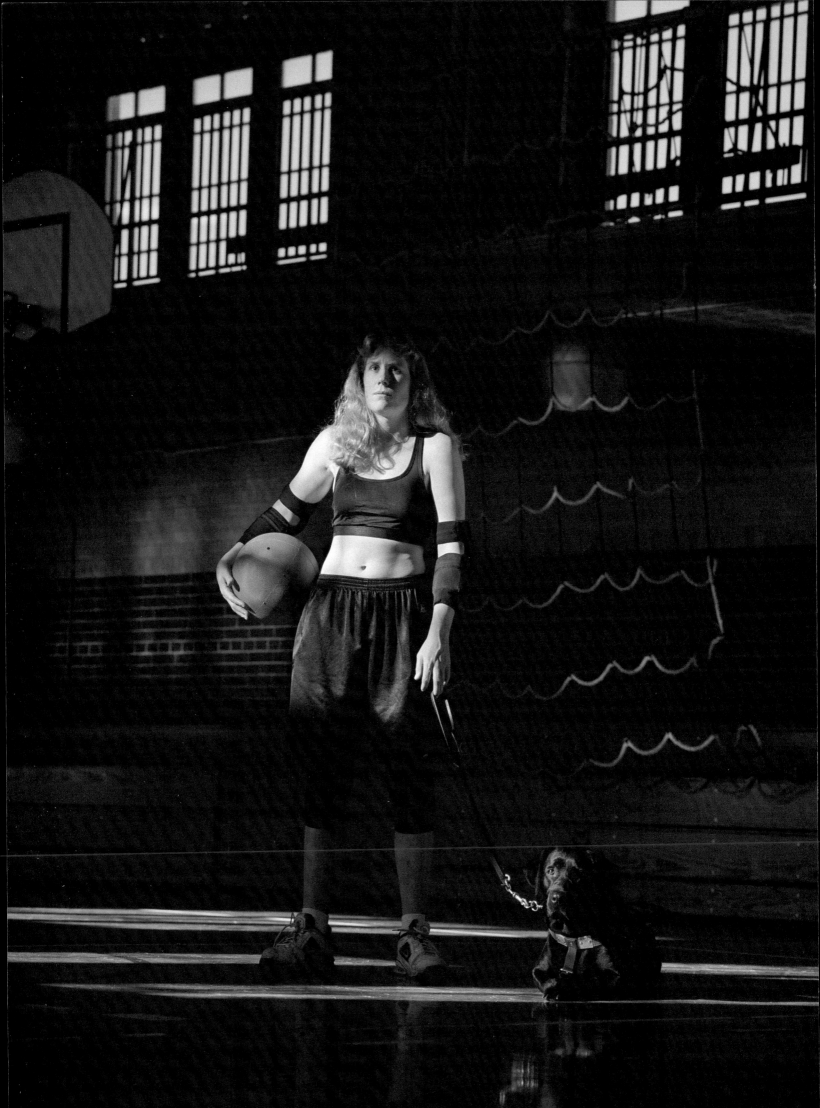

You have got three blind mice out there,

so it is a total trust factor that everyone is

where they are supposed to be, doing

their coverage and communicating.

W hen I started losing my vision at fourteen, I was fortunate to get introduced to goalball. I lost partial vision in my right eye in July of '89. The pain was there, the blurriness was there, and then it never recovered. Then in '92, a day before we left for the Barcelona Paralympics, I went totally blind in a matter of four hours. Had I not had sports, I'm not so sure everything would have gone as smoothly as it did.

In goalball everybody plays blindfolded, so there is equal vision. All the lines have string underneath tape, so you can feel them with your feet or your hands. The ball has bells in it, so it is all auditory, all hand-ear coordination instead of hand-eye coordination. It's totally different than what you experience growing up.

Sports did the same thing for me when I was sighted as it did when I became blind. The skills you learn in sport—responsibility, communication, teamwork, goal setting, learning to win, learning to lose—are skills that sport brings to any kid.

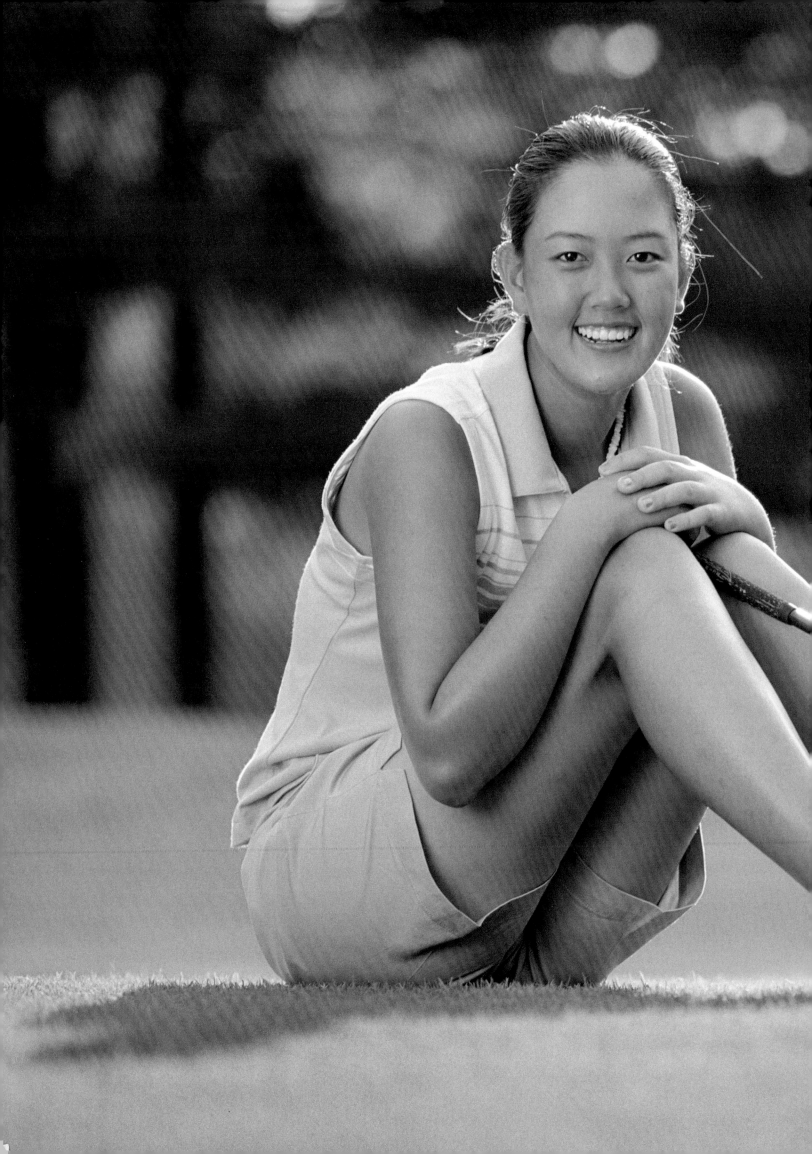

I really want to play in the Masters.

32

Golf (Professional)

My mom says that I got my rhythm and my swing because she played golf when she was expecting me. Even when I was not yet born, she says, I felt the vibes.

When I was young I would miss putts on purpose so I wouldn't win, so I didn't have to be in the limelight. I never played golf to be onstage.

The [PGA Tour] Colonial was something that I wanted to do. I was doing it my way, just being me. I really didn't expect all that attention. I was focused on getting my game ready. Other people were thinking more, What's she going to say, what's she going to do? That never really crossed my mind because I was there to play. Of course I was nervous; it was an arena I was not familiar with, so obviously I didn't feel totally comfortable. But by doing it the way I planned to do it, my way, just playing, I think people accepted that I was really there to try and test myself. I think people's opinion changed after that.

I'm very pleased with my performance. A lot of people think, Oh, you didn't make the cut, so you didn't succeed. That wasn't really the point. I went for the experience, to see how the guys approach it and to test myself. I wanted to see if I could handle it. I've won many tournaments in the LPGA, I feel comfortable doing that. I wanted to see what I was made of. Am I just a little tough, or can I be very tough if I need to [be]? I learned so much that week. It was everything that I could have expected, plus more. It was fantastic. It was the best golf experience I've ever had.

My ultimate goal? It's called Mission 54, which if you don't play golf just means you can birdie every hole. Nobody has done that. The way I look at it, if I play twenty rounds on this golf course right here, I know I'm going to birdie every hole at least once. So I always keep asking myself, Why can't I do it all in one day? If you think about it, the golf ball doesn't know which day it is or which hole it's on. I was the first woman to shoot 59, and I credit that a lot to thinking about the 54.

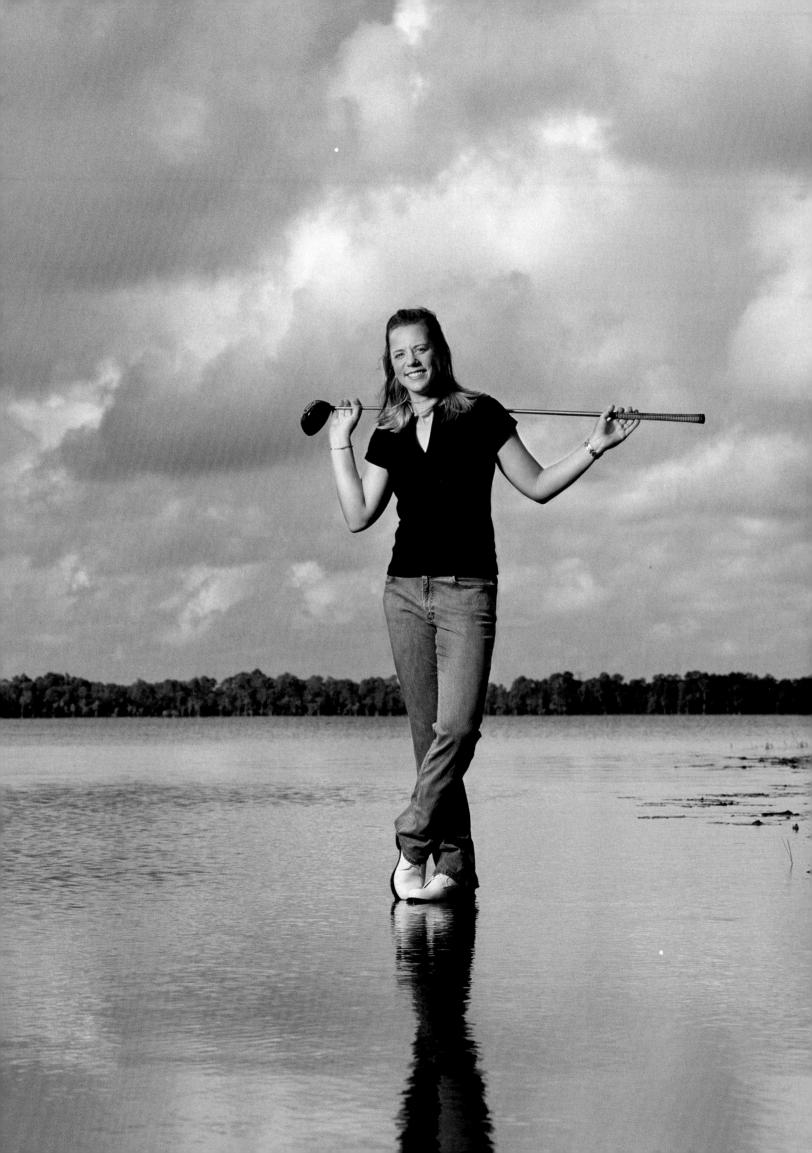

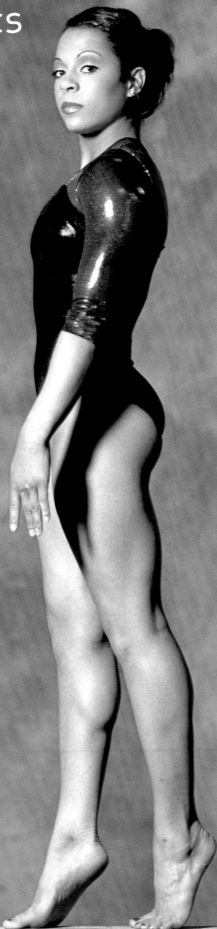

I thrive on competition. The Olympics was an awesome experience. I remember when I mounted the beam, I could hear myself breathing. It was so loud and yet I was in a quiet little place. My brain was thinking a hundred miles an hour of every correction I've ever been told. If anything could possibly go wrong, I was going to will it to make it go right. And after I landed my dismount, I could hear all the cheers. And that little special place went away.

Hammer Throw

It's not about hanging on tighter. It's about letting go.

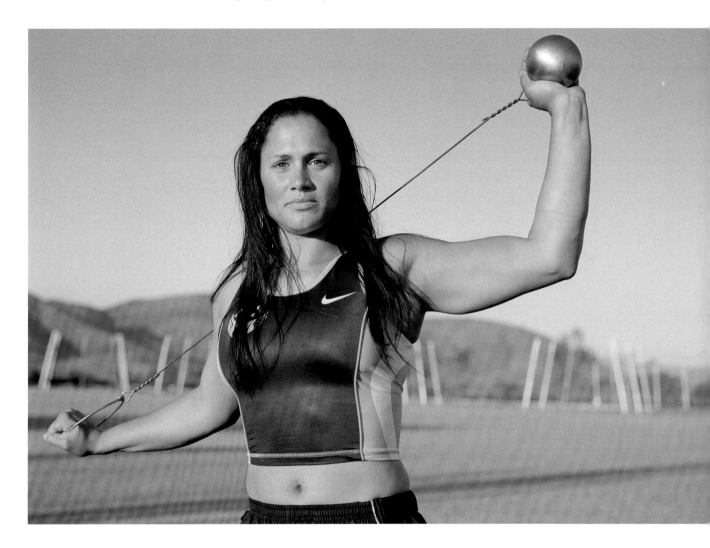

always felt bigger than the other girls. I started gymnastics, but the trend was toward smaller, petite athletes, so I played football. I can't kick the ball, but I can hit it, so I went out for volleyball. I was just searching for something, searching for something that fit me. Hammer just kind of found me.

It wasn't something that came easily for me at all. It was the hardest to learn of all the events that I've tried. You have to combine strength, speed, and technique. Hammer is a ball on a wire with a handle. You hold the handle, and then you spin around in a ring and release it. Whoever spins the fastest throws the farthest, and whoever throws the farthest wins.

Heptathlon

I n the 1996 Olympic Games a hamstring injury stopped me from finishing the heptathlon. I pulled out of it in hopes of saving my leg for a gold medal in the long jump. And the moment I qualified for the final, I realized that this is what athletics is about: when your back is up against the wall and everyone else doesn't believe that you can do it, but in your heart you believe that you can, and you find a way to achieve it.

I visualized myself being successful, and as bad as my leg was aching, never once did I think I couldn't do it. As I came running down that runway, I said to myself, Just attack the board, and if the leg falls apart, at least I will know that I gave my all. When I landed in that pit and walked away, regardless of what place I was going to be in, I knew in my heart that I had done my best.

And that's what the 1996 Summer Olympics was for me, the ultimate performance in the long jump and coming away with that bronze medal. I had broken world records before, I had won gold medals, but I did all that with a healthy body and a healthy mind and spirit.

I was so proud of that bronze medal. I felt like a champion because I pushed as hard as I could, I gave every ounce of energy that I had.

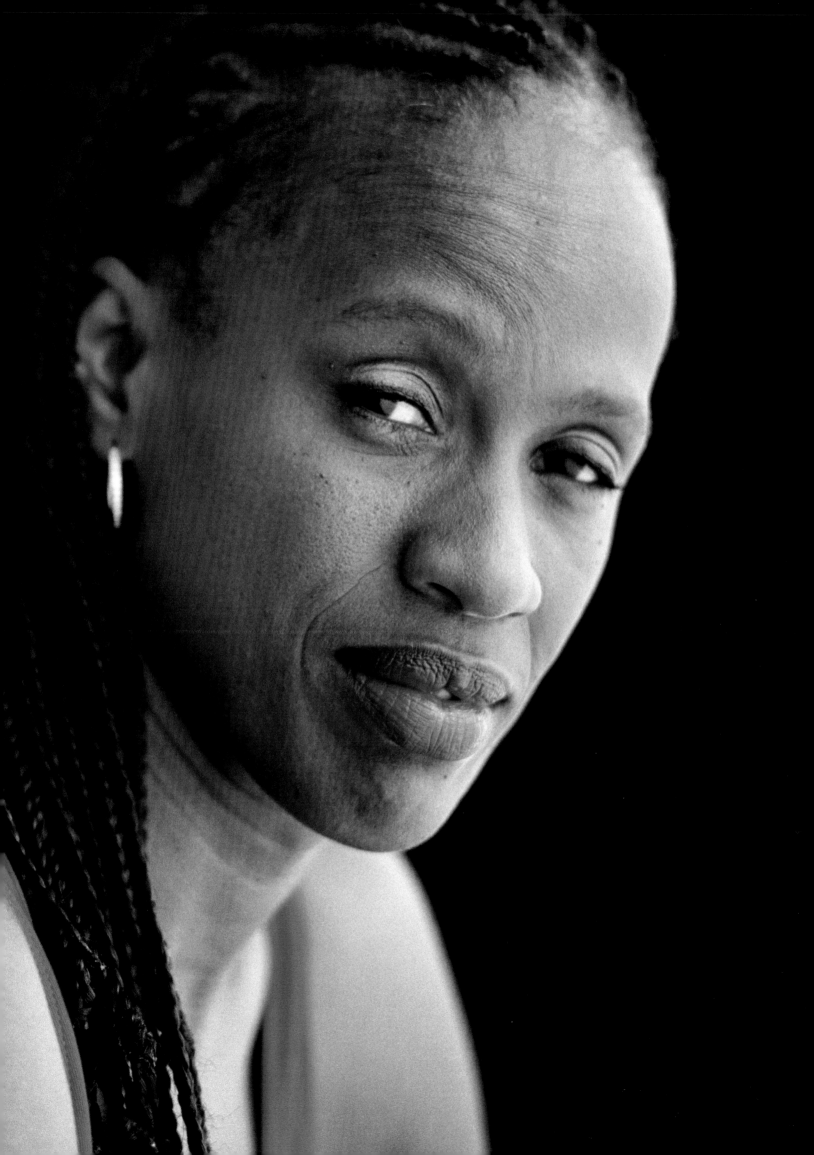

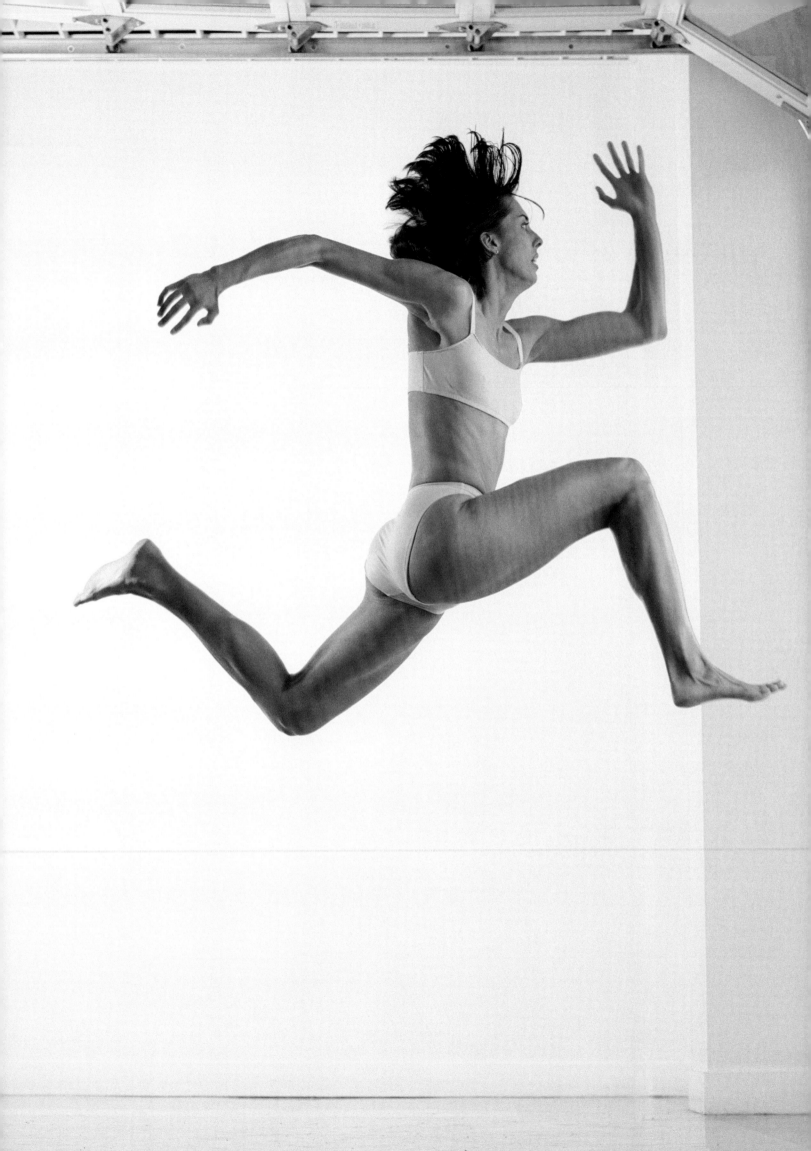

High Jump; Volleyball

I remember watching the Olympics

when I was really little, turning to

my parents and telling them that

I was going to be there one day.

When I started getting heavily recruited in both volleyball and track, I decided to challenge myself to become an Olympian in two sports. I started with track. At the Olympic trials, I was so fired up, so excited because I had trained for so long. But I was overanxious and missed my first two attempts. So I was like, It's now or never. I jumped, my feet hit the bar, and it wobbled up and down for a long time. I was in the pit going, "Oh, my God," just trying to send mental energy to the bar to stay up. I was completely freaked out, and my whole family was in the stands hoping that I'm going to make my first Olympic team since it had been my dream for so long. It stayed up.

All my competitors thought that they could count me out, thinking that I wouldn't be able to recover from the experience mentally. But I knew better because I knew how to be an athlete. The most exciting day of my life came at the finals, the day that I cleared the bar to know that I had nailed my spot on the Olympic team.

In volleyball, I play middle blocker. I'm fighting for the one position that is left open on the Olympic team. It's a huge challenge. I'm going to get that spot. If I don't believe that, then I might as well go home. I've always had really, really high expectations for myself, and I feel that with my athletic ability and my determination, there's no reason why I shouldn't be able to do it.

I've never set a goal for myself and not come through.

I see Olympic rings.

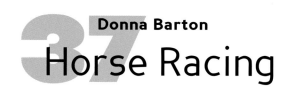

Donna Barton

Horse Racing

When I was a jockey I would pray every morning,
"Lord, please protect everyone involved with
today's races and this morning's training,
and thank you for blessing me with an open line of
communication between myself and my horses."

My first race.

Sitting in the starting gate, I look to my left, I look to my right. Everybody just has this look of competition on their face, their game face on. I look down the track, knowing that I have to try and get to the wire before all these other people. And from the moment that latch opens, you're thinking as fast as you can possibly imagine about what your next move is going to be. Every second you have to have another thought about what you're going to do next. And while you're thinking about trying to map out your course in the race, you have to pay attention to what the guy next to you is doing. You have to pay attention to what your horse is doing. Like, am I asking my horse for too much? Is he being reluctant? Is he wanting to go? Am I taking him back too much? So you have a thousand things going on all at one time. And all the while you are experiencing this incredible feeling of going that fast for that long and having a horse just spend itself for you on the racetrack. Horses are born competitors. And you try to extract that out of them. What you don't get from watching in the grandstand is how mentally challenging it is and what a thrill it is every single time that latch springs open.

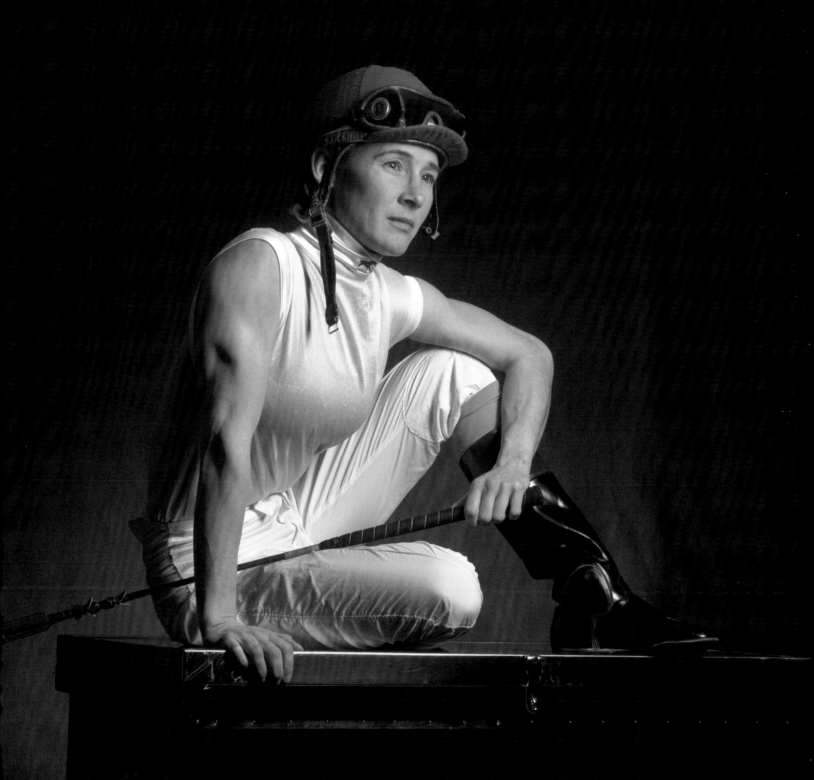

DONNA BARTON

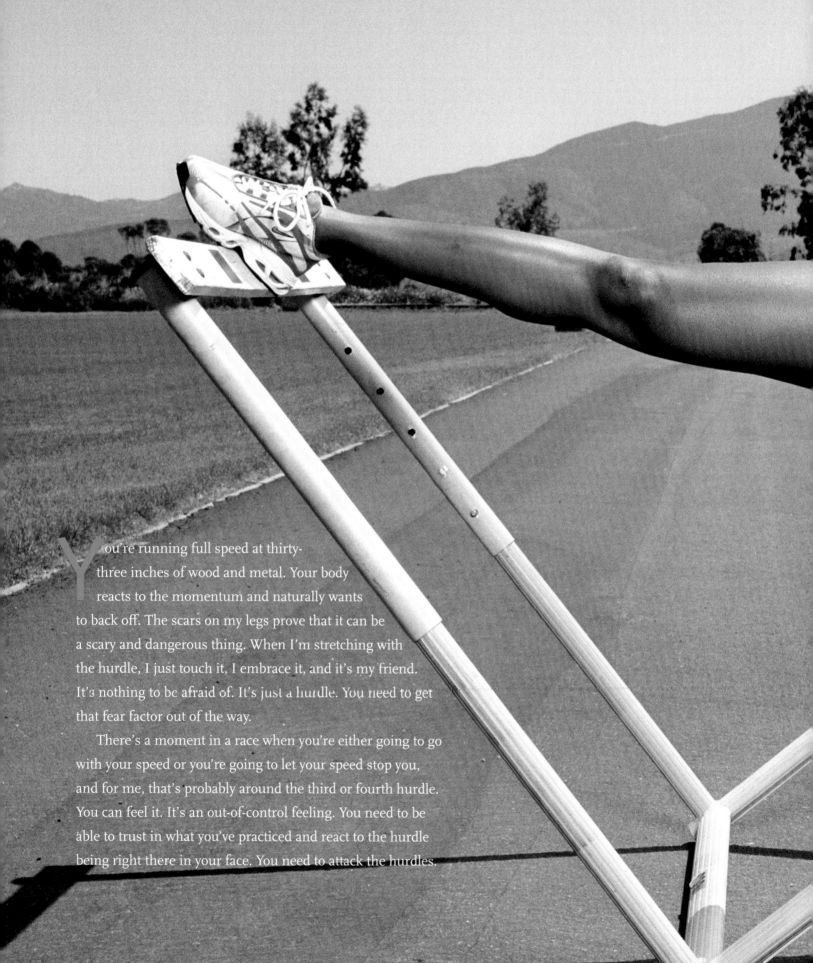

Chi Chi Ohaeri

Hurdles 100 meters

Y ou're running full speed at thirty-three inches of wood and metal. Your body reacts to the momentum and naturally wants to back off. The scars on my legs prove that it can be a scary and dangerous thing. When I'm stretching with the hurdle, I just touch it, I embrace it, and it's my friend. It's nothing to be afraid of. It's just a hurdle. You need to get that fear factor out of the way.

There's a moment in a race when you're either going to go with your speed or you're going to let your speed stop you, and for me, that's probably around the third or fourth hurdle. You can feel it. It's an out-of-control feeling. You need to be able to trust in what you've practiced and react to the hurdle being right there in your face. You need to attack the hurdles.

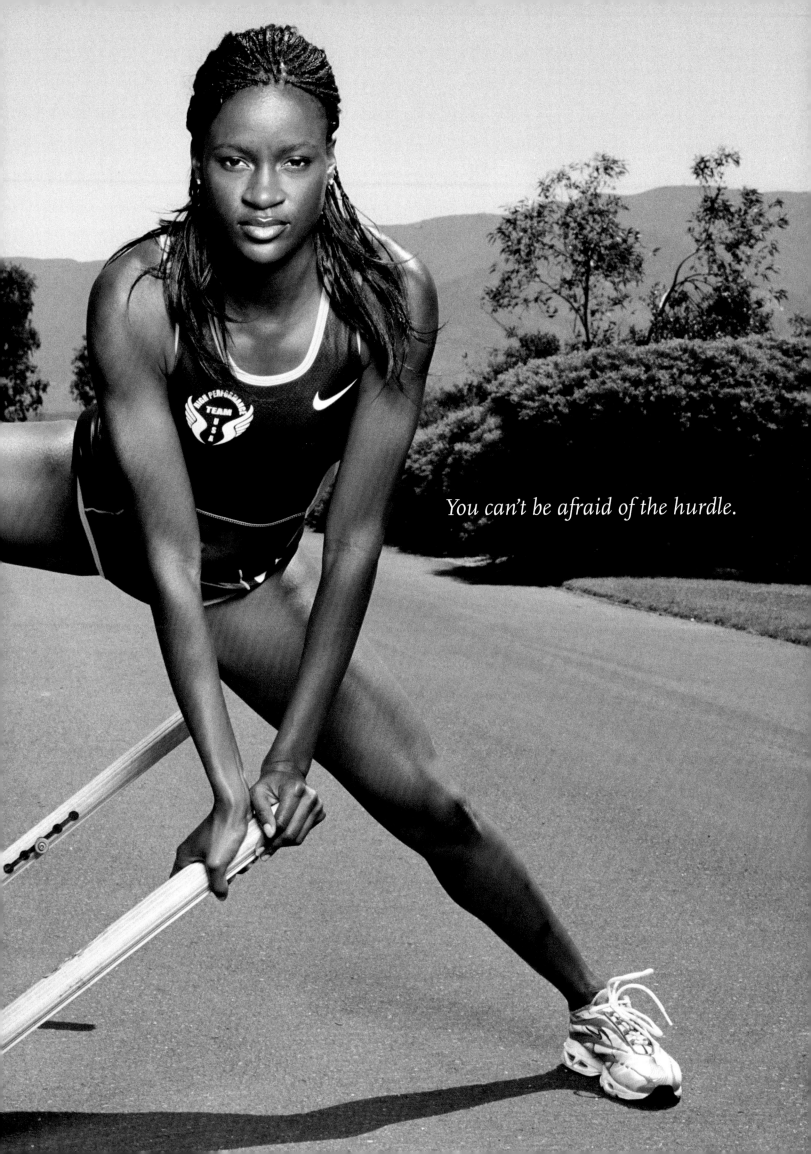

You can't be afraid of the hurdle.

Tanisha Mills

Hurdles 400 meters

Though there may be thirty thousand people in the stands, you are competing for an audience of one, and that is Jesus Christ. The world's success is how fast you run, but God's success is how you obey him and how faithful you are to him.

I really want to break the world record. But my ultimate goal is to use my success to share God's love with kids and youth in sports. I want to be a role model to motivate kids to lead productive lives. God gives you the talent. This can be your gift back to him.

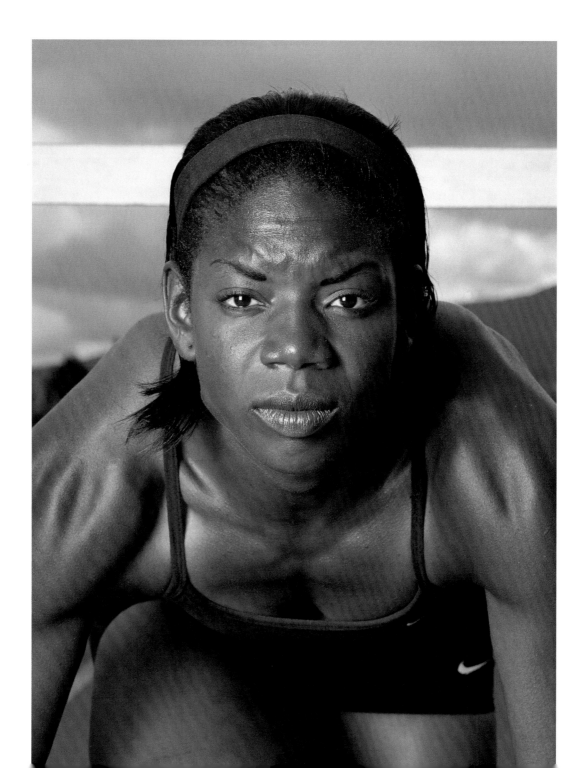

When I told my father that I wanted hockey skates, he thought it was the greatest thing in the world. He was an ice hockey coach. So we go to the lost and found and he starts outfitting me. I'm just a little six-year-old girl, and all this gear is huge on me. You've got your shin guards, your big hockey socks, your garter belt. He dresses me in a male protective cup, and I don't think anything of it. He puts on the shoulder pads, the elbow pads, the jersey. I'm just standing there like the Stay-Puft Marshmallow man. He puts my helmet on and off I go. I come back after skating and I'm waddling. I had these huge bruises on the inside of my thighs because there's just no way a little girl should wear a male cup. It was so funny. People gave my dad such a hard time about it.

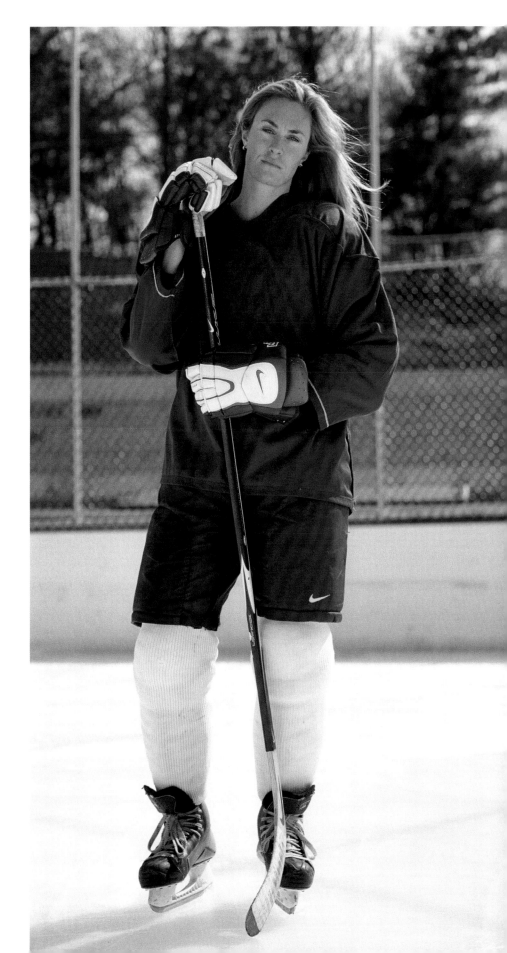

41 In-Line Skating

Skate or die. Every scar, every bruise,

they're all memories, anyhow.

When I was nine my grandfather passed away. He was my best friend, my soul mate. Whenever I skate I tell him to be there and protect me. When I won the World Championships, I know that he was there to help me flow. I believe that God is always there for me, he's always looking out for me.

My best friends gave me the name Kelly Butta 'cause I skate smooth like butter. It's important that I have my friends around 'cause they're the ones who will push me. It gives you more of an adrenaline rush when you're with other people and you can show them how much you've learned. We're like a family. When you see kids skating on the street, that's where the heart is. When you're just having fun without competition, that's where the real love is.

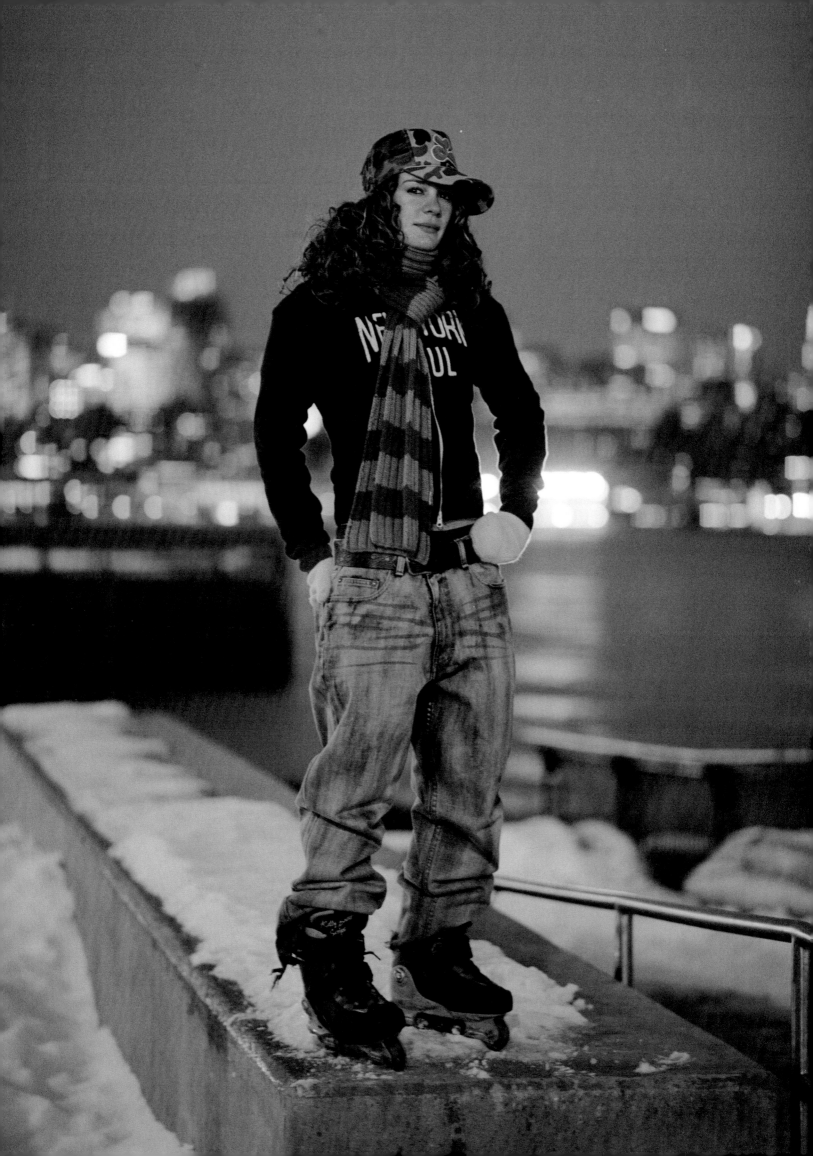

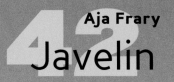

42 Javelin

Aja Frary

When my stepfather didn't want me to succeed, it just made me want to succeed that much more. He was not supportive of anything I did. It got to the point where if I was starting to excel in something, he would hold me back and try to put me down. He told me I had to quit sports and made me drop off my high school basketball team. That's when I decided to leave. I moved out when I was fifteen.

I realized that I have a talent and have been blessed with something that not everybody has. I wasn't going to just fold up and think that I was not worth anything. I went to my grandparents. I immediately jumped onto the track team, onto the basketball team, and onto the cross-country team. I made the varsity basketball team. I was MVP for cross-country for three years and then team captain and MVP for track and field. And then my senior year, I got a scholarship to college.

Sports was my escape. If it wasn't for sports, I don't know where I would be right now. It was the one thing that I loved. Sports was my drive, what kept me going. Sports allowed me to feel good about myself and to succeed.

I didn't have the best childhood growing up. So I spent a lot of time with my friends, and sports were my main way out, my escape.

Rusty Kanakogi

Judo

The bow signifies mutual respect.

You respect your opponent for being there for you. If you win, you respect your opponent for doing their best, and if you lose, you respect them for being better than you for one split second. The bow is a salutation. It's hello at the beginning, and in the end, it's a thank you.

When I got word from the International Judo Federation that all my battles, all the fights, all the aggravation, all the work, all the money, and all the effort that went into the fight to include women's judo in the Olympics had worked, I think I went higher that any pro basketball player in history. My feet left the ground and my head was almost embedded in the ceiling. Giving birth, getting married, all those things were cool, but hearing that women's judo would be in the 1988 Olympics was probably the greatest moment in my life.

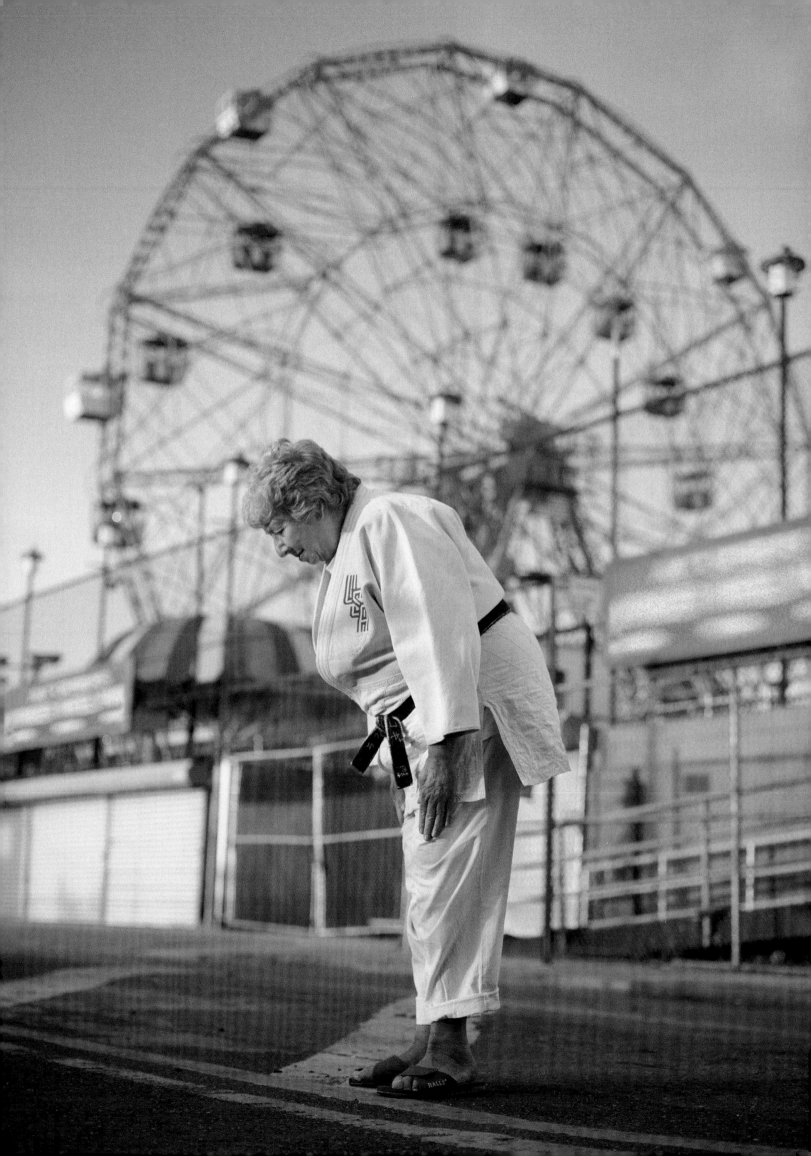

44 Kayak—single (K1)

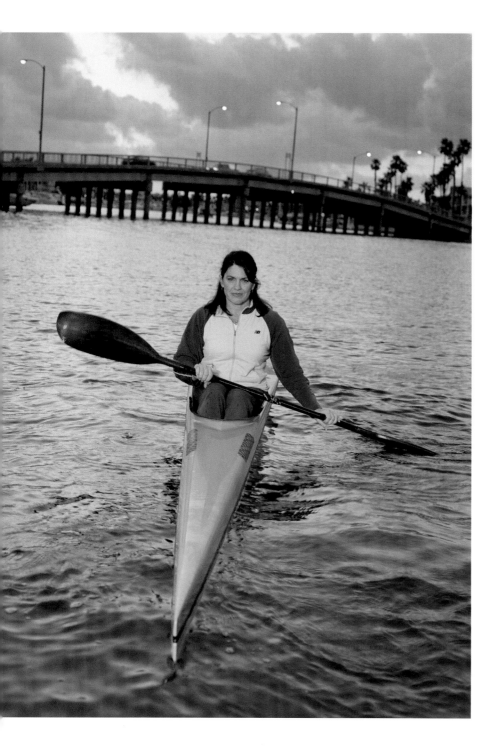

At the Olympic trials in '88, I was coming off a shoulder injury. I was still icing, getting ultrasound, and taking ibuprofen. When it came down to the end, it was neck and neck, and I didn't focus on anything but that finish line and God. It's that kind of pushing past the pain barrier, pushing past everything, and being extremely focused that makes the difference between winning a race and losing a race.

In '92 I was a single mom. My parents used to follow me to competitions with my son in tow. I paddled while my mom watched the baby. Then I'd jump out of the boat, breastfeed him, and jump back in. It was just crazy. But to me it was an opportunity. This child was my strength. I didn't win that year, but, wow, what a ride. I like to say that my son is my gold medal.

So for me, both Olympics were opportunities to overcome obstacles. I believe that when you're truly vulnerable, when you're truly weak, you can become strong. To be an athlete, to be successful, you have to overcome what other people see as a disadvantage, and if you choose to make that your strength, then anything's possible.

Kathryn Colin

Kayak—double (K2)

*If you have anything left, then you know
you didn't have a very good race.*

L ast year we finished our
race at Worlds. We got to
the dock. My lungs
were burning so much. My
legs were completely done. I
couldn't get myself out of
the boat. A lot of times you
get a postrace cough just
from breathing so hard
through your lungs.

It's just pure exhaustion
if you do it right.

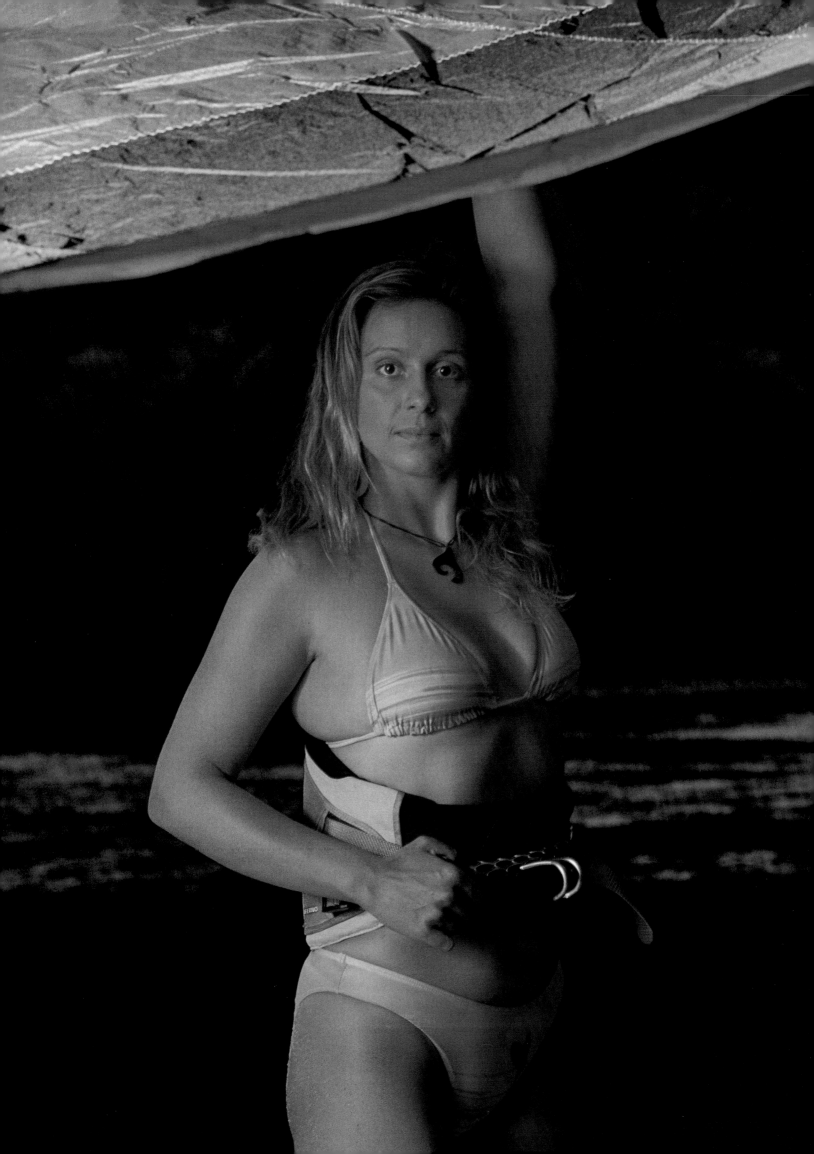

Kiteboarding 46

Look inside and find out what you love.

When I look at the guys, I really believe that I can perform at their level. I can do these massive, thirty-feet-in-the-air triple rotations with a grab inverted, land perfectly, and sail away, or do this really fast, really powerful wakeboarding-style move. I really believe that I can achieve that. I know the wind direction, I know what my skill level is. It's just a matter of calculating the risk, facing the challenges, and pushing my own inner strength and inner wisdom to become a successful woman athlete in this extreme sports world. I believe in myself.

My message is to just really love what you do, love yourself, and do what you love. I love kiteboarding, extreme sports, traveling, and interacting with people. So I focused on those, and that's opened up an amazing world. Follow whatever it is that you feel drawn to and are passionate about; follow your heart.

47

Loretta Claiborne
Long Distance Running (Special Olympics)

God is my strength and Special Olympics is my joy. That is the oath that I follow.

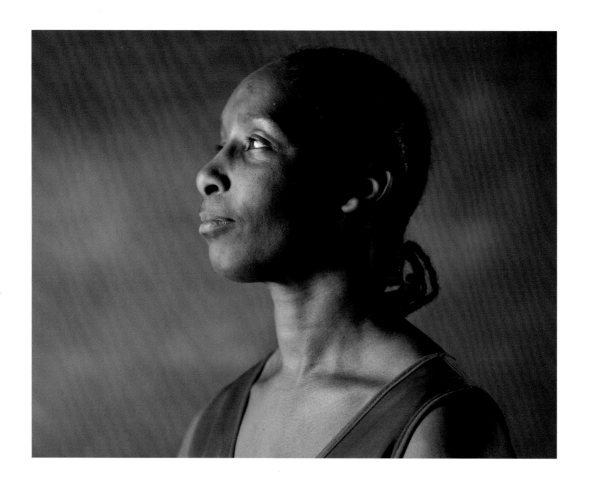

speak about acceptance of people with mental disabilities. If you learn to accept somebody, you learn to get along with them instead of just tolerating them. I speak about the commonality between me and you as human beings. And that's basically what Eunice Kennedy Shriver tries to show the world through sports, that people should be accepted. The only difference in the people who are in Special Olympics is that they are a little bit slower in learning something; otherwise we are all the same.

If I can change one person's mind about how they think about themselves or about somebody else, then my work is done.

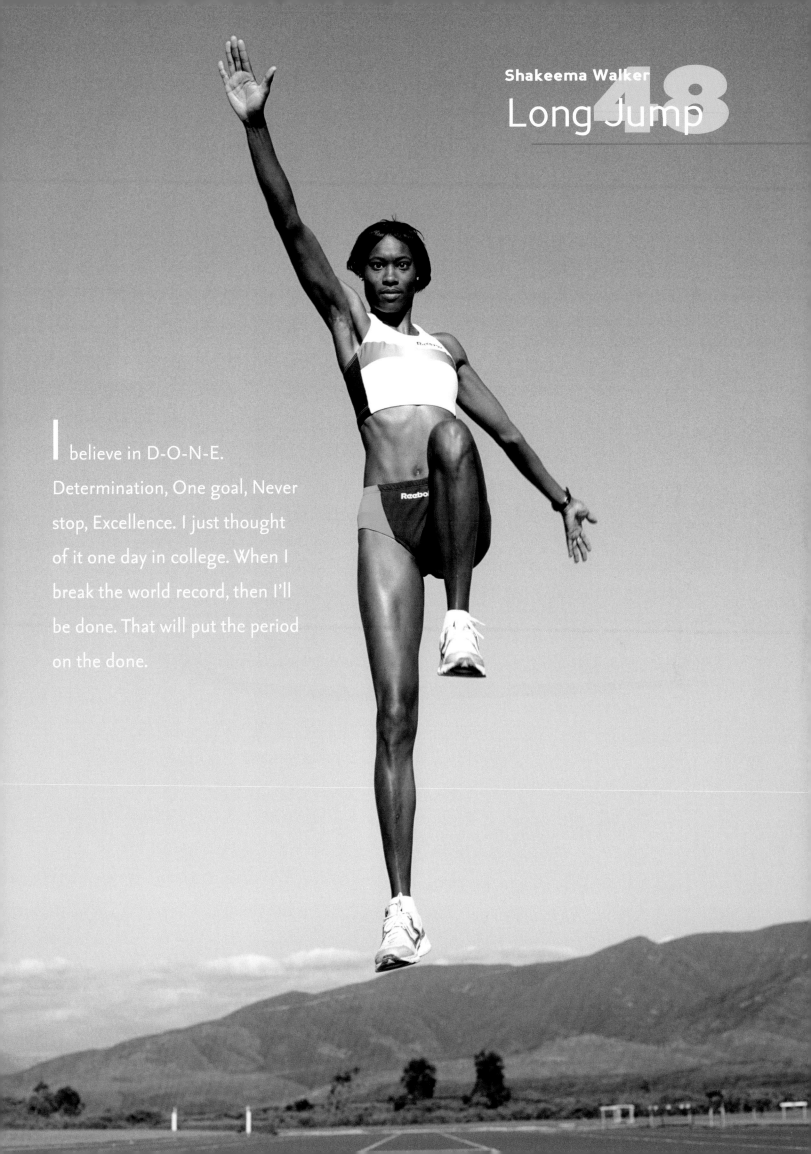

I believe in D-O-N-E.
Determination, One goal, Never
stop, Excellence. I just thought
of it one day in college. When I
break the world record, then I'll
be done. That will put the period
on the done.

48
Luge

*You need to be able to let yourself go
when you're on the sled, trust your
instincts and let your body do
what is has learned how to do.*

When I was sixteen and won Nationals, I realized that I could do just about anything. I knew, at least for that day, that I was the fastest person in luge in the country, and it seemed as though there were endless possibilities.

I competed on the national team for fourteen years and competed on four Olympic teams. I've won eleven World Cup medals. And while I was competing I held every American record on every single track in the world, and broke some track records as well.

Luge is the only Olympic sport that's timed to the thousandth of a second. The fastest I have gone is just about ninety, up from the men's start on the track in Park City, which is the fastest track in the world. Most of the time, you wouldn't even notice the speed. There's not any sensation of feeling out of control. When everything works well, the run seems to be in slow motion. There's plenty of time to think about what you're doing and steer. You relax and have a good time; everything flows.

Luge came pretty naturally for me. I was just at home on the sled.

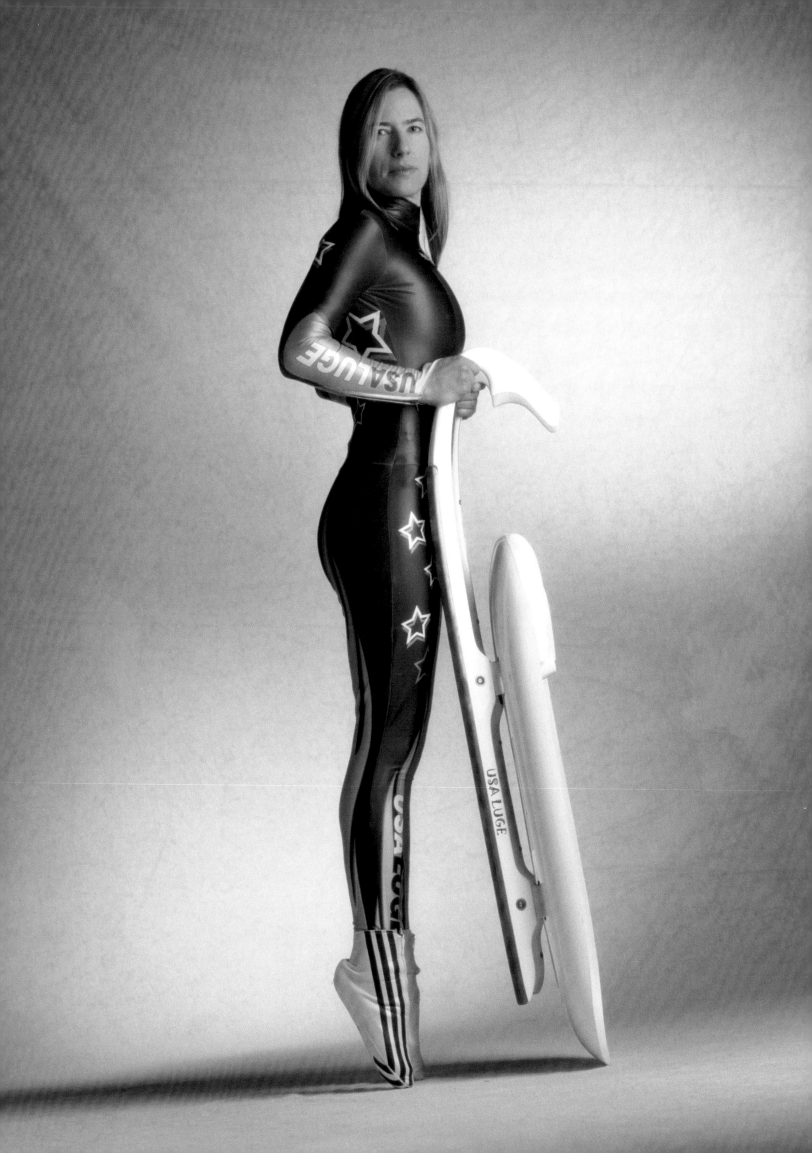

50 Katherine Switzer
Marathon

In 1967, I was the first woman to register for the Boston Marathon and pin on numbers. In the '60s there were extremely limited opportunities for women in sports in general. And even worse, there was this social stigma against women in sports. People perpetuated these myths. They said that if a woman was a long distance runner, her uterus was going to fall out, she would never have babies, she'd grow a mustache, have big legs, or turn into a man. People thought that there was no way a woman could ever run a marathon, or that if she did, she'd be a freak of nature. As I was training for the marathon, I was thinking, Why aren't there other women here? I know I am not exceptional. My God, maybe they listened to the men. Maybe when they were little girls they were told at a certain age that it's time to stop climbing trees and to just play with dolls. And that if you run you're going to get big legs, and all those myths I heard all my life. I thought they were silly, but maybe most women didn't. And when people are afraid they don't do things. That's when I realized, if women had their own opportunities and somebody welcomed them, they would be here running. It's like *Field of Dreams*. Build it and they'll come.

Everybody remembers me for being the first
woman to officially run in the Boston Marathon.
But I'd most like to be remembered for getting the
women's marathon into the Olympic games.

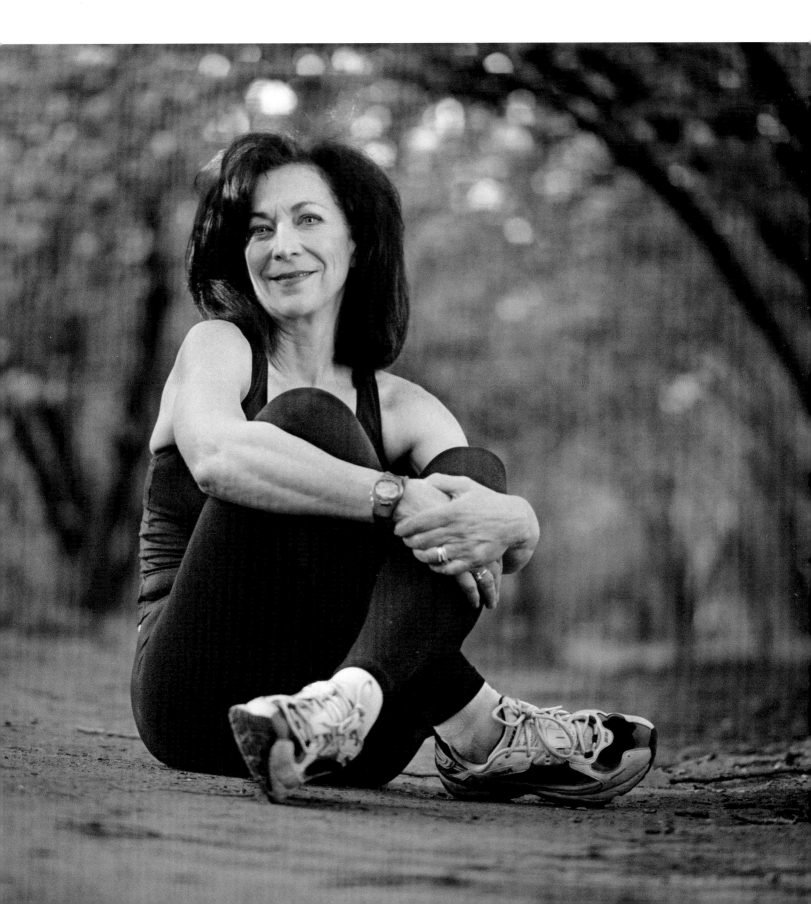

Sasha Spencer

Middle Distance Running 800 meters

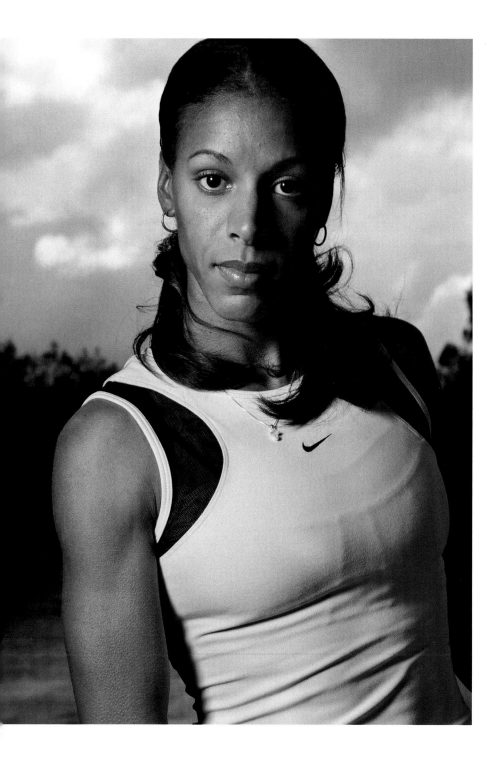

I got my degree from business school, and for the first time I was the only one holding myself accountable for my training. It wasn't because I was on scholarship. There wasn't anyone out there watching me. I was working during the day and training at night. And often I was the only one on the track. After the first couple of weeks, I asked myself, Who knows if you do four laps or five, or how fast you go? There's no one out here to watch.

And that's really the moment, when you're standing there by yourself and no one knows what you do, that's when you decide not only how good you want to be but how good you are. That's when you find out if you can dig out that last 600 meters at eight o'clock at night on a dark track. And it stops being about the time you run and becomes more about completing what you set out to do that day. And at the end of those days, regardless of what times I ran, as I left the track I told myself you won today because you set a goal and you completed that goal. And every day, that's what really keeps me going.

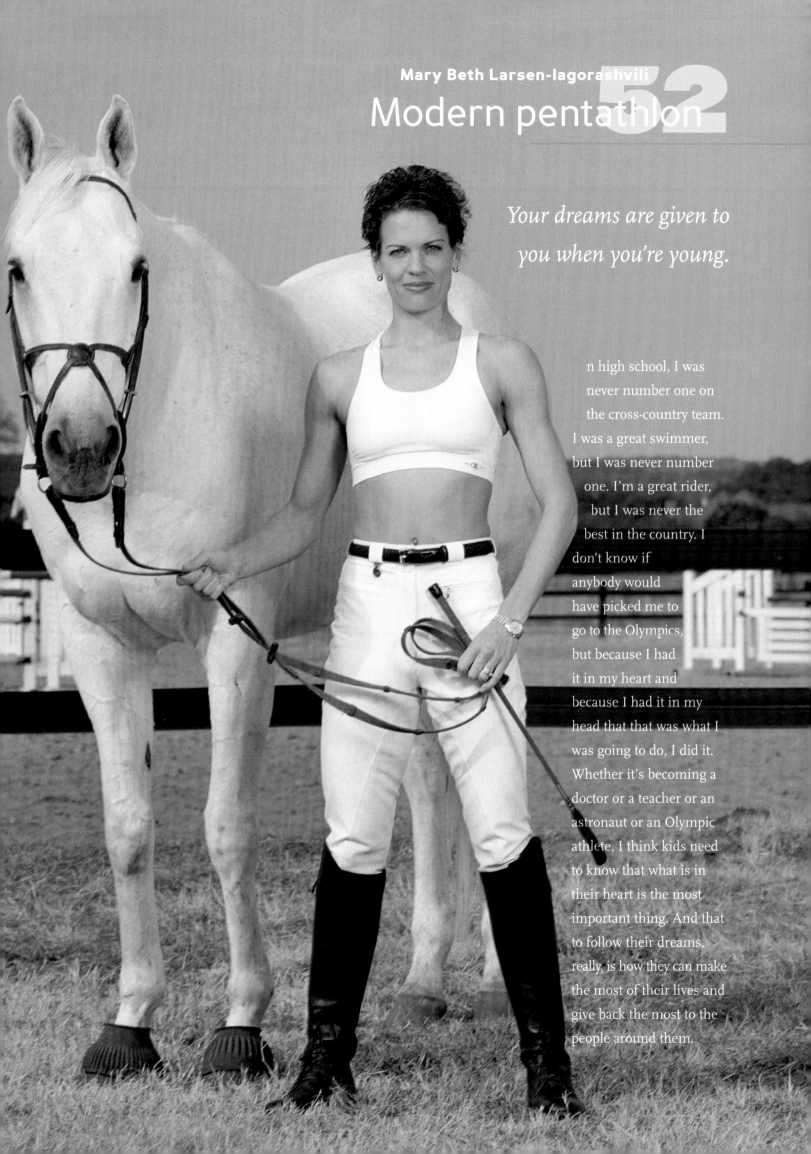

Your dreams are given to you when you're young.

n high school, I was never number one on the cross-country team. I was a great swimmer, but I was never number one. I'm a great rider, but I was never the best in the country. I don't know if anybody would have picked me to go to the Olympics, but because I had it in my heart and because I had it in my head that that was what I was going to do, I did it. Whether it's becoming a doctor or a teacher or an astronaut or an Olympic athlete, I think kids need to know that what is in their heart is the most important thing. And that to follow their dreams, really, is how they can make the most of their lives and give back the most to the people around them.

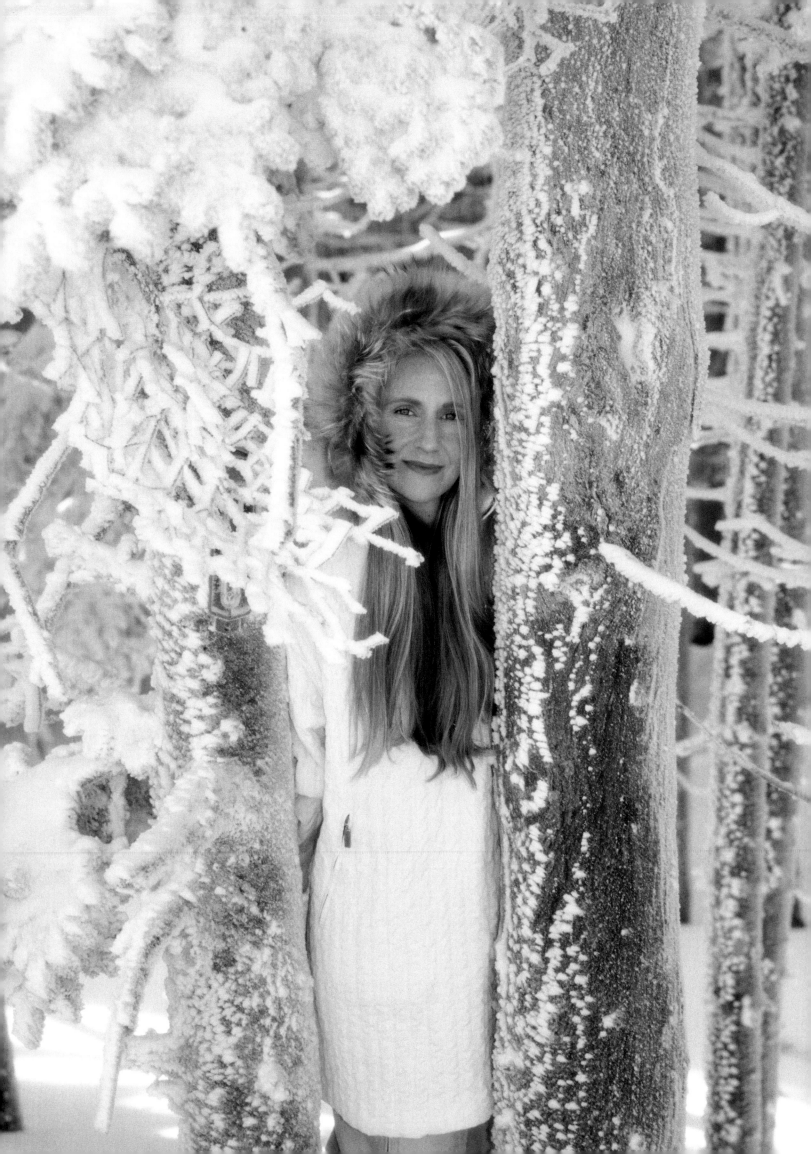

Moguls

I always respected my competition.

No matter what my ability,

as soon as I disrespect them, I lose.

You get up and it's dark out. You get suited up and start to get ready. You need to warm up, you do a lot of stretching, spinning; you do a lot of running in the hallways. You eat, if you can get it down because you're nervous. It might not be like yesterday when it was just perfect weather. Your arena is constantly changing—the light, the visibility. From minute to minute the course can change. And you have to accept that as what has been given to you today. You're kind of going with that and trying to get strength. And I would always look myself in the eye and be open to the day. I would just smile at my reflection and go.

Sara Will

Monoskiing

grew up skiing; the slopes were basically my baby-sitters. I was a natural. I just loved the skiing environment—the mountains and the whole social aspect of it. After college I moved out to Aspen. I was just going to be a ski bum for a season. I lasted only three months before I had an accident.

When I started to learn how to ski again, I started crying and thought to myself, This is not the way I remember it; I don't like this. As I was struggling, I saw some of the best disabled skiers in the world fly by me. And I never really saw their disability. I saw their skiing ability. I saw them lay down a perfect arc at over sixty miles an hour. And I knew right away that I wanted to compete. This was my second chance at an Olympic dream that passed me by a long time ago. So this was an awakening for me, and I've been pretty much addicted to it and committed to it ever since. I just love ski racing and free skiing and the whole feeling of being out there in the mountains. There's a sense of freedom and a happiness that I don't find in any other way.

We are athletes first, disabled second.

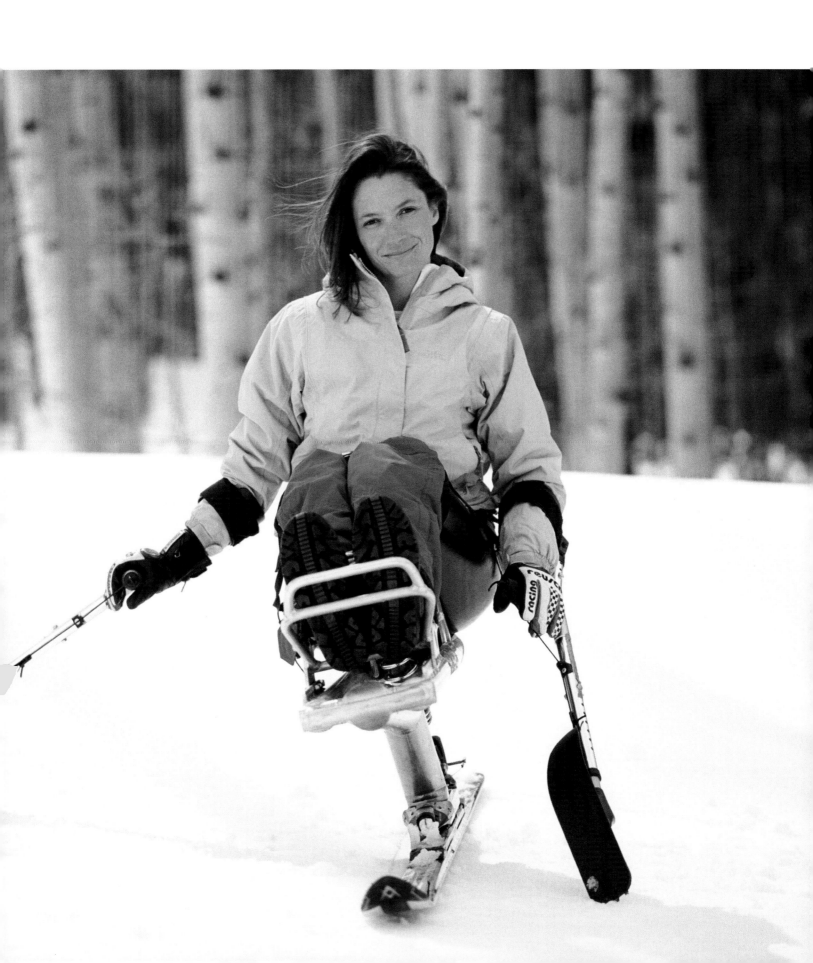

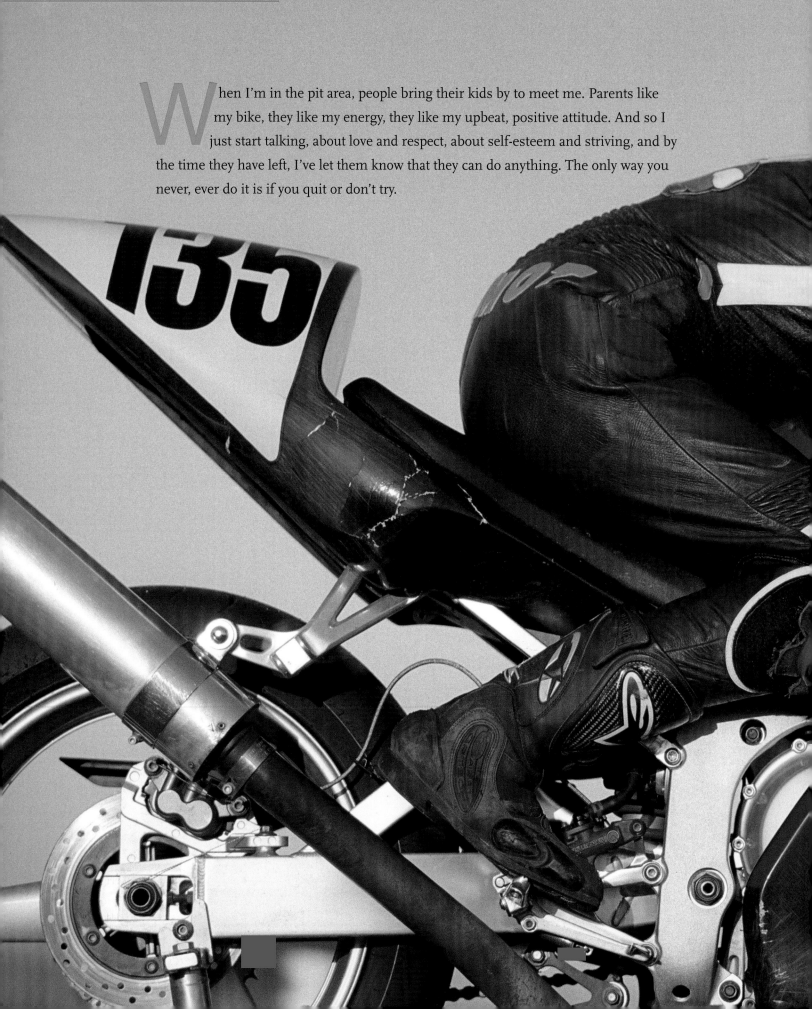

Jodie York

55 Motorcycle Racing

When I'm in the pit area, people bring their kids by to meet me. Parents like my bike, they like my energy, they like my upbeat, positive attitude. And so I just start talking, about love and respect, about self-esteem and striving, and by the time they have left, I've let them know that they can do anything. The only way you never, ever do it is if you quit or don't try.

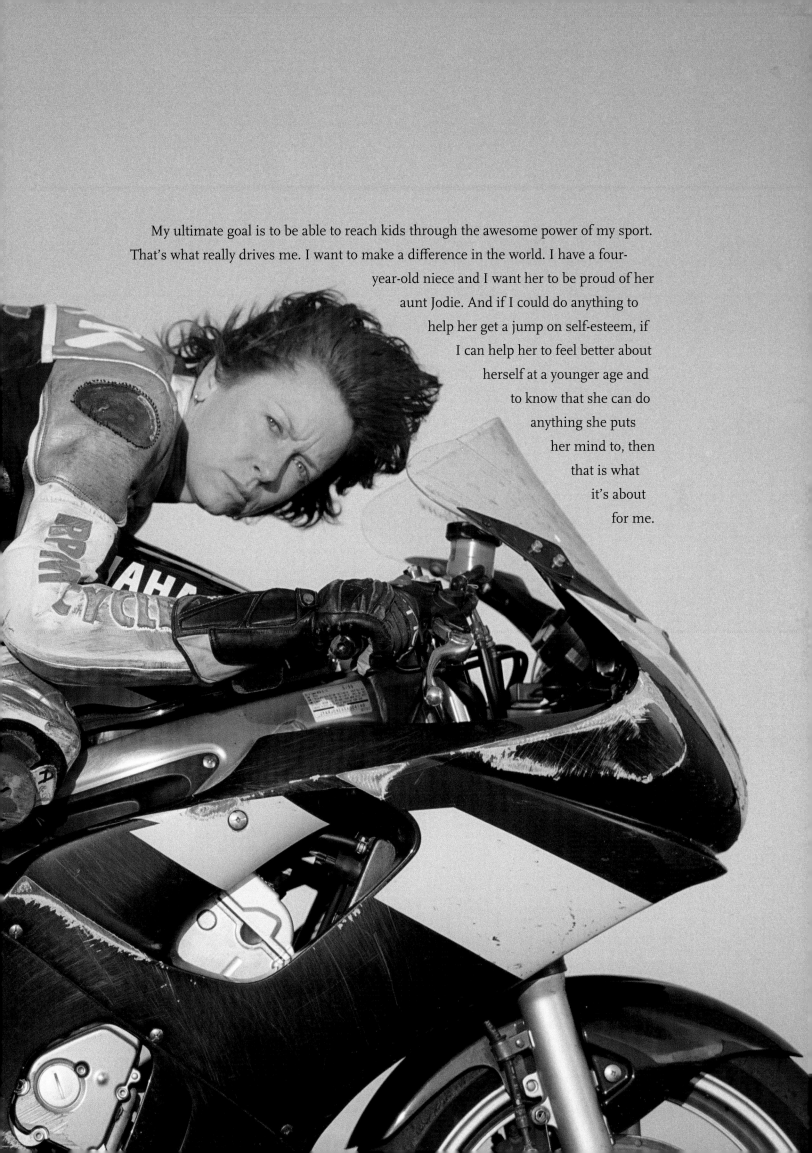

My ultimate goal is to be able to reach kids through the awesome power of my sport. That's what really drives me. I want to make a difference in the world. I have a four-year-old niece and I want her to be proud of her aunt Jodie. And if I could do anything to help her get a jump on self-esteem, if I can help her to feel better about herself at a younger age and to know that she can do anything she puts her mind to, then that is what it's about for me.

56

Open Water Distance Swimming

I was three days shy of my
fifty-eighth birthday when
I swam the English Channel.

Sixty strokes per minute, thirty-minute miles. Mile after mile for twenty-one miles. My coach said you could set your clock by me.

The three challenges are the boat traffic, the temperature, and the currents. Over 500 container ships traverse the channel in the course of a twenty-four-hour period. There are huge tidal fluctuations, so there are very swift currents. I had a reasonable day. It was 63 degrees, I had about three-to-five-foot swells, and the sun was out the whole way. My time was 12:32.

I'm the oldest woman to swim the English Channel by ten years and thirty minutes. And it was life altering because I figured I can pretty much do anything I set my mind to do. It made me realize how mental things are. I had to get to a place in my life where I either needed to do this or wanted to do this or felt I could do this. I don't think I would have at fifteen or twenty-five; it just wouldn't have been in my realm. Actually, I'm very happy that I didn't start this earlier because it gives me something really exciting to do now. And I can see doing it for a long time yet.

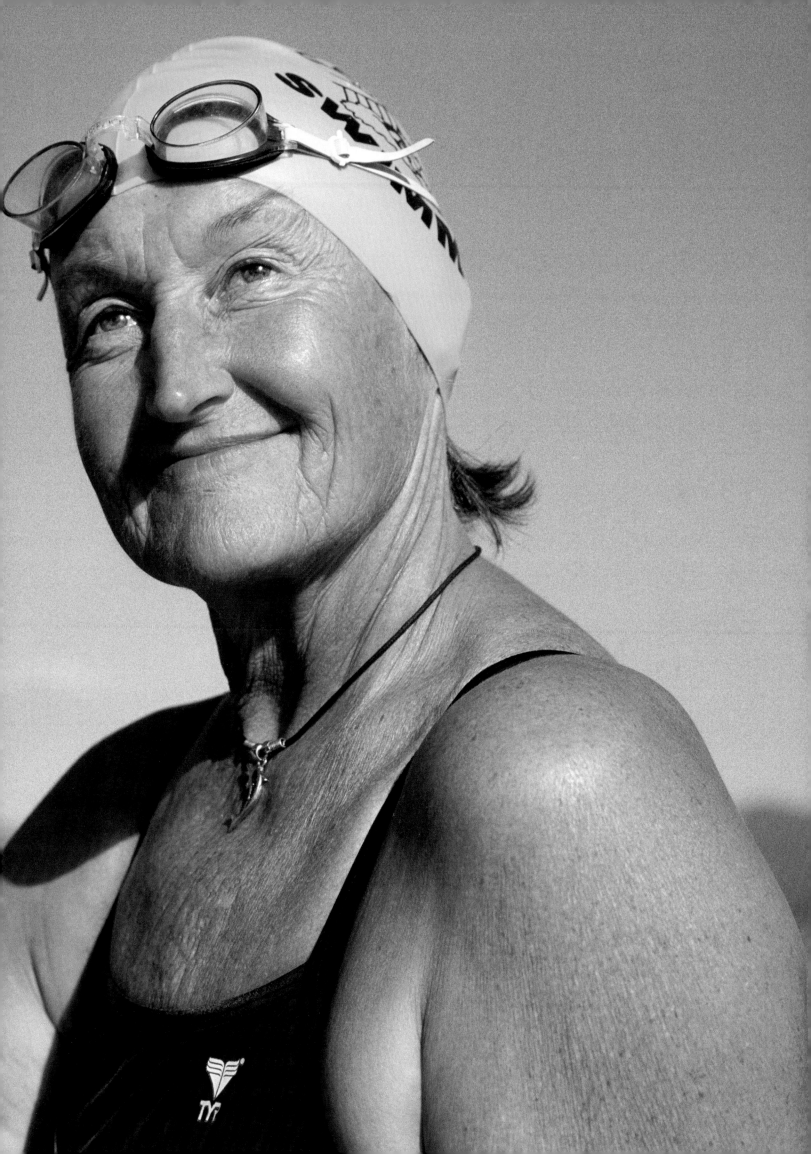

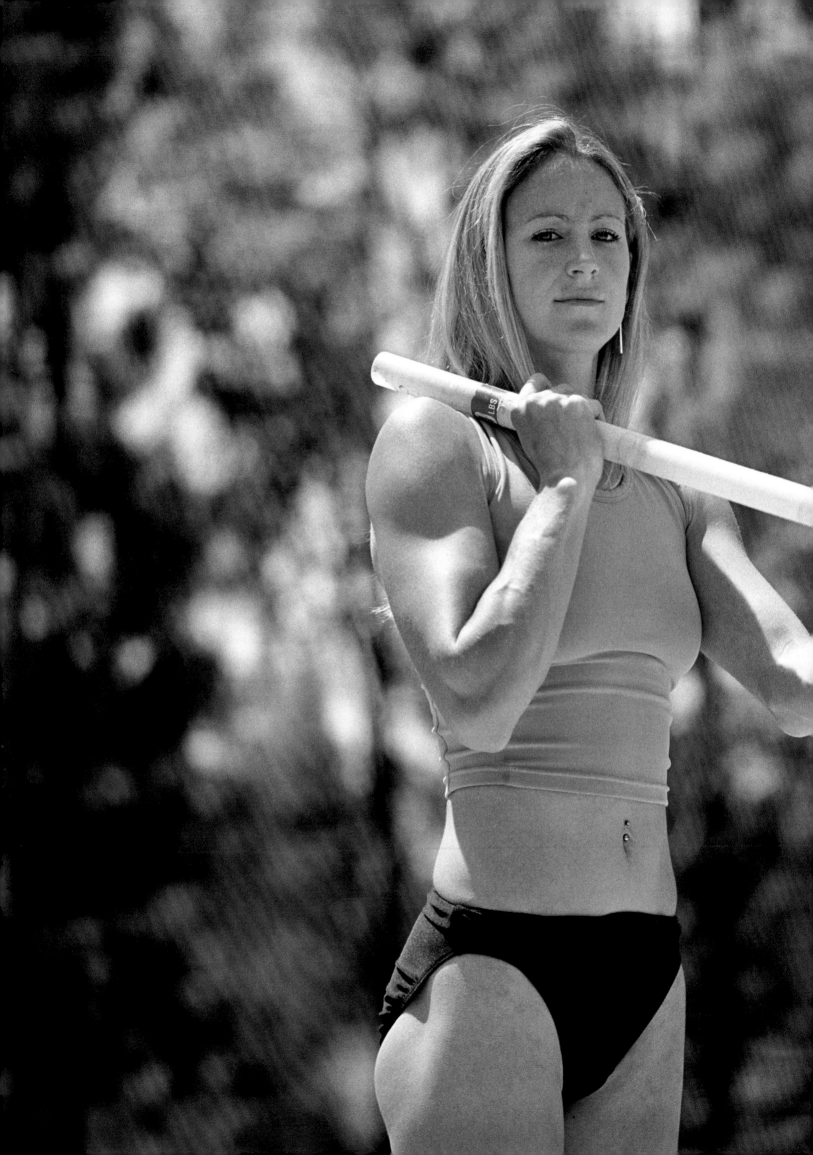

Y ou run, you plant the pole, you jump, and you take off. You rise with the whole momentum of yourself in the bend of the pole, and as you rise you swing up. Your legs go up, your hips go up, and you just kind of take the ride of the pole. You keep an eye on the bar, and eventually you catapult your body off the pole. You take the juice that it gives you and go with it. And you're flying down thirteen, fourteen, fifteen feet onto the big, soft landing pit.

I never give up, even if I'm in extreme pain. I go to practice, I go to meets, and I give 100 percent. I'm just going to enjoy it and be the most competitive person out there that I can be. Please the crowd and just go for it. The crowds are amazing; they love pole-vaulting. They're loud, they scream, they cheer, they start to clap when you're at the end of the runway. It's a slow clap, and as you start running they speed it up.

You have to become one with the pole. Take all the energy the pole has in it, add it to yours, and feel the ride.

58 **Taylor McLean**
Polo

I would love polo to be an Olympic sport. That would be really neat, because right now my options are pretty limited after I graduate. When I came to Cornell I decided that, since four years was pretty much what my polo experience would be, I was going to put all my effort into it. I'm the first polo player at Cornell to win four national championships. I don't want to say I expected it, but that's kind of how I operate. I never thought it wouldn't happen.

After I graduate, I'm going to go off on a different tangent than horses for a while. I'm going to go to grad school for international agriculture. Then I hope to go to the Peace Corps for a few years.... Did you know that they play polo on elephants in Africa?

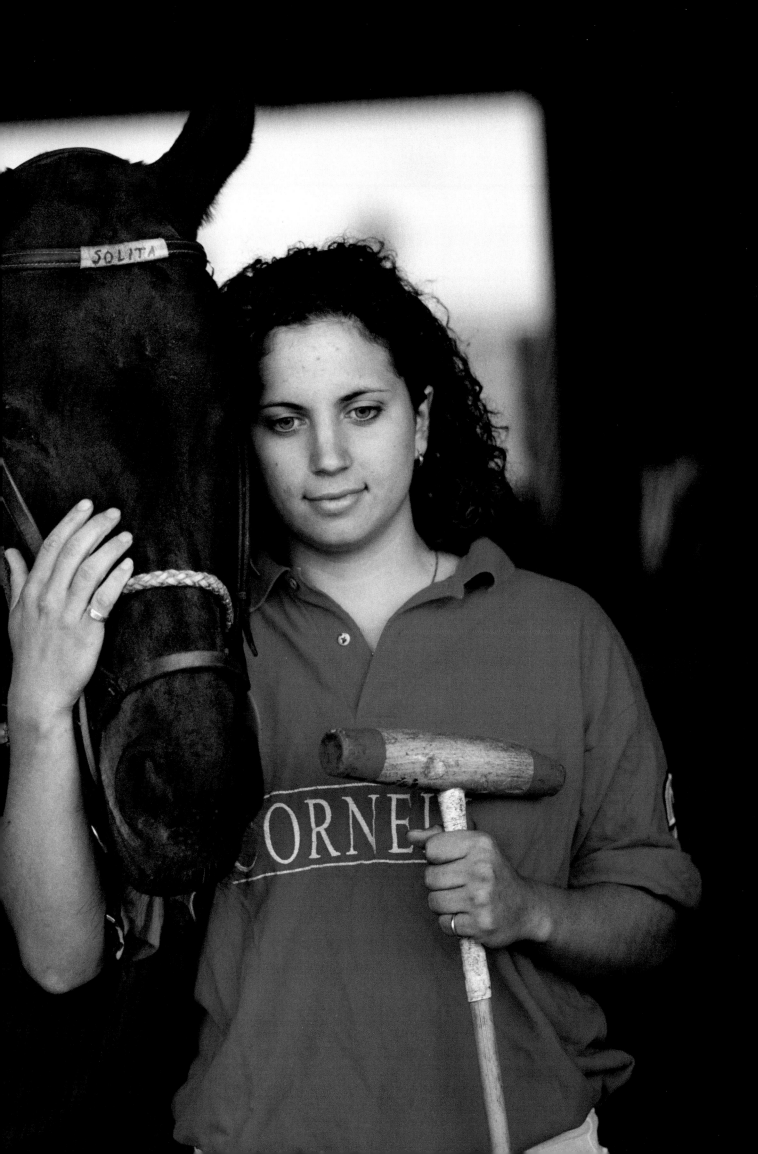

Kim Richards

Powerlifting (Special Olympics)

When I'm powerlifting I get angry at whatever is wrong with my life, and I lift it up.

I've been in Special Olympics for eleven years. It helped me out a lot. It's fun. You meet new friends. You meet a lot of cool people. You go home feeling very good about yourself.

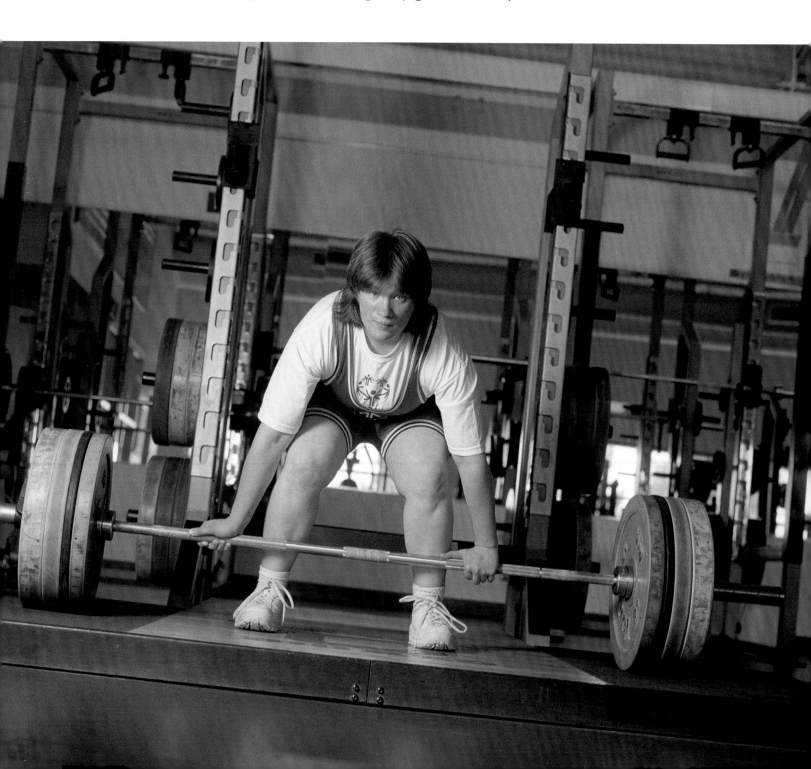

In the Hispanic culture, you're expected to get married young, have lots of kids, and just be at home. The second I graduated from high school, I moved out of the house and I have not lived at home since. I'm glad that I didn't become the typical Hispanic female. I know that's kind of harsh, but I wanted a lot more. I expected a lot more. I think people don't realize the importance of taking yourself out of what's comfortable. They don't give themselves a chance.

61 Rhythmic Gymnastics

It's a lot of pressure.
You train for years, then you
go out for a minute and it's over.

There is a group exercise in which six girls perform the same synchronized routine. The Americans thought all the girls should look alike. I was placing third in the U.S., and I wouldn't let them just push me off because I wasn't a young golden girl. I had to protest to the Gymnastics Federation to get on the team. It was hard being in a world where there weren't any other blacks competing. I became the first black member of the rhythmic gymnastics national team. I've had to fight a lot since then. I learned the power of voice.

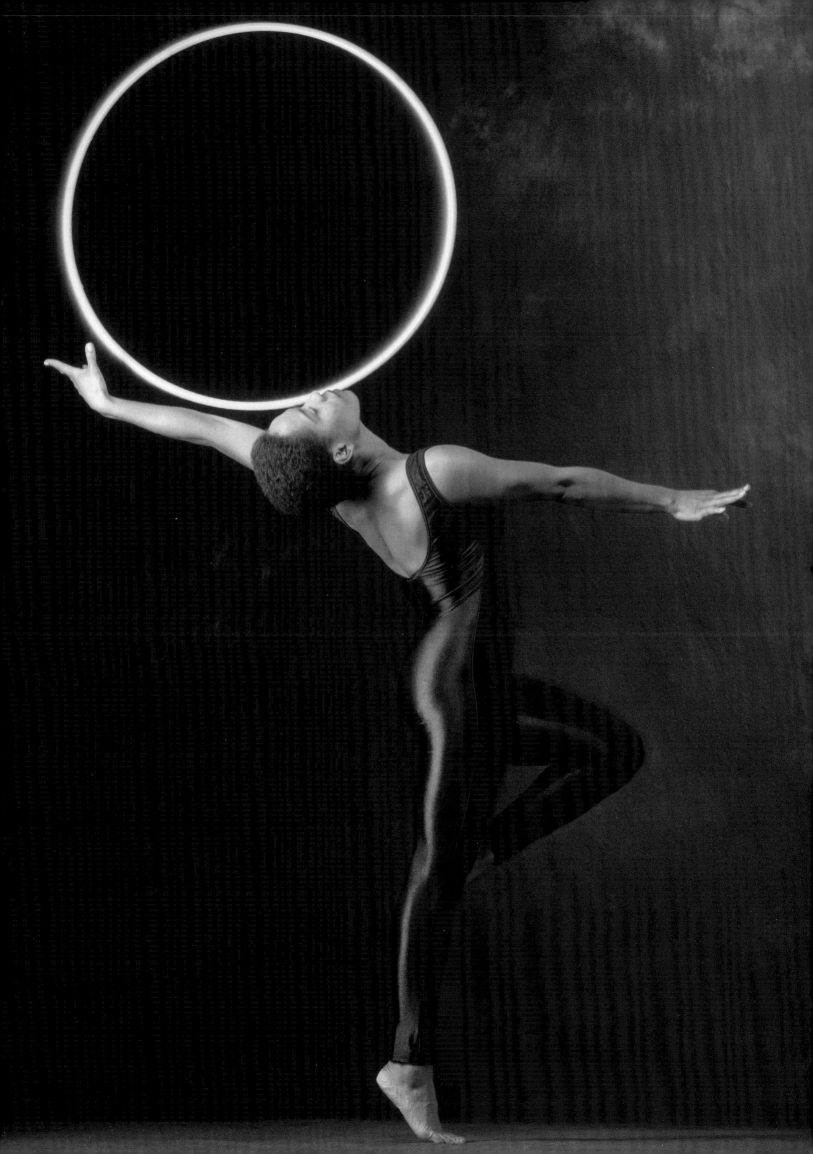

Mari Holden
62 Road Cycling

If you find out you're good at something and you have a passion for it, you can't be afraid of it. You need to go for it. When I was twelve years old, it wasn't feminine to be in a sport. Now I look at my body and I think, God, what my body's done for me is incredible. When you get your body to the best that it can be in whatever you may excel at, it's a beautiful thing.

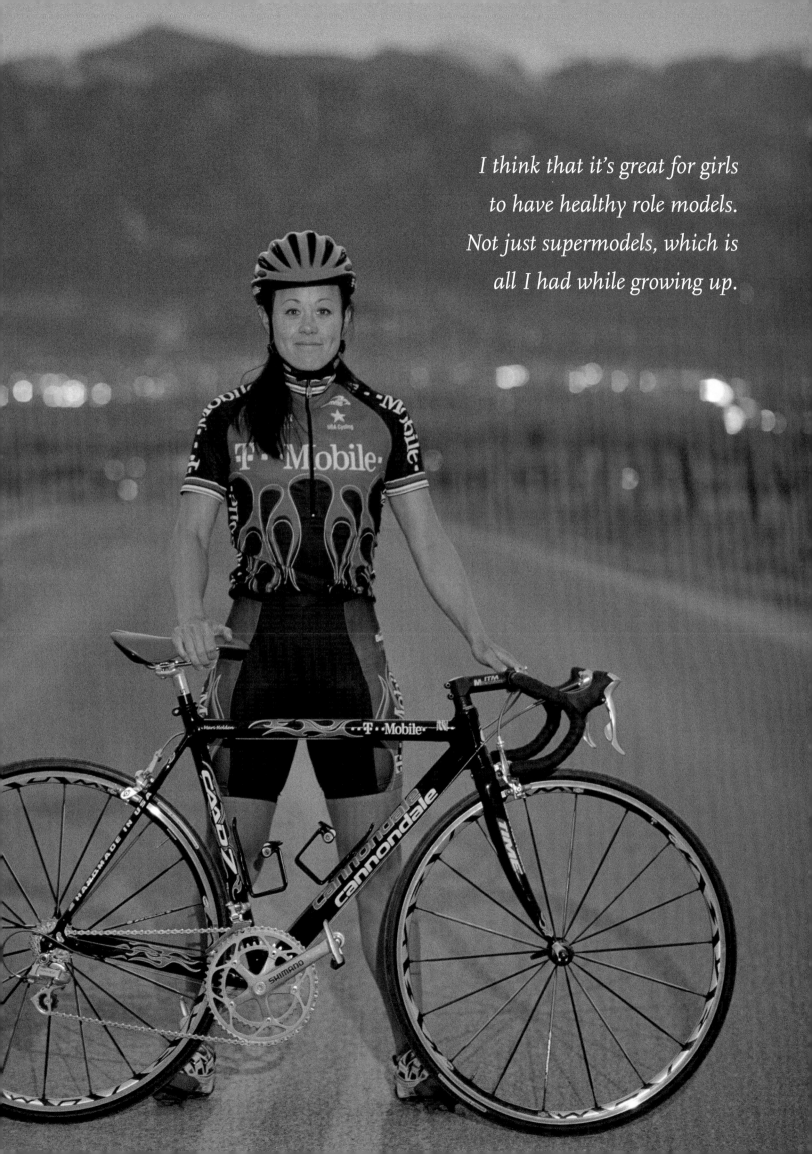

I think that it's great for girls to have healthy role models. Not just supermodels, which is all I had while growing up.

Tori Allen
Rock Climbing

Rock climbing is done outdoors, on real rocks. I do that just for fun. Competitions are held indoors on plywood-and-phosphate climbing molds.

I like the competitions. I like the adrenal rush. I like the crowds. I like the afterparties. I like the announcers. Once you experience that feeling of winning, that feeling when your dad says, "I'm so proud of you," you just become addicted to it. That moment is just so unbelievable that you want it again and again. When I won the X Games, there were five thousand people, and I was the only woman representing the United States. So that was a lot of pressure on me, and I'm only fourteen, and the whole crowd was chanting, "USA." It was so cool. I never let it go to my head though. I get my fifteen minutes of fame when it comes around and then I go back to being an average high school student.

Whenever I sign autographs, I write, "Reach for your dream," because that's what I do, and it's done me well so far. I think that you can never dream too big. Dream the impossible.

It's never against someone else; I just compete against the wall. It's me against the wall, and if I can get to the top, then even if someone else does that too, I still won because I beat the wall.

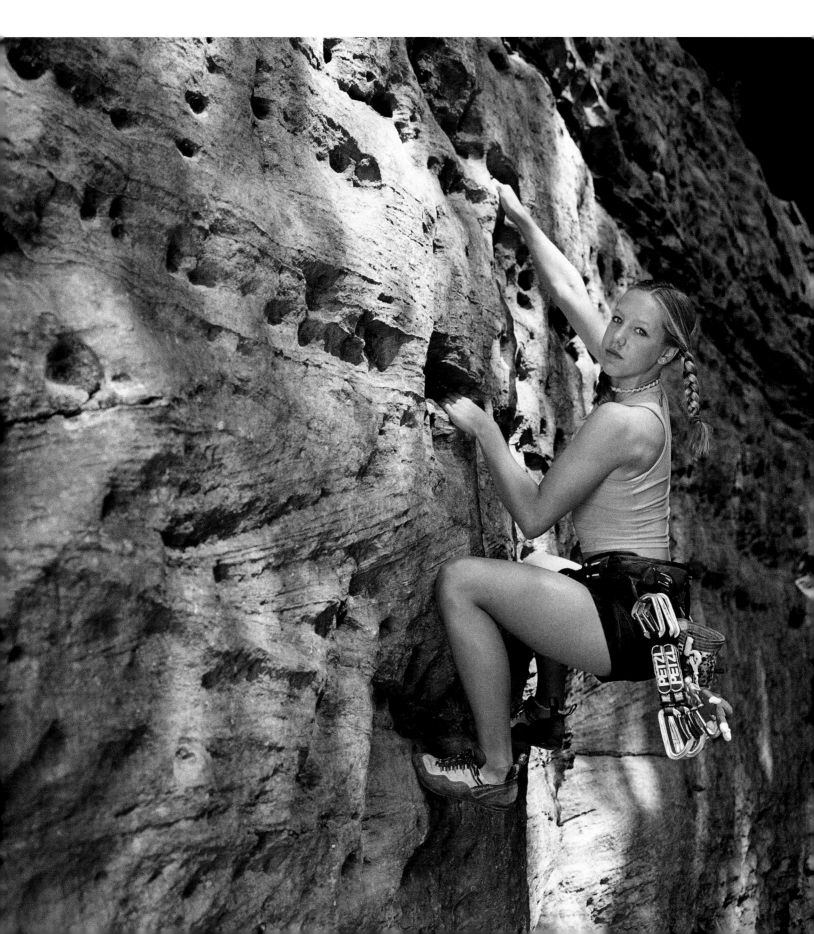

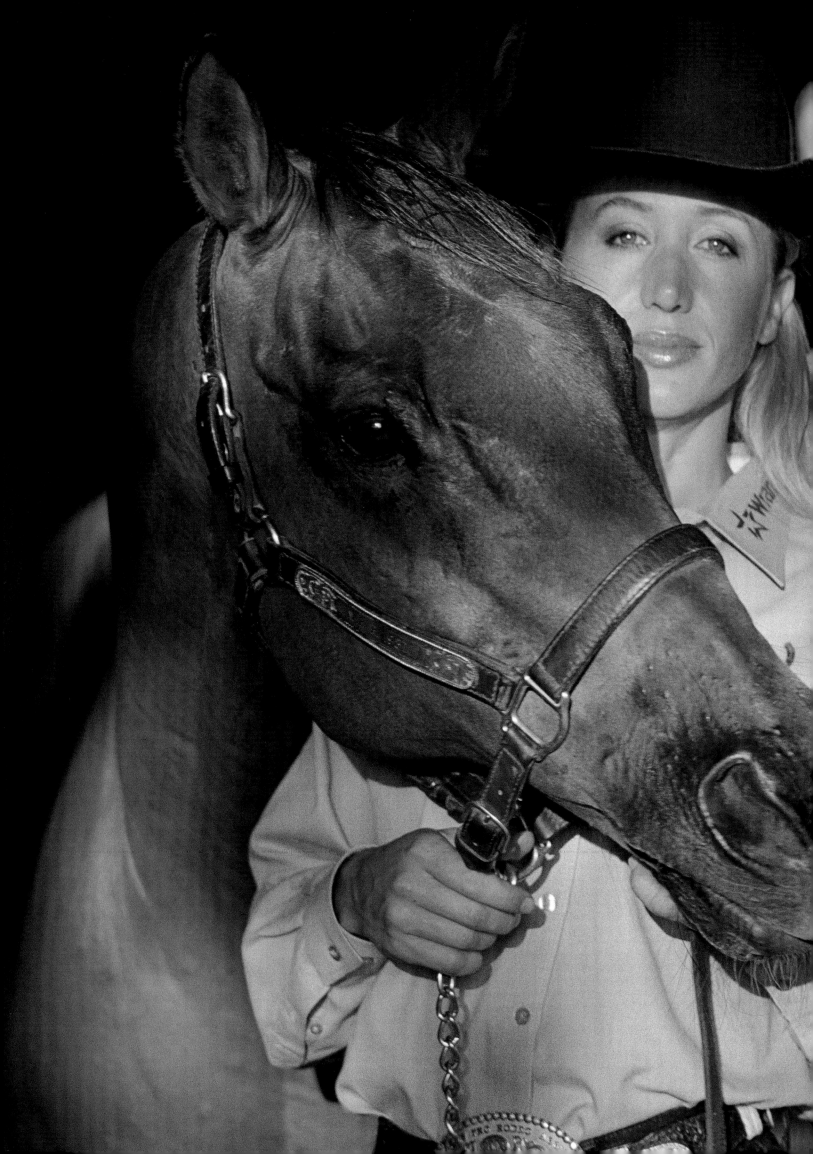

Rodeo

After I won my tenth consecutive world championship in barrel racing with Scamper, I retired him. I didn't want him to ever get beat.

I grew up on a ranch in New Mexico, and from a very young age, I had a passion for riding horses. That's all I cared about. I started competing when I was six, and that's what I lived for every day. I didn't want to go to school, all I wanted to do was ride. It was something that I was born to do.

Scamper had actually been through about four or five sale yards before I found him. He was real mean. Nobody wanted him. When I got on him, he bucked and I just giggled and laughed because I thought it was funny. Scamper just loved little girls. He still does to this very day.

I would clean his stall, feed and water him. He was just truly my friend and wanted to do everything right for me. We had a bond; we were buddies. I won a barrel race within two weeks of when I started training him. Scamper loved what he did. He loved his sport, and he was one of the greatest horse athletes ever. Scamper's won more than a million dollars.

Scamper was inducted into the Pro Rodeo Hall of Fame along with four or five people. We led him up there on the lawn and I got up and spoke about how I won ten consecutive world championships on him. It was just one of those things that was meant to be.

Anita DeFrantz

Rowing

My goal is make sure that everyone has access to sport. I believe sport is a birthright.

I was captain of the women's rowing team in 1976. Rowing was very difficult. We had no support. And for some reason, the U.S. Olympic Committee at that time seemed to have neglected to realize that they had a women's rowing team. When the time came to get our uniforms and everything else that an Olympian got, they didn't have enough for the women's rowing team.

The only difference between someone who rowed on the national team and someone who was on the Olympic team was having a uniform that said "U.S. Olympic Team." You had to earn it. And it was a fairly big deal. So I spent a great deal of time during the Games in the offices of the USOC asking when we would get our uniforms. It took me an entire year to make sure all the members of the women's rowing team got all their opportunities.

I decided to train for a gold medal performance in the 1980 Olympic Games. I had one more year in law school, and I trained and trained and trained. I was determined to do everything possible for this one last shot. And lo and behold, athletes were used as political pawns. President Carter said that the team would not go to Moscow for those games. There were about 159 Americans who never got to compete. We were all dressed up with no place to go. And on the 1980 International Olympic Committee's register of Olympians, we do not exist.

I finished law school. I am a member of the Pennsylvania bar. I went from advocating for Olympic athletes' uniforms to advocating for athletes' rights under the 1977 Amateur Sports Act. The act created a system in which each sport had its own representation at the USOC, and, most important, it established the athletes' right to compete. Since then I've moved forward into the International Olympic Committee with that same determination. Today there are more opportunities for athletes on the field of play and more opportunities for athletes in the decision-making arenas.

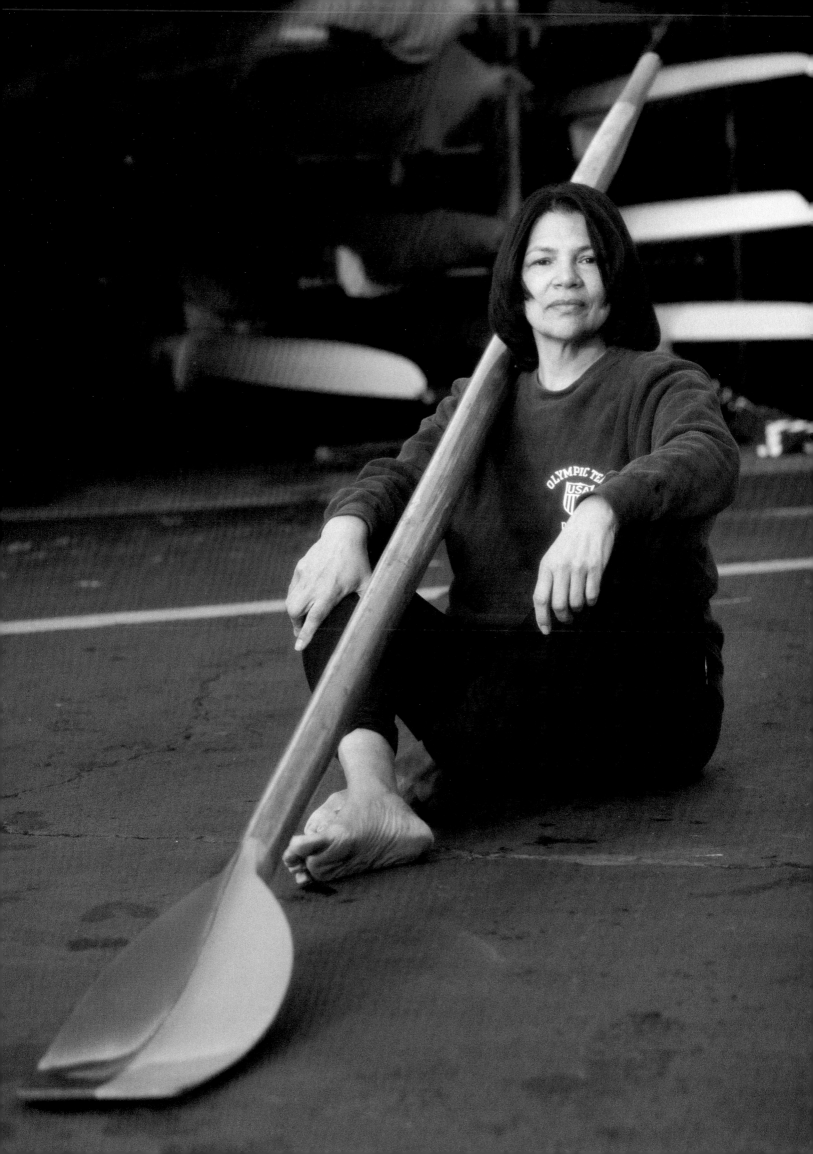

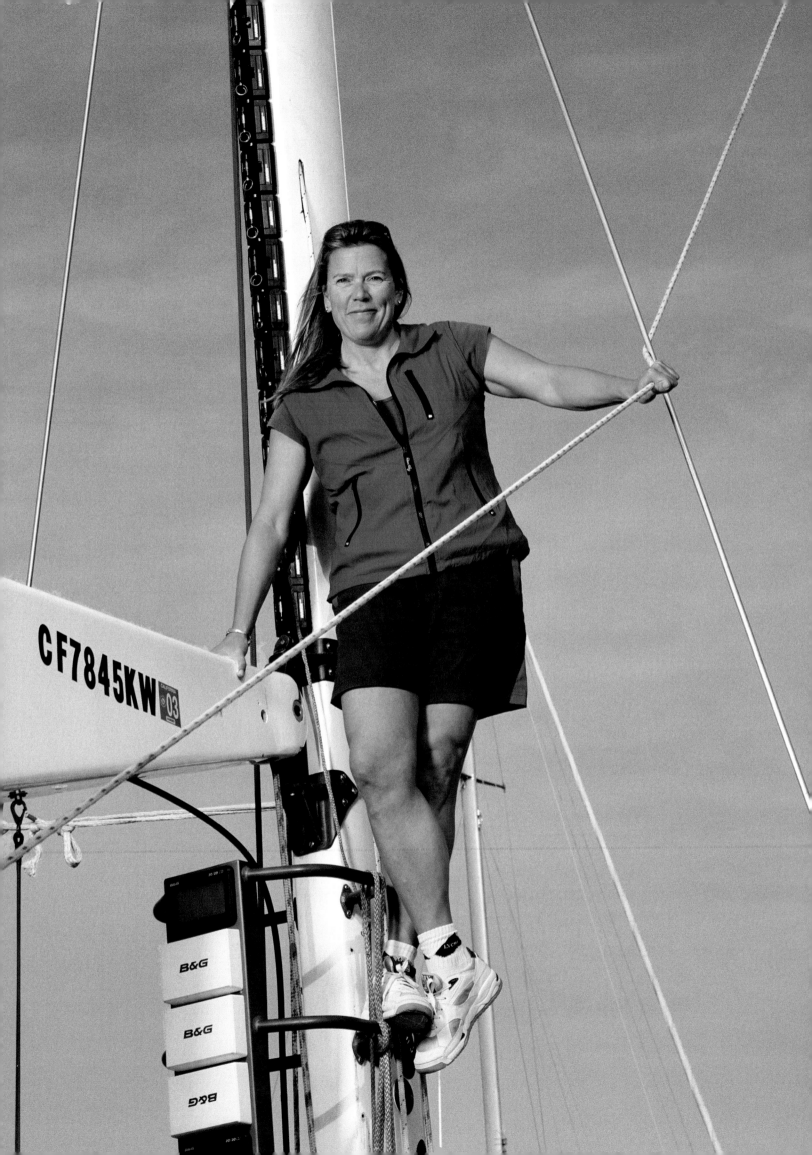

In ninth grade, the track coach walked in and said, "Title IX has passed. So, you girls— we're going to have great opportunities and you're going to have equal rights." And we all looked at him like, "You mean we didn't before?"

I ended up sailing around the world twice and doing three America's Cups. I was the first and only woman on any of the America's Cup teams.

Ten years ago I walked into the Women's Sports Foundation. I felt like I was home. There were all these other women who had a lot of the same experiences that I did, but ultimately we were alone until we came to the Foundation. We work really hard to make sure that men and boys know just as much as women and girls about how important sports are for all of our society—financially, emotionally, physically, healthwise, the whole deal. Sports teach calculated risk taking, goal setting, and consequence of action, finding your passion and dreaming your dream.

NO SMOKING.

In my family, shooting was passed down from generation to generation. I can remember sitting around the campfire in my dad's lap when I was about five. I was so small he'd help me hold the gun up. And when I shot, he'd take the recoil. I started competing when I was ten. At thirteen I'd won the Ladies World Championships. And by the time I was seventeen, I had won my first gold medal in the Olympics.

International doubles trap shooting is considered to be one of the hardest set games in the world because nobody has ever shot a perfect score. No man or woman has ever done it. The best I've ever shot is a 118 out of 120, which is really good.

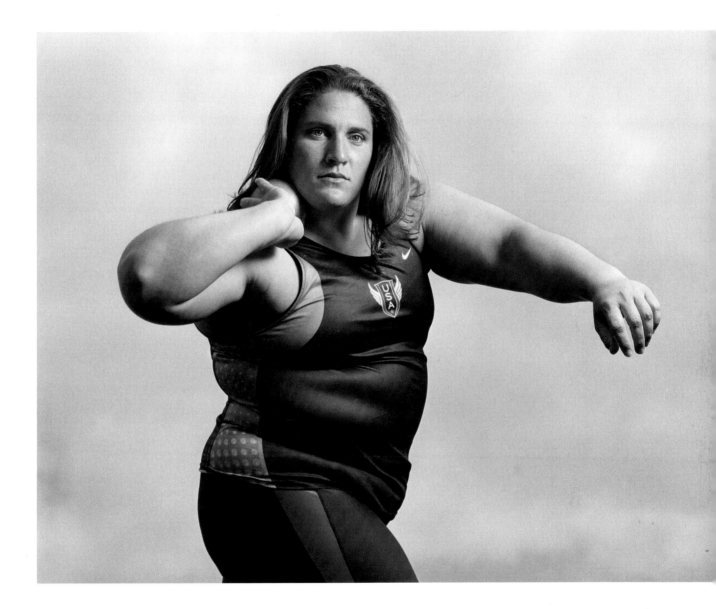

My dad is my biggest inspiration. Even though he's gone now, I really feel close to everything he taught me. All the words, all the lectures, everything. My dad would work with me in the weight room. It got to the point where I couldn't imagine missing it because that was our time to hang out together. I loved listening to him coach. Just the way he spoke to people, he seemed to always know what to say. He was amazing. And plus he was a giant. He was a big guy. And I'm six feet tall, 275 pounds. He made me look like his little girl. He would make my size be something that was an awesome thing instead of a bad thing. And he was the only person in my world who did that for me. So to me my dad walked on water. He is my biggest fan. Here or not.

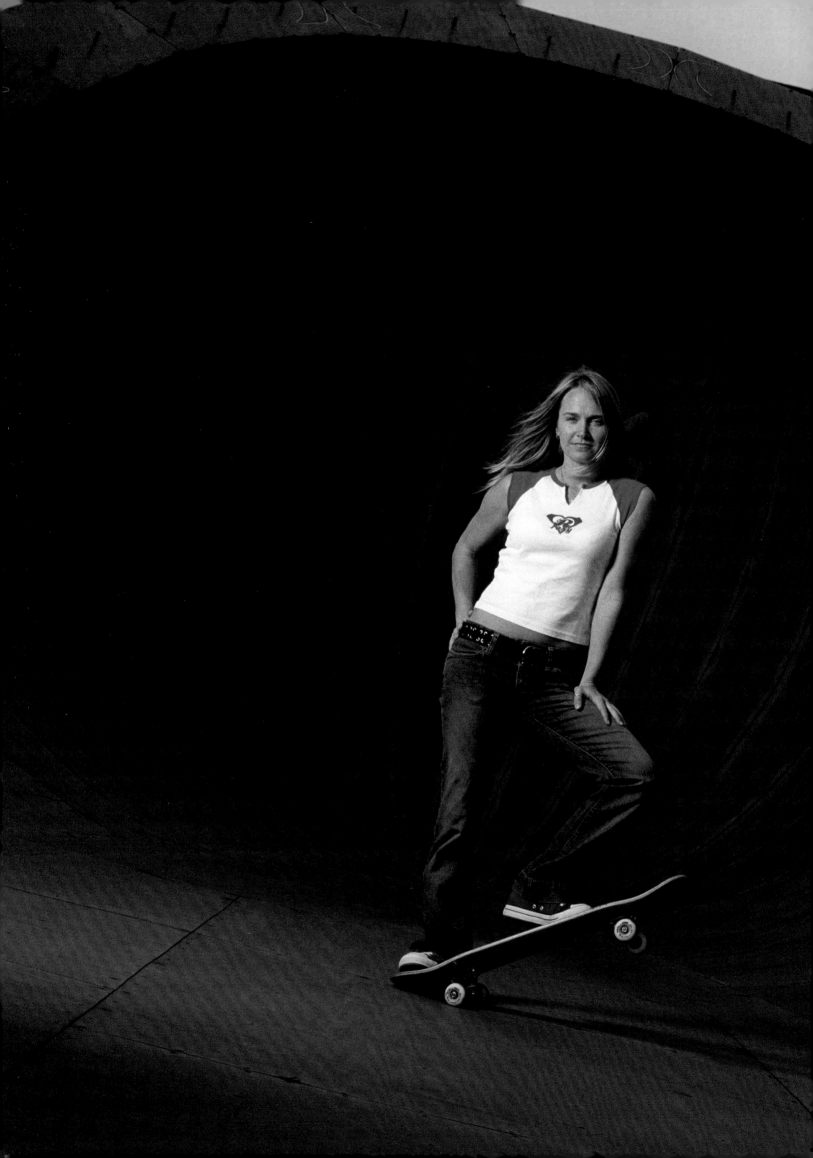

Skateboarding

69

Skateboarding takes a lot of practice,
a lot of blood, a lot of pain,
and it's a lot of fun.

don't really care so much about the competitions. Skateboarding to me is a lifestyle. It's my passion. It's my heart. It's what gives me the freedom to do what I want to do, and it makes me feel strong. Anything else that's come along with it was just fate. When I first started skateboarding there wasn't any place for me. So it's cool that these contests have come along. But at this point, it's more about helping the girls who are behind me get an opportunity to actually compete and make some money and have a future. I feel that I've been put into a position and in a place that's exactly where I need to be. I'm pushing for the girls in skateboarding.

Skating

It was nine o'clock, and I was on the ice, skating at the Olympics. When I was standing on the podium, I looked up at the clock again. It was ten, exactly one hour later, and I knew that my life had changed and things would never be the same.

There's a certain feeling when you glide across the ice or when you master something you've been working on for years. It's about peace of mind. When you're skating you don't think about anything else. You just think about skating. And it's so nice to be able to get away from things for a while. When I was twelve years old and my mom had breast cancer, skating was like therapy for me. It was an escape from the realities of what our family was going through. And that was when I really started improving. That was a real turning point in my skating.

My mom's doing great, and she really has a winning attitude. I've learned that the way you look at things is more important than anything else. Many things in my life have shaped me for the Olympics. I knew that if I gave it everything I had, no matter what happened, I would be happy. Whether I was first or whether I was fifteenth, with the skate that I did, I would feel the same way.

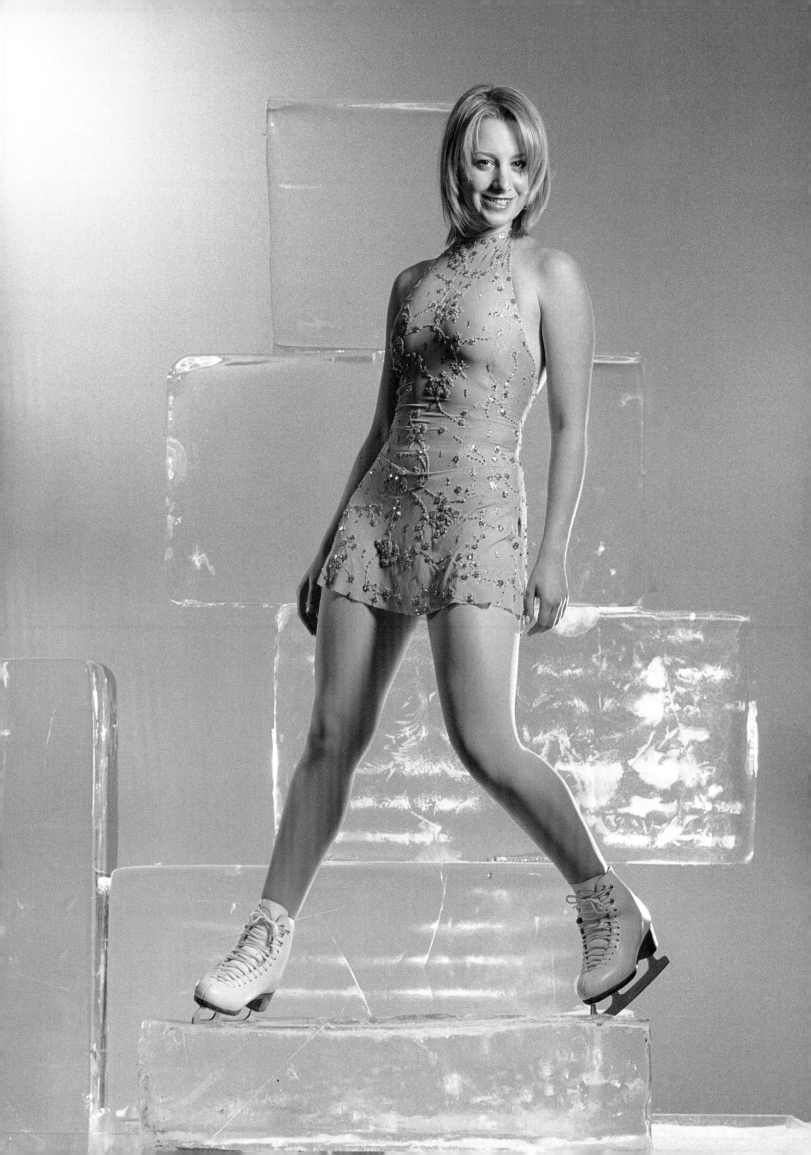

Confidence is huge in this sport. You have to have it. At eighty miles an hour, if you're not confident, you're going to be in pain.

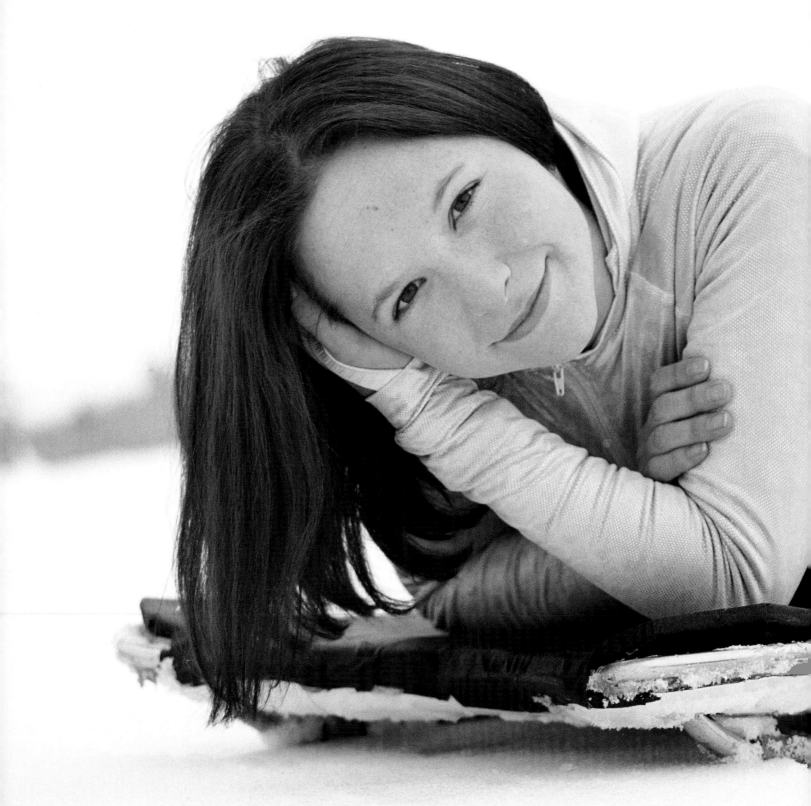

Skeleton

Being in first place after the first run is a lonely spot. You're the only athlete standing up there, and everyone else is at the finish line. But I knew I put the work in, I knew the track, and I knew if I thought about it for one more second it was going to make me crazy. So I put my sled down and ran it off. I had a couple of bobbles on the way down and I thought, You might have lost it on that one, Tristan, but I was OK. I still had the best race of my life. When I crossed the finish line, people thought I knew what the result was, but I had no idea.

The clock is digital, and the snow was as big as the dots. It looked like either a one or a four. When I realized it was a one and it was next to my name, LeAnn, my teammate, screamed, "You just won the gold," and picked me up. Now LeAnn is like five feet eight inches and extremely strong. When she picked me up, my feet were like a foot off the ground. She was just wild and jumping, and it was slowly sinking in. When I get nervous I puke. I was like, LeAnn, you have to put me down now. So she put me down, and I took off my helmet, and out comes the mouth guard and the whole bit. I'm a little person—I weigh about 114 pounds—and I won during the hardest conditions. I could have had the worst day but I made the most of it.

On race day it's how you deal with the pressure, whether you can take your steers in the right direction and whether you can keep your toes pointed that extra little point. All of that matters.

Rachael Scdoris

Sled Dog Racing

'Ve raised about three-quarters of our kennel since they were pups. They're so cute. I just love them to pieces. We all are one team, but every dog has its own tendencies, and every trail is different. I know who can run the shorter distances really fast. I know who might not be as fast but can go for sixty miles without getting tired. I know who is comfortable towards the front, who will not run close to the sled. You really need to know every dog. When we're racing, they're happy. I'm letting them go for a run. I'm also kind of their coach. I'm encouraging them and making sure they stay focused. It's something we're out there doing together.

I'm legally blind. I have a shortage of rods and cones in my eyes so I have a lot of trouble with detail. I can't really control how much light comes in, so bright light really wipes me out. I can't tell a lot of colors apart, and moving things are really hard to follow. When I race I have a visual interpreter. They go to a place where there could be a problem, like a fork in the trail or a really sharp turn or a face-slapper, which is a branch that sticks out on the trail and hits you in the face. We use two-way radios, and they tell me when to get ready. Then they scan the team really quickly to make sure no one got tangled.

Everyone who steps behind a dog team is taking a certain level of risk. It can be really scary, but when you get past that, it's really quite a rush. You feel lucky to be alive, and then you want to do it again.

Most blind people have one
Seeing Eye dog. I've got sixteen.

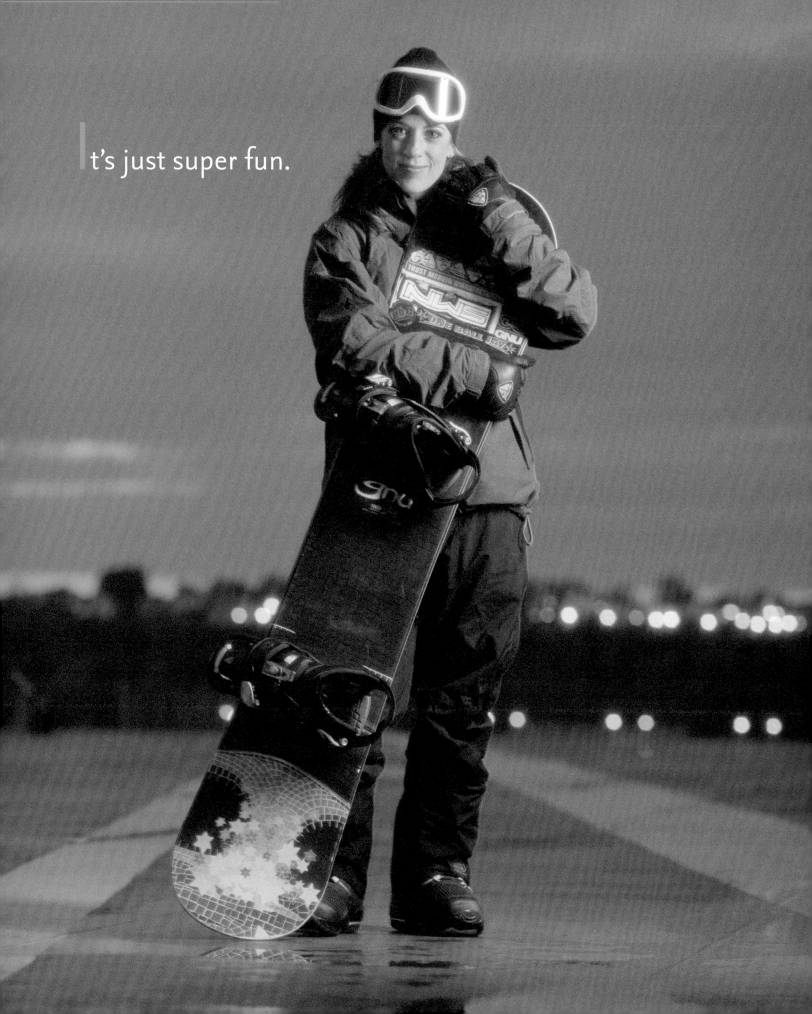

Barrett Christy

Snowboarding

It's just super fun.

Snowshoeing (Senior Olympics)

The only thing better than winning a race is to finish it.

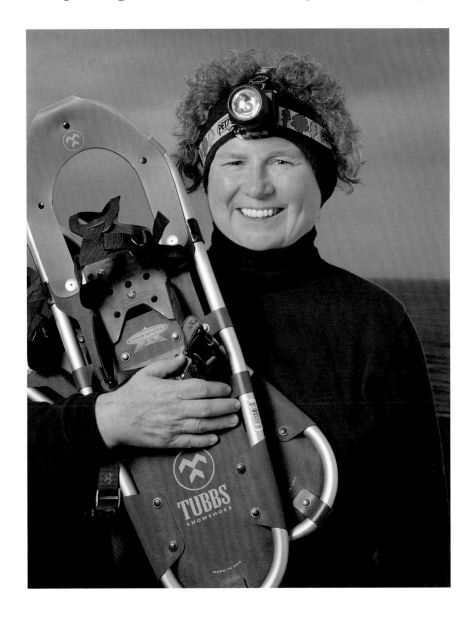

I could not believe that I started swimming when I was fifty, and at fifty-four I was actually finishing a triathlon.

When I heard about the first Winter Senior Olympics, I looked up what sports they had that I could do. There's snowshoeing? So I read all the books to find out what snowshoeing was. Then I went out and bought a pair of snowshoes and I practiced.

I won the gold in the 10-kilometer cross-country, and I am now the world record holder in snowshoeing in the National Senior Olympics.

Soccer

My mother is from Holland. My father is African-American, part Cherokee. Being mixed, I had a hard time identifying when I was a kid. I got a little discriminated against on both sides. When I played sports, my color didn't matter. I think that is what's so beautiful about sports. When you see the World Cup you see Iraq play against Iran. When you get on the field, barriers are dropped, and it's about winning. People forget about the other things for a while. If the world operated like that, we would all be all right.

I feel like I'm playing an individual sport on a team. That's what goalkeeper gives you. It's this little entity back there; nobody else is allowed to do what that person can do, but it affects everybody. A lot of people ask me, "Why are the two national goalkeepers black and in the back?" The thing is, it's a leadership position. It's almost like being a captain.

Women's soccer has come an incredibly long way. Look what happened at the World Cup in '99—ninety thousand people in the stadium, media blitz all across the country.

We get great crowds because parents want their kids to meet us and talk to us. You're given a gift to be an athlete. You're in the public eye, and little kids look up to you. You have to be responsible and respectful. All of us love being role models. My role models growing up weren't women athletes. We didn't have them.

When I played sports, nobody cared if I was a girl, a kid,
black, or white. I played, and if I was good, that was good
enough. It was my sanctuary, my equal ground.

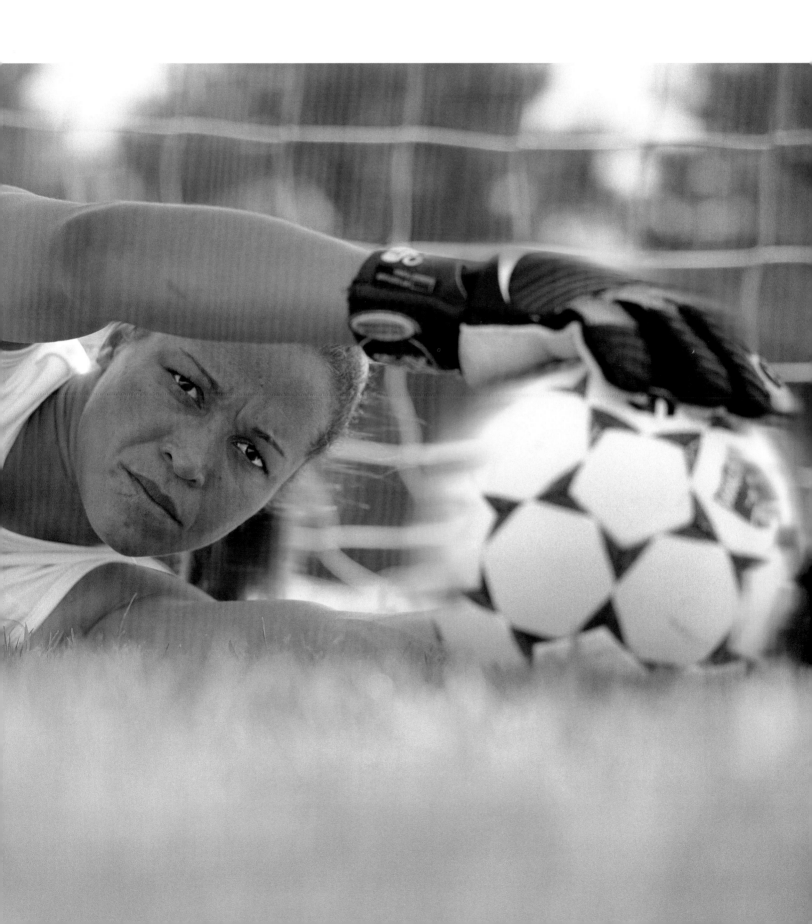

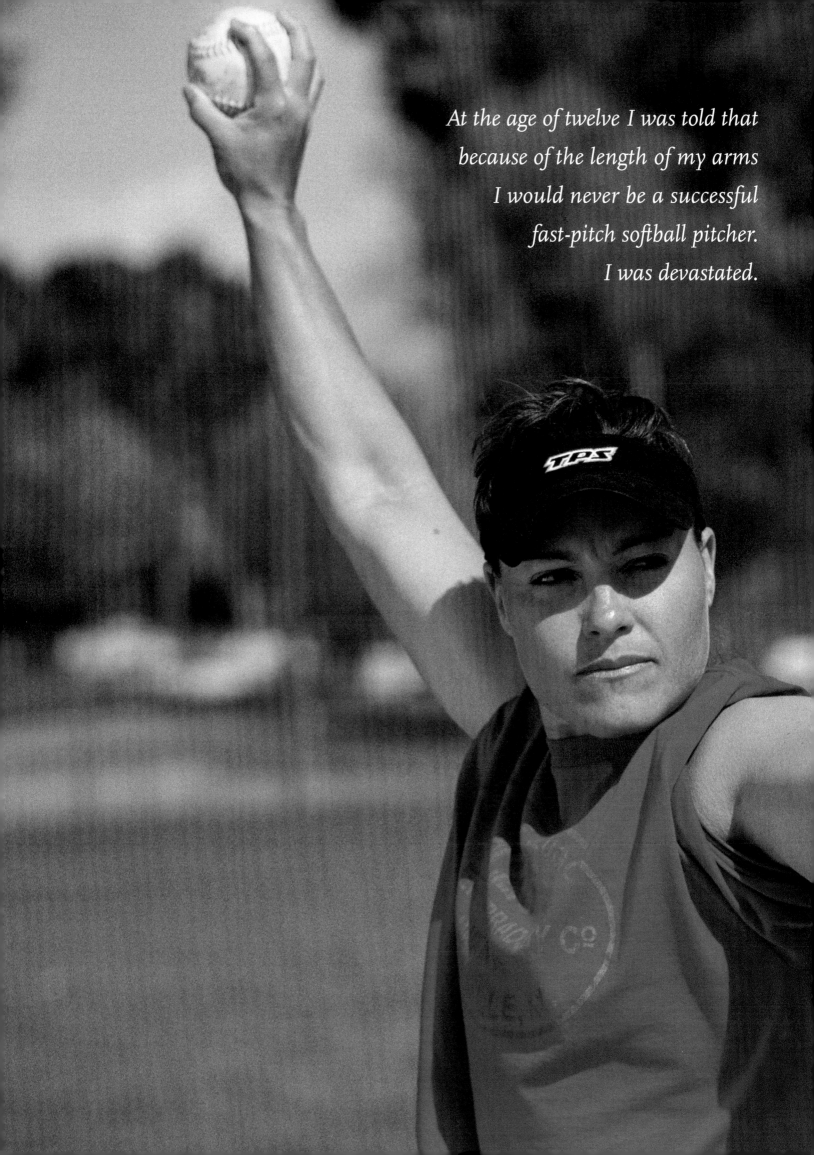

At the age of twelve I was told that
because of the length of my arms
I would never be a successful
fast-pitch softball pitcher.
I was devastated.

My pitching coach told me that I would never be able to throw past the age of sixteen because I didn't have the right build, the right height and size.

I remember sitting in the back of our van bawling, and my mom told me to stop crying. She took me to the doctor to see if my arms were normal, to see if there was any reason why I shouldn't be able to do what I desired to do. She sat me down and said, "If you're ever going to let someone in life tell you what you can or cannot do, you'll never make it. You may have to work a little harder, but if you have the drive and you have the desire and if you want it badly enough, you'll be willing to do whatever it takes."

I pride myself on having that work ethic because it's not easy. I may not be tall, but I'm powerful. I may not have the longer levers that some of the more successful pitchers have, but I have stronger legs. I have a different training regimen. I have to push myself a little harder. Physical ability can get you only so far. It's the inner drive that really separates. I want to be the best that Lisa Fernandez can be, and every year I look to improve. I look to change my training.

I look to see how I can get the edge.

Once I don't find a challenge, that's when I'll know it's time to retire.

And who knows? Maybe I'll be playing ball forever.

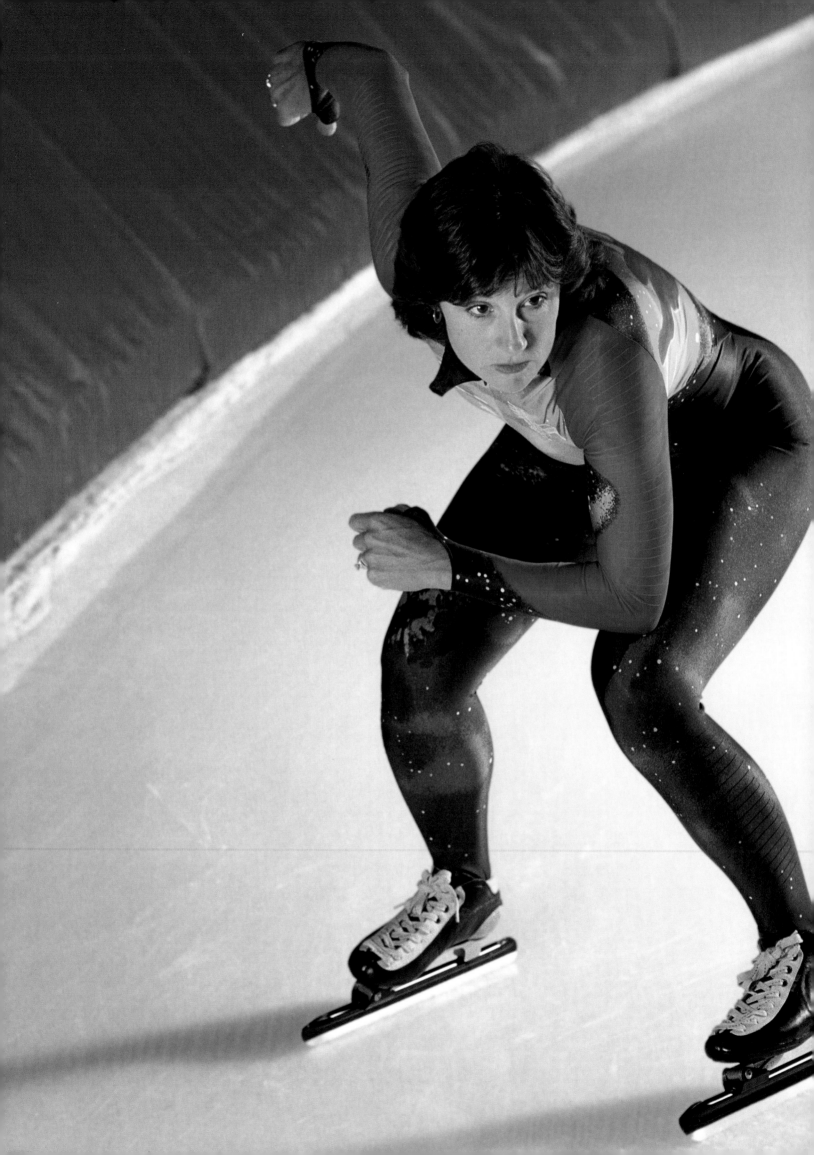

Speed Skating

Every time that gun went off it was the Olympics.

It didn't matter what race I was skating in.

I raced against myself, and I raced against the clock at the end of the straightaway. Those were my competitors, no matter who was on the starting line. And if I beat everybody in the way, then that was fine. Whenever I went to various competitions in this country and around the world, I would try to remember what times I skated at each place so that when I returned, I could try to be better than I was the time before. I always focused on achieving a personal best. I won two gold medals in 1994 at the Lillehammer Olympics. But my best race was the 1500 meters in which I set a personal best by over one second. It was the first personal best that I'd had since 1988, at the Calgary Olympics. There has to be that personal satisfaction, that feeling good about what you did, and that might not necessarily mean finishing first. Relative to myself, to how I skate and how I perform, that was my best race, and I was fourth.

Aimee Mullins

Sprint 100 meters; Long Jump

was born without fibula bones. Last year I ran into the doctor who delivered me. He was the one who had to tell my mom the prognosis, that I would be in a wheelchair for the rest of my life. He told me that ever since I was in second grade he has kept every article about me—when I was on the championship softball team, when I won competitions, when I marched in a girls' club parade. I'm part of his medical course now. He says that the X factor in any prognosis is willpower. He told me, "You have consistently proved me wrong, Aimee. To have to tell your parents that you would not walk, and then for you to set world records in sprinting . . ." It was a very cool moment.

The physical impediments in your life shape you for sure, but clearly your character is something you are born with. An athlete is an athlete is an athlete. You should be driven by your passion. You have to decide who you want to be. That's why I love that quote by Gandhi. Who are you and who do you want to be? Start moving yourself and start shaping yourself to be that person. It's completely in your hands. It's not about your parents or your upbringing. Get over whatever you think was unfair in your life and make something of yourself.

I'm an athlete. I'm the first athlete with a disability to make the crossover into mainstream sports. I'm regarded for what I did as a competitor. I jumped far. I ran really fast, faster than a lot of people with two legs can run. When people make it all about the legs, they deny me the work that went into it. The legs are not the divining rod taking me through my life. They're not making decisions for me.

"You must be the change that you wish to see in the world."—Mahatma Gandhi

Angela Williams

Sprint 100 and 200 meters

What makes me so good is my start.

I'm short but powerful.

I just explode out of the blocks.

My parents were from Mississippi. My dad came from a family of thirteen. He knew about the struggles of growing up in poverty. My mom had it a little better. But being from the South, back in the '50s, they saw so many of the things that I didn't see. And they didn't want me to go through the struggles they had to go through. They wanted my brother and me to have all the opportunities that they ever wanted, and we've gone beyond that. It's like they're living through us. I just love to be able to show my parents that no matter what they went through in the past, look at what they've produced. And there's no way that I would be where I am now if it weren't for them. They're my backbone. They're my best friends. I get all my advice from them and the Lord. They keep me grounded.

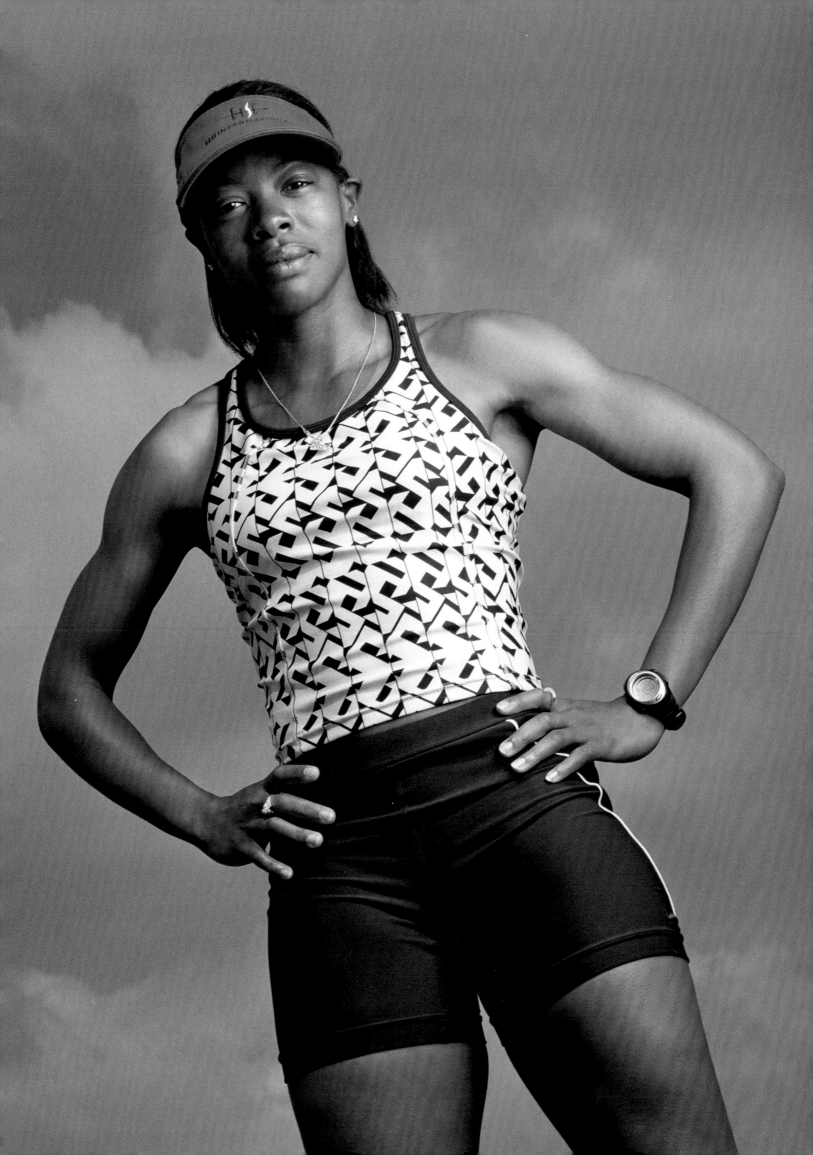

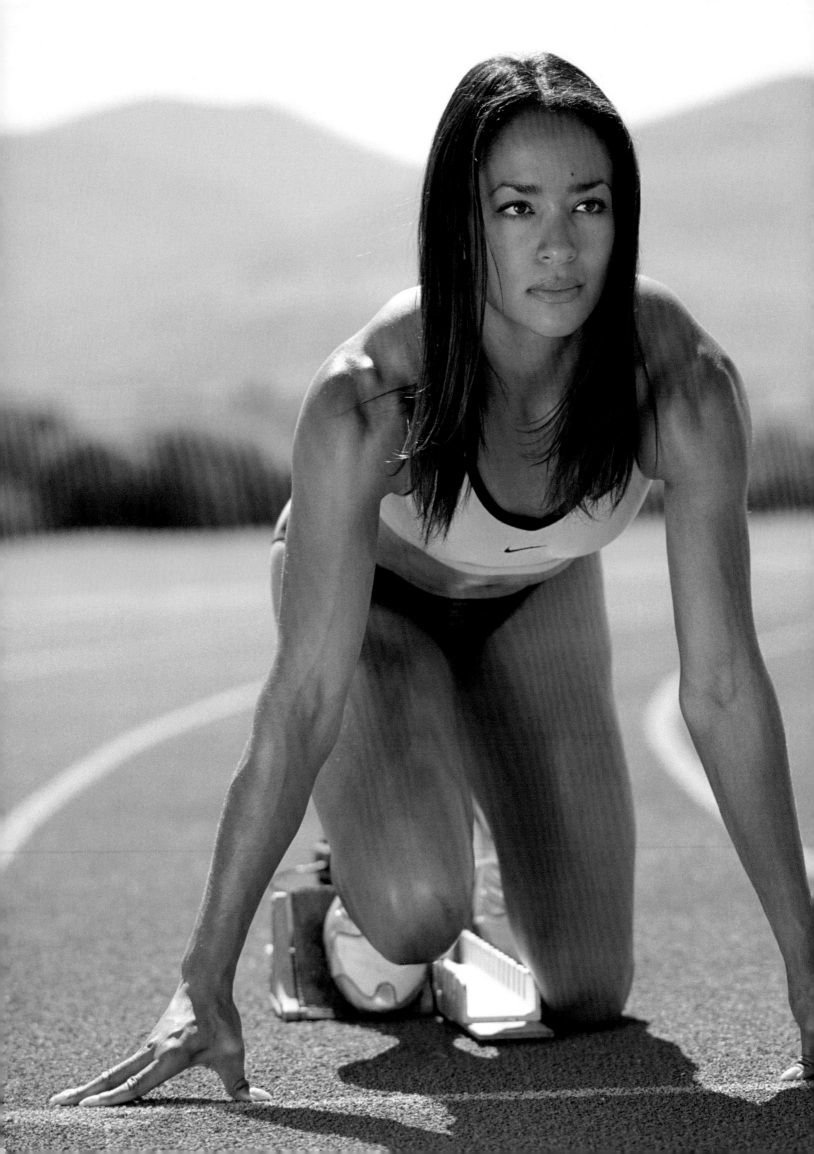

Brenda Taylor

Sprint 400 meters

think I was born a competitor. I have a twin sister, so right out of the blocks I had somebody to gauge myself against.

I went to Harvard. Lindsey went to Brown. We were actually big rivals in college; first and second, always battling it out. Lindsey was captain of her team and I was captain of mine. It was great. We were our biggest competitors and our biggest supporters. When we crossed the finish line, the first thing the winner would ask was, "Is my sister second?"

I love the thrill of pushing myself, of transcending my boundaries. In track and field you can do that every day. It's objective. We have a clock, and we can see in a finite way when we're making progress. You can see where you are, that you're doing things you've never done before and things that maybe you never knew were possible, and you just keep reaching for something new. I know that what happens at the finish line is ultimately a question of my own strength of will.

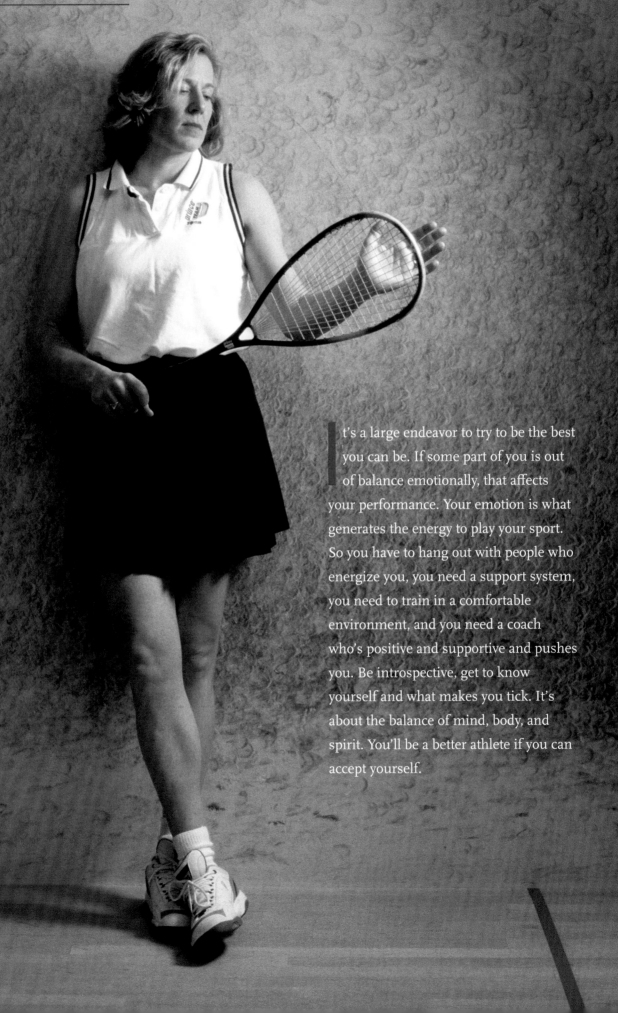

81 **Alicia McConnell**
Squash

It's a large endeavor to try to be the best you can be. If some part of you is out of balance emotionally, that affects your performance. Your emotion is what generates the energy to play your sport. So you have to hang out with people who energize you, you need a support system, you need to train in a comfortable environment, and you need a coach who's positive and supportive and pushes you. Be introspective, get to know yourself and what makes you tick. It's about the balance of mind, body, and spirit. You'll be a better athlete if you can accept yourself.

Surfing

*The best surfer in the water
is the one having the most fun.*

remember catching waves on my dad's surfboard when I was eight. It was so cool. It was like floating on the water. I would read my dad's surf magazines. I loved looking at all the colors of the oceans, the blues and greens. And I would look through every page to try and find a single picture of a woman surfing.

I saw girls sitting on the curb watching boys skate. I saw girls sitting on the beach watching boys surf. So I started an all-girls surf school. I've taught thousands of women how to surf. I want to open the door for women and tell them that they can do whatever it is that they want to do.

Why should the boys have all the fun?

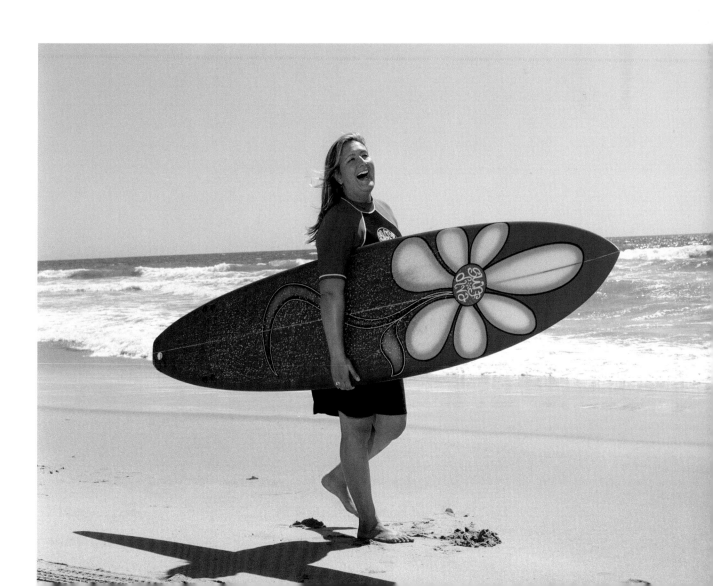

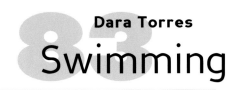

Dara Torres

Swimming

Swimming came so easily to me that kids
would get mad at me because I didn't really
try very hard in practice. I would goof off
during workouts, and then I'd get up
on the blocks and break national records.

When people would ask me about the Olympics, I would be too embarrassed to tell them that my four Olympic medals were in relays. One day a friend asked me if I ever thought about making a comeback. I started laughing. "Are you kidding me? I'm thirty-two and I haven't swum in seven years." I dreamed about it all that night, called my old coach, and within three weeks, I had moved out to Palo Alto to train. I ended up making my fourth Olympic team. I medaled in five events, including individual events. It was nothing I thought I was ever going to do.

A coach asked me to speak to other swimmers. I started talking about my experiences, and all of a sudden I just blurted out about my bulimia, which I'd never discussed with anyone ever before. I had always felt so ashamed and embarrassed. It was such a relief to finally start talking. I always feel there's a reason things happen, and for me the reason wasn't winning all those medals. It was to be able to share my experiences, the good and the bad, with other people who may be going through what I went through. Now I tell girls not to be afraid to talk about their problems, to get them off their chest. It's not over—it's still something you have to work on, but the biggest thing is to find someone you feel comfortable with, maybe a teacher or your coach, someone to talk to.

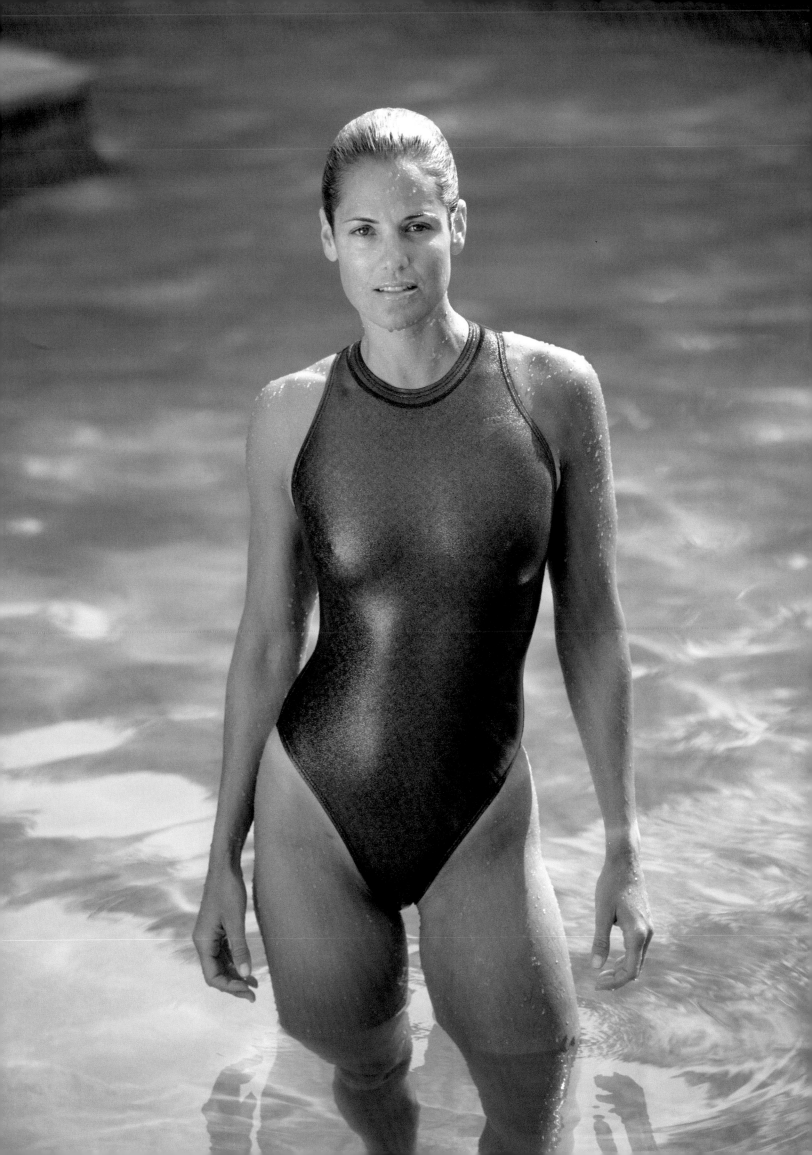

84 Swimming (Senior)

You can't wish something to happen. It takes discipline.

The name of our swim team is the Harlem Honeys and Bears. The women are the Honeys and the men are the Bears. We compete against the other city boroughs in water ballet and in swim strokes. You have to be fifty-five or older to join. I'm eighty-one, but truthfully, I feel more like eighteen. Really! At my age, I don't have a pain. I take no medication. I've been swimming for sixteen years and I do it daily, five days a week. I do yoga from my TV seven days a week and I drink ten glasses of water a day. All this keeps me going. I fell three times in 2001. I didn't have any broken bones.

I love people and the only way I'm going to meet them is to get out of the house. So I get out, I swim, I eat right, and when I look in the mirror, I'm pleased with myself. Basically, I am a happy person and I have a way of being able to leave the bad behind me and enjoy the good. So I don't have time for anyone who's negative; I stay away from them. I will not let anyone steal my joy.

It's just an amazing experience being part of a team, to all work together. You have to be like eight identical people swimming in unison.

Tawny Banh
Table Tennis

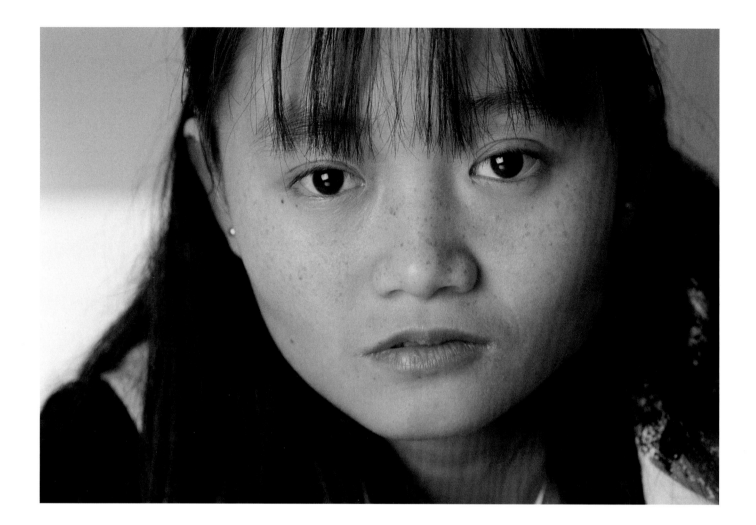

I was born in Vietnam but I came to the U.S. when I was three years old. When I started playing table tennis, we used something the size of a dinner table and we made our own net. I played with my brothers and sisters in the living room with wooden paddles. People think it's slow but the ball can go as fast as ninety, one hundred miles per hour. We would watch the Olympics on TV. But to actually participate, to walk and represent the U.S. during the opening ceremony, that is really an honor.

Simona Hradil
Tae Kwon Do
87

My dad was a car mechanic all his life. Living in Czechoslovakia, if you weren't for the government you really didn't have much of an opportunity, and my dad wasn't for the government. He thought that there must be something better out there. He had a dream and wanted to go for it. When I was five, we escaped. My dad planned the whole thing. We didn't tell anyone that we were leaving. We went through an underground railroad to get our visas to the U.S.

Dad had guts. I give him a lot of credit. I don't think my parents were really thinking about themselves; they were basing everything on me, just for me to have a better life. And I appreciate that no end. I don't want to take anything for granted or waste any opportunities. I want to make the most of what I've been given.

I think that the reason I am who I am comes from seeing what my parents did for me. In life and in sport, when you go out and step into the ring, the people who walk away champions are the ones who took the risks.

Chris Evert

Tennis

There are a million athletes who are better than me physically, so I always had to work a little bit harder.

My dad was the one who guided me along. I never would have motivated myself and picked tennis at age six. I don't think he knew how far I was going to go, but I think he saw that I had good balance, a good head for the game, good anticipation. But he never let me know it. He never put that pressure on me. For a long time I played for him. I enjoyed it, I got satisfaction out of it, but when I won a match, I'd run to the phone and call him.

I would watch Wimbledon and the U.S. Open, and it was just a dream for me. But when I turned fifteen I beat the number one player in the world. And that's when I knew. I was born with an ability to concentrate. I stayed calm under pressure. I stayed focused and won more points. When it was the finals at Wimbledon, I didn't panic. When I was on the court, I was there to win. It wasn't mentally draining for me; it came easily. The physical part came harder. I wasn't born with genes like Martina or Billie Jean. My concentration was a little bit of a compensation for what I maybe lacked physically.

When I talk to kids, I say that I found something in my life that I wanted to pursue. It's really important that you find something you have a passion for, that you are stimulated by, and that you really want to put your heart and soul into. You'll get so much back in return. That's what tennis did for me.

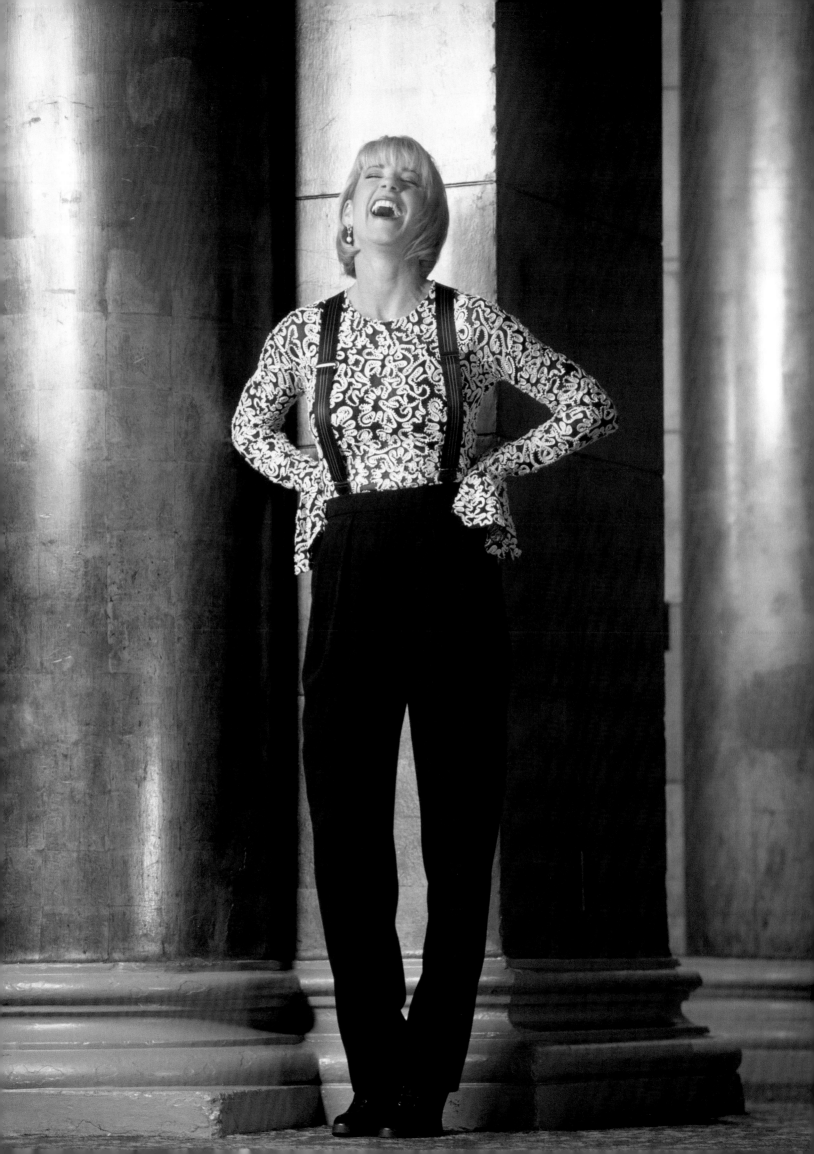

Karin Korb

89 Tennis (Wheelchair)

People love to use that word: "confined" to the chair. My chair gives me the freedom to go wherever I want, to do whatever I want.

I was meant to be in this chair. It is the catalyst to conversations I'm sure I would never have had, had I been walking. People come up to me. They look at my legs. They ask, "Why are you in the chair? You don't look sick." People associate being in a chair with being unhealthy. I broke my back. That's the simple fact of it. I am healthy. I feel wonderful. I just sit. I live my life sitting, that's all. When I talk to people, I can change perceptions. I can change in ten seconds what someone has believed in a lifetime. It is very powerful. I know that at the end of our conversation, they're going to be talking about me to their family. They will say, "I met this girl today…" They come away with a sense of a dynamic person. People come away seeing past the chair.

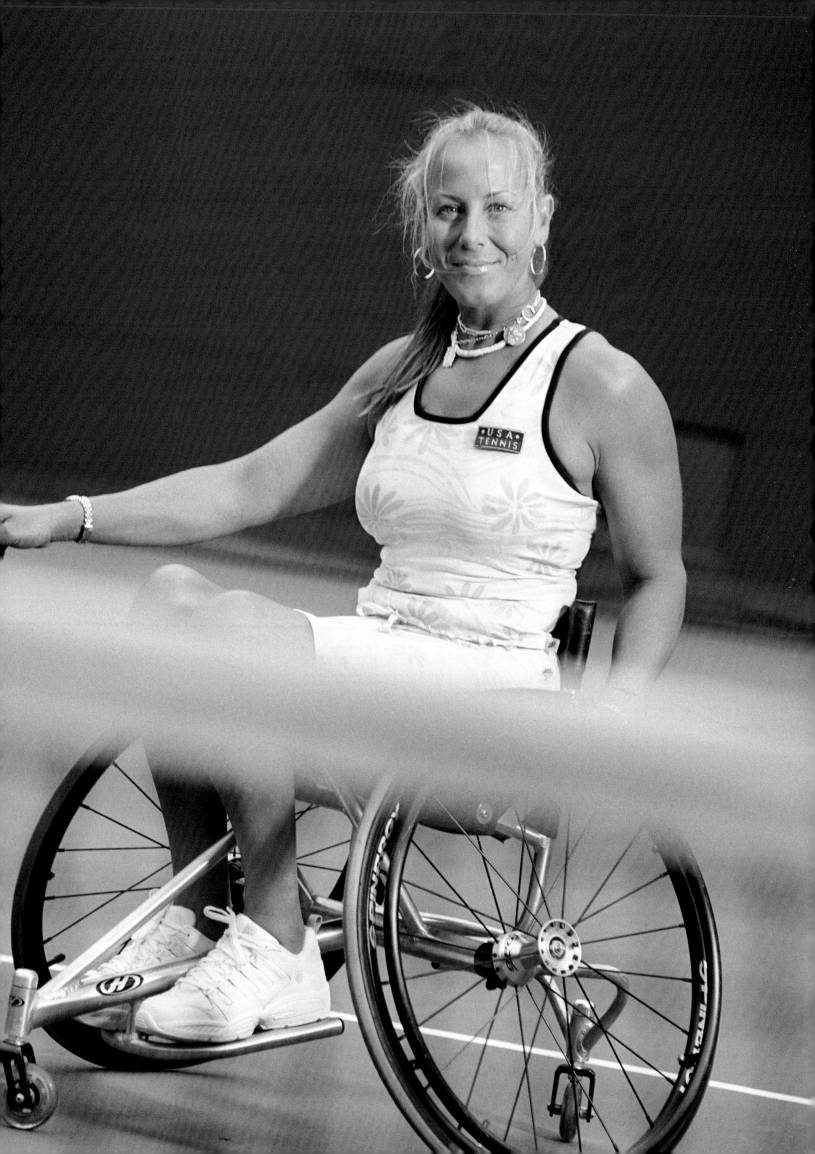

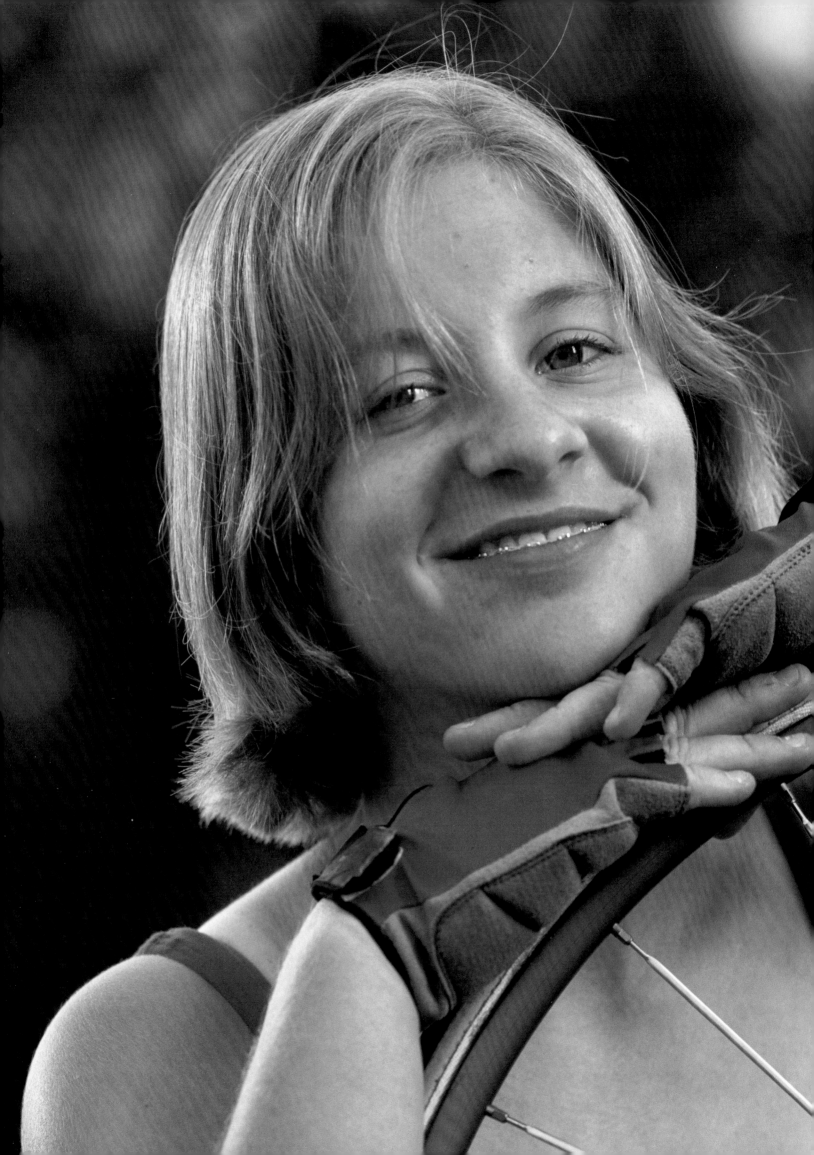

The guys pretty much treat you like every other racer. I'd rather have it that way than have special considerations. When you're out there fighting for that guy's wheel, they're not going to say, "Oh, please go ahead, you're a woman."

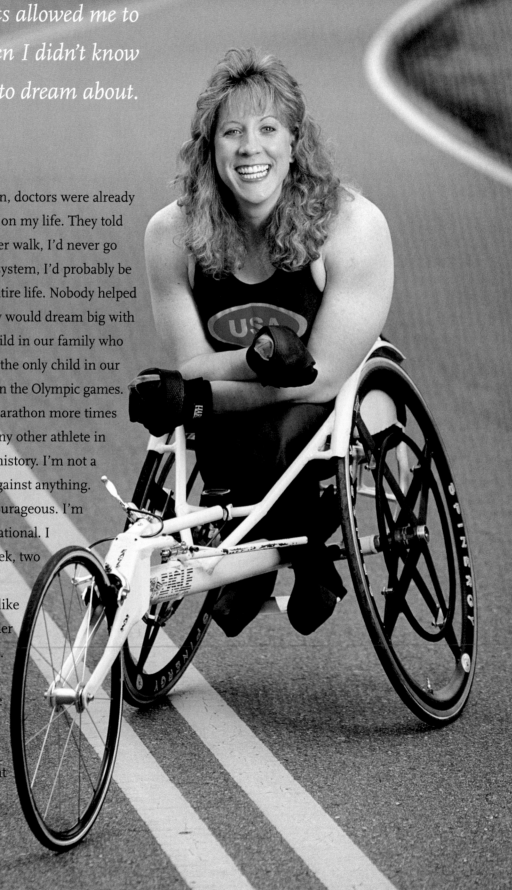

91 Jean Driscoll
Track and Road Racing (Wheelchair)

*Sports allowed me to
dream big when I didn't know
what to dream about.*

On the day I was born, doctors were already placing limitations on my life. They told my parents I'd never walk, I'd never go through a regular school system, I'd probably be dependent on them my entire life. Nobody helped me dream big and nobody would dream big with me. Now I am the only child in our family who owns world records. I am the only child in our family who has competed in the Olympic games.

I've won the Boston Marathon more times in a single division than any other athlete in that marathon's 107-year history. I'm not a victim; I'm not helpless against anything. I'm not out there being courageous. I'm not out there being inspirational. I was training six days a week, two to five hours a day, lifting weights, doing miles just like any athlete has to do in order to compete at the top level. I was one of the top three in the world for at least the last decade of my racing career. It's because of the focus and the commitment I've had, it's about the athleticism. Disability has nothing to do with it.

It's all about the journey.

By about the age of twelve, I knew that I wanted to go across Antarctica. Being part of an expedition, of a community that had that spark of wanting to seek out something beyond what you knew and what was comfortable, that just totally appealed to me. I saw myself there. And I started taking what I considered to be steps. I started to sleep out in the backyard in the thirty-below winter. I tried to teach myself how to build an igloo. I would go out in the field where the snow was very deep and pretend I was pulling a sled.

I have the kind of personality that lends itself very well to long pursuits, long physical pursuits. I like the solitude. I find real solace and comfort in places where there aren't a lot of people around. I'm drawn to the polar regions primarily because of the huge, expansive space. I feel really alive in it rather than feeling crushed by it. When you are in this enormous, vast, unencumbered space, you see the horizon all around you rather than just out in front of you. At these two pinnacle places on the globe, everywhere you turn, there it is. It just encompasses you.

Siri Lindley
Triathlon

When I got to my first triathlon I was a disaster. So my first goal was just to become proficient in the swimming, biking, and running. To be able to cross the finish line in one piece, feeling good, and having had no one laugh at me. On the day I became world champion, I wouldn't have cared if nobody in the world knew. In my heart, for the very first time in my life, I felt I had accomplished something really special. For my whole life, I had been searching to prove to myself that I'm worth something. And what that did for me personally is just incredible. If I have a dream, I can achieve it. I am living proof that those impossible dreams that we all had when we were little kids can come true. Passion is everything in life. It will get you everywhere.

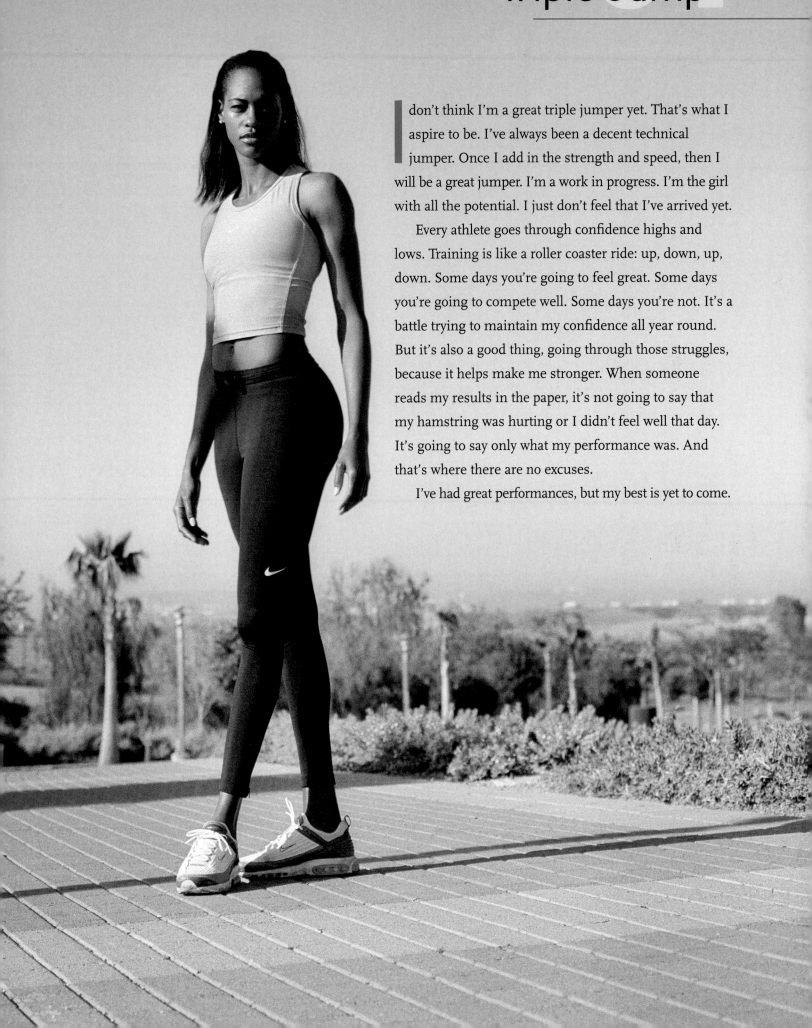

I don't think I'm a great triple jumper yet. That's what I aspire to be. I've always been a decent technical jumper. Once I add in the strength and speed, then I will be a great jumper. I'm a work in progress. I'm the girl with all the potential. I just don't feel that I've arrived yet.

Every athlete goes through confidence highs and lows. Training is like a roller coaster ride: up, down, up, down. Some days you're going to feel great. Some days you're going to compete well. Some days you're not. It's a battle trying to maintain my confidence all year round. But it's also a good thing, going through those struggles, because it helps make me stronger. When someone reads my results in the paper, it's not going to say that my hamstring was hurting or I didn't feel well that day. It's going to say only what my performance was. And that's where there are no excuses.

I've had great performances, but my best is yet to come.

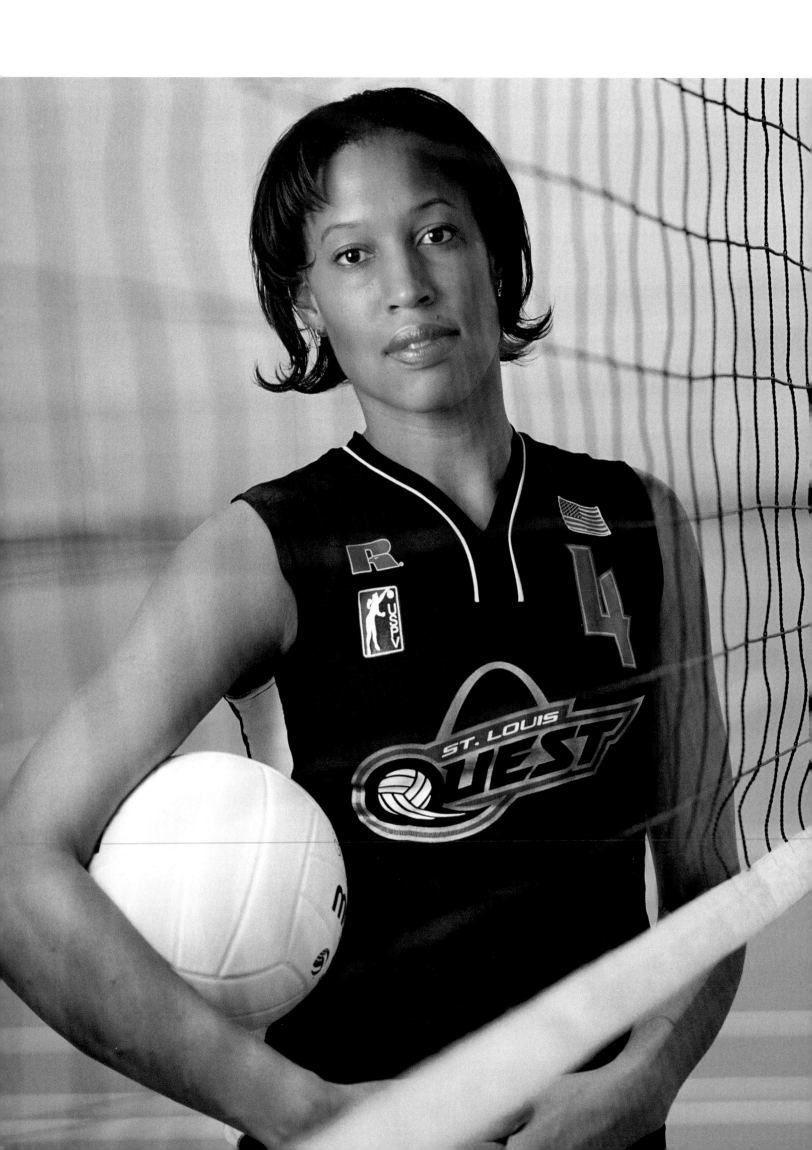

Volleyball

*I enjoy pressure. When my team
is down, I want to be set every ball.
I want to block every ball. I want
the ball to be served to me. I want to be
able to say, I lost the last point, or,
I helped the team to win it.*

I ended up being an alternate for Sydney. I didn't get to go.

After the Olympic thing, you swear, I'll never play again, I'm never going to look at a volleyball again. You take a week off, and you're like, OK, I need to go play. The biggest thing I learned was that there are other ways of playing. It doesn't have to be at the highest level. I went to Italy and had an amazing time there playing volleyball. And it was really competitive, everybody was intense, and I could still give 100 percent.

The Olympics experience was hard, but the more I tell people about it, the more proud I am. I didn't get to go, but I was still a part of it. Watching it on TV, I still felt like, Hey, I played with her.

Wakeboarding is extreme;
it's like something off the edge.

You come off a ramp and go like fifteen feet up in the air and you're like, "Oh, that's so cool. I'm up here," and you get this adrenaline rush. You have to have a certain type of talent and skill level and focus to be able to do that kind of stuff 'cause it's so crazy. You just got your helmet on, you got no pads—why would someone want to try that? It's a blast.

With extreme sports, you can't really have a doubt. When you're coming into the wake and you're gonna try a new trick, you can't think, "Oh, I'm gonna kill myself." You can't really think negative 'cause then you can't focus. You need to think positive: "I can do this."

What I tell other girls who are trying stuff is "You don't know unless you try. You don't know if you'll land it or how close you'll get. The more you try, the closer you'll get to your goals."

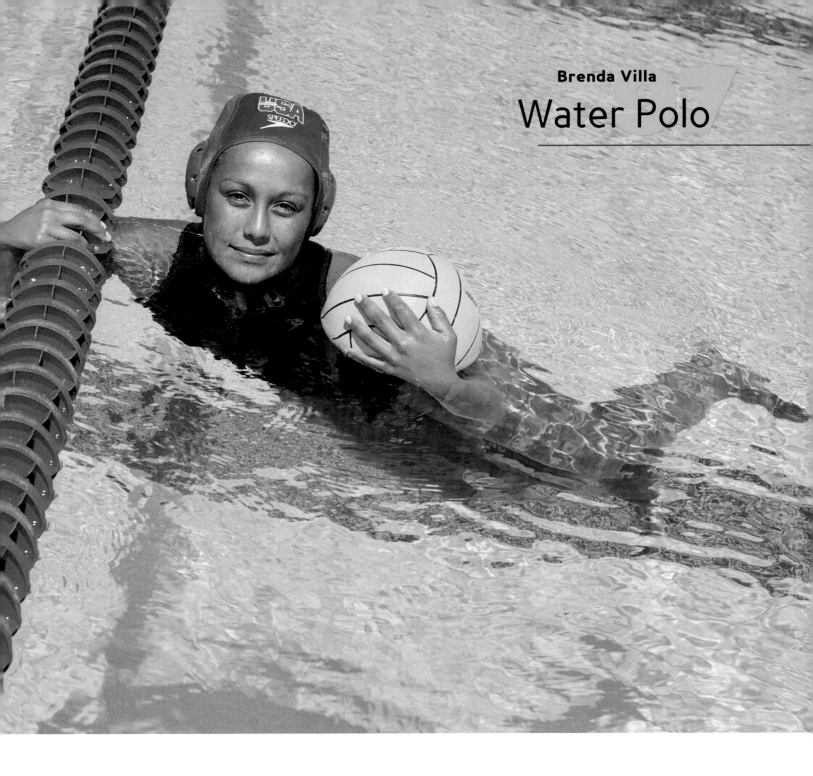

I t all comes down to those intense pressure moments, the ecstasy of winning and the devastation of losing. You want to feel those extreme emotions.

I think I've been lucky. Water polo has grown. It has been around longer than me. And I think that I was born at the right time. I was given a scholarship to Stanford University for water polo. I was on the first team that represented the U.S. in water polo at the Olympics.

There were so many women before me who didn't have the chance to go to the Olympics or didn't even have the opportunity to play their sport in college. I'm riding the wave that other women set for us. I'm trying to make the most of it and show them appreciation for what they gave to our sport.

Waterskiing

was four years old and it was time to learn to ski. When I got behind the boat, I would ski about 15 to 20 feet and drop the rope. My dad would circle back, pick me up, and I'd ski and drop the rope again. He got really frustrated and said, "If you don't ski this time, I'm leaving you." I skied 15 or 20 feet and dropped the rope. He just went back to the dock and left me there in the middle of the lake. It probably wasn't very long, but it was certainly enough time for me to be able to know that when he came back, I was not going to let go.

I started doing local tournaments when I was six. I skied my first national championship when I was nine. I think my father had a grand plan for my brother and me. When we got to the point where he taught us everything he knew about skiing, he bumped us up to the next coach. Every school holiday, we would get into our car, drive down to Florida, and ski.

I must say that it worked, because I set seven national trick records and I always won, always. But there was a lot of friction. Everything I was doing was regulated—school, free time, travel, friends. I made the U.S. team the summer I was fourteen, so I was one of the youngest people to ever do that. By the time I hit nineteen, I was mentally, physically burned out. I said, you know what, I don't want to do this anymore, and my dad said, "See you later, bye."

So I got a job and lived a normal life for two and a half years. I ran across an old coach and he said, "What are you doing? You're like a thoroughbred horse. A thoroughbred horse was born to run, you were born to ski. We'll do it low key, we'll do it really easy, no pressure." So, of course, I was immediately bitten by the bug and the thing that I loved the best and was back skiing. Now I'm skiing because I want to, not because my dad's making me.

During the Worlds in '85, my dad became really ill. I didn't want to leave him. He was like, "Get back out there. It's happier for me to see you on ESPN Monday night than having you hold my hand in the hospital." That particular season, I don't think I lost an event. I won every single thing that I had entered, along with the tour, the Masters, the Worlds the year before, the Nationals, everything. I didn't want to lose now, 'cause it was really important. Dad died that September and had lived to see the end of his dream, which was to see both his children become world champions.

99 Weightlifting

Someone called me and said, "Is this Tara Nott?"

"Yes."

"Is this Tara Nott the weightlifter?"

"Yes."

"Is this Tara Nott the Olympic champion?"

"No. Ha, ha, ha."

"You know, the Bulgarian tested positive. Now you're the Olympic champion."

"You're kidding me!"

It was definitely a shock. I hadn't even accepted being a silver medalist, let alone a gold medalist.

I'm proud that I'm able to say that I'm drug free. I was tested. It's on paper and there's no dispute about it. I don't want my life to be cut short by a choice that I made just to get to the Olympics or just to win a gold medal. My life after weightlifting is so much more important than anything I can accomplish within weightlifting. I'm getting married. I want to have a family. Winning a gold medal doesn't change who you are. People may look at you differently, but, truly, it doesn't change you as an individual. I'm the same person after the Olympics as I was going in. I had a wonderful experience, but ten, twelve years down the line, the gold medal is not going to be who I am.

My ultimate goal is to be a mom. I think all other accomplishments pale compared to being a mom. I can't wait. I'm going to be like any of those other moms taking their kids to soccer practice. My kids aren't going to care if I was an Olympic gold medalist or not, and that's what's important to me. They're going to care what type of mom I am, what type of role model I am, and about the lessons I can teach them.

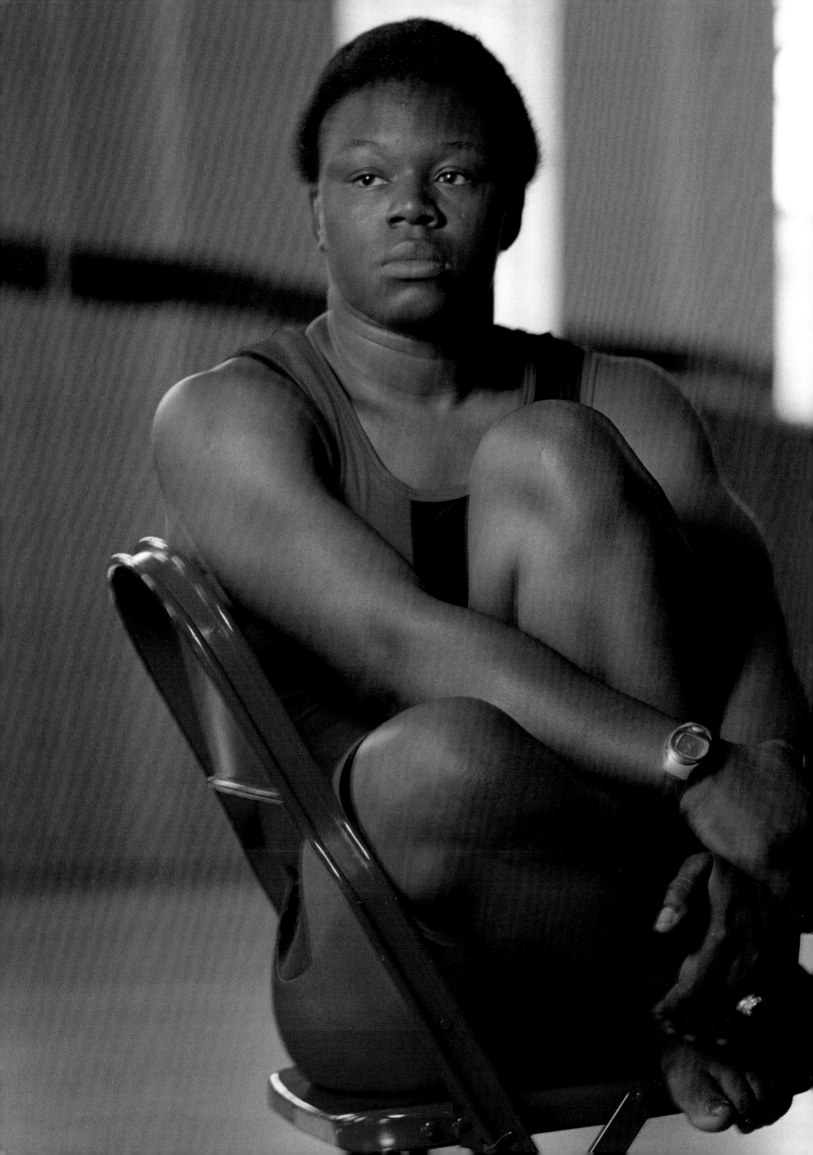

Wrestling

*I never really understood
why some coaches wouldn't allow
their male athletes to wrestle us.*

I had to wrestle guys. By the end of my high school career, there was only one other female on the team. It was really difficult because a lot of guys didn't want to wrestle me or the coach wouldn't let them. A couple of guys actually went out of their way to try to hurt me, I think because they were scared or maybe intimidated. About a year and a half after I started wrestling, I started to see a change. The guys started to know who I was. They knew that I was really serious about wrestling and that I was working just as hard as they were. They began to respect me.

There was a tournament in Michigan that four hundred girls from all over the country came to. It was an amazing thing for me to see. I had no idea that so many women were out there wrestling, especially on the high school level. I wasn't the one who stuck out anymore, and I knew that no one was going to refuse to wrestle me. I felt like I belonged there. It was such a good feeling to see so many women who wrestled and wanted to pursue it.

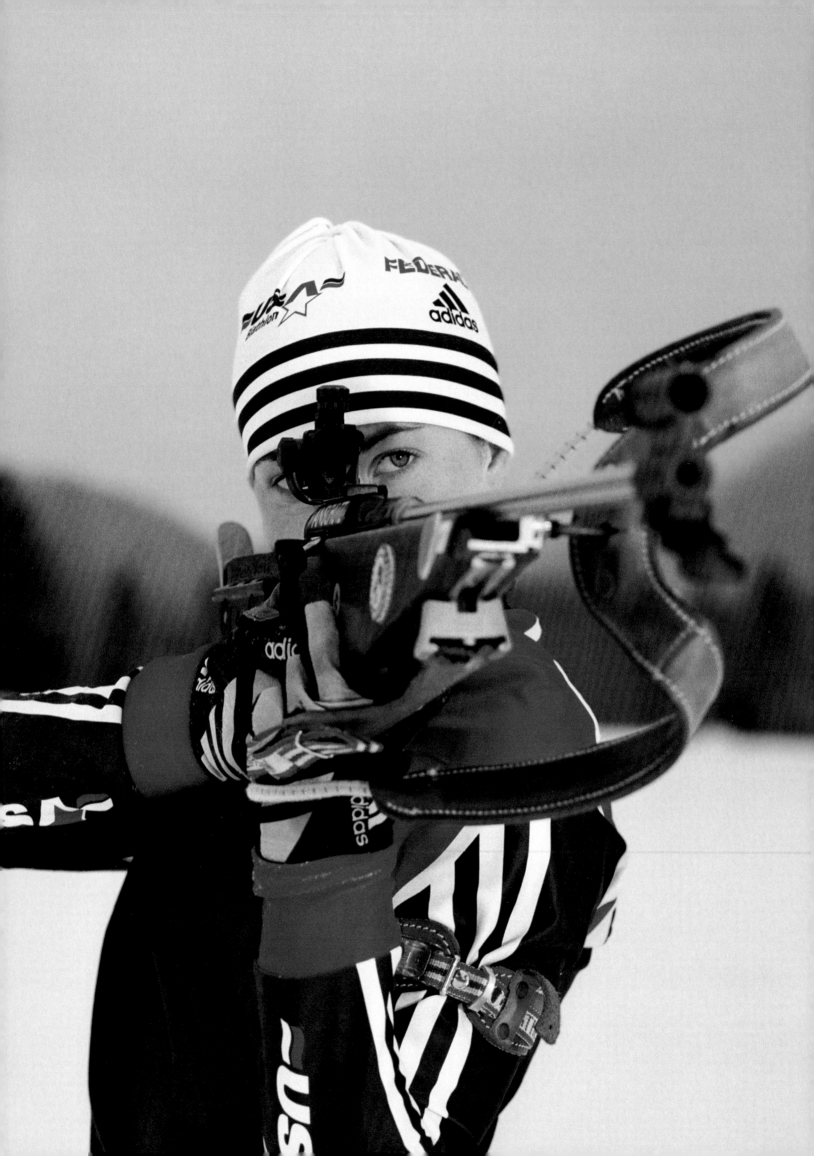

Selected Glossary

ADVENTURE RACING: Adventure racing is a multisport team challenge that tests both physical and mental conditioning and requires teamwork and individual strength. Races vary in distance and typically last between one and ten days, but all courses take competitors through remote wilderness and must be navigated without outside assistance.

BIATHLON: Biathlon brings together the sports of cross-country skiing and rifle shooting. With its roots in both the Scandinavian military and northern European survival tactics, biathlon has evolved into a precision and endurance sport in which skiers stop at intervals to shoot at designated targets. Biathlon was featured in the Winter Olympics as a demonstration sport in 1924, 1928, 1936, and 1948; the event was officially added to the Olympic program in 1960 for men and in 1992 for women.

BICYCLE MOTOCROSS RACING: Bicycle motocross racing, also known as BMX racing, is a cycling sport that started in California in the late 60s. Competitions consist of several heats, or "motos," in which up to eight racers run a 300 to 400 meter–long track with dirt jumps, banked corners, and other course obstacles. The winner is the rider who crosses the finish line first.

BOBSLEDDING: Developed in the nineteenth century, bobsledding (or bobsleigh) is a team sport in which groups travel on a downhill ice course in a walled sled. Winning teams are determined by the fastest times. Men's bobsledding has been part of the Olympic program since the first Winter Olympic Games in 1924. Women's bobsledding made its Olympic debut in 2002.

BOX LACROSSE: Box lacrosse is the Canadian counterpart to lacrosse. Developed in the early 30s by a group of hockey promoters, this sport differs from the field game in that box lacrosse is played indoors in a hockey rink and has only seven players instead of twelve. It is the most popular version of lacrosse played in Canada, but has gained a large following in the U.S. and Australia in recent years.

CURLING: Curling is a game in which two four-person teams take turns pushing a 19.1-kilogram stone across an icy surface. Players attempt to get the stone as close as possible to the center of a series of concentric circles that have been marked on the ice. Curling originated in the sixteenth century in Scotland, and the sport made its Olympic debut in 1998.

DECATHLON: Athletes amass points in ten different track-and-field contests, with the overall winner determined by the highest cumulative score. Over the course of two days, decathletes compete in the 100-meter sprint, 400-meter run, 110-meter hurdle race, 1500-meter race, discus, pole vault, javelin, long jump, shot put, and high jump.

DINGHY SAILING: A "dinghy" is a smaller class of sailboat that is typically 8' to 17' in length. Competitive dinghy sailing includes single-, double-, and triple-handed events, and athletes compete against members of the same sex. The Olympic Yachting event debuted in 1896, but women did not officially enter the Olympic sailing competition until 1988.

DISCUS: Discus is a track-and-field event in which competitors throw a wooden plate rimmed with metal as far as possible. The weight and size of the discus varies for men and women, but standard technique involves rotating several times within a circle before releasing the plate. An ancient Greek exercise, discus made its debut as a Summer Olympic sport in 1896.

DOWNHILL MOUNTAIN BIKE RACING: This extreme sport engages athletes in a task similar to that of downhill skiing: riders attempt to make the fastest run down a rugged hill with a mountain bike.

FIELD HOCKEY: Field hockey is an outdoor team sport in which players hit and dribble a solid plastic ball down a field and try to shoot it past a goalkeeper into a goal cage. Players use a wooden stick with a curved head and one flat side to move and control the ball, and shots may be taken only from within a striking circle. Although field hockey is the oldest known ball-and-stick game, the modern version of the game was developed in England in the nineteenth century. The sport has been part of the Olympic program for men since 1908 and for women since 1980.

FREE DIVING: Free diving, or breath-hold diving, is an underwater event that prohibits the use of an underwater breathing apparatus and tests a diver's ability in time, distance, and depth. Different competitions may involve the use of flippers, a ballast weight, and balloons.

GOALBALL: Goalball is an indoor team sport played primarily by blind and visually impaired athletes. Teams consist of three

players each, and the object is to throw a 3-pound ball—called the goalball—past the opposing team into their goal. All players wear masks during the game so that athletes with varying levels of sight may play together, and the goalball contains bells so that its location may be detected. The sport is an event in the Paralympic Games.

HAMMER THROW: The hammer throw is a track-and-field event in which competitors throw a heavy metal ball attached to a handle by a wire cable. Athletes try to throw the "hammer" as far as possible within a designated sector that measures 34.92 degrees. Hammer throwing was developed into a sport centuries ago in Ireland, Scotland, and England, and the event has been included in the Olympic Games since 1900.

HEPTATHLON: The heptathlon is a seven-event competition spread across two days, and consists of the 100-meter hurdles, high jump, shot put, 200-meter race, long jump, javelin, and 800-meter race. The heptathlon has been an Olympic sport since 1986.

JAVELIN: Javelin is a sport commonly included in the broader category of track and field. In this event, a spearlike metal or wooden shaft with a metal point is thrown for distance. Javelin has been a sport in the Summer Olympic Games since 1908.

KITEBOARDING: Kiteboarding is an extreme water sport in which an athlete is propelled across the water by a large kite while standing on a board with foot bindings. The kite may be controlled with either two or four lines and allows the surfer to lift off the water by capturing the wind.

LUGE: Luge, the French word for "sled," is a sport in which competitors race down an icy track in a sled at speeds in the range of 140 kilometers per hour. Athletes lie on their backs with their feet stretched in front of them and must navigate the course without the aid of brakes. Records indicate that luge dates back as early as the sixteenth century, but the sport made its Olympic debut in 1964. Men's singles, women's singles, and mixed-doubles events are featured at the Olympic level.

MODERN PENTATHLON: A multievent Olympic sport, modern pentathlon includes swimming, cross-country running, pistol shooting, épée fencing, and equestrian show jumping. The five disciplines were chosen based on the skills a Napoleonic courier had used in order to get a message across an enemy battlefield. Modern pentathlon has been a part of the Olympic program since 1912, but 2000 was the first year women were permitted to compete at this level.

MOGULS: One of three freestyle-skiing events in which skiers perform aerial maneuvers as they ski downhill, moguls requires competitors to travel over numerous hard, snowy bumps and two jumps during a run. Skiers are awarded points based on their performance in four categories: turns, line, air, and speed.

Similar to all skiing disciplines, freestyle skiing has its roots in Scandinavia; however, its primary development occurred in North America during the 1960s. Moguls was first introduced as a medaling Olympic sport for both men and women in 1992.

MONOSKIING: Monoskiing is a sport that combines the motion of skiing with the balance of snowboarding. An athlete's feet are attached side by side to a single, wide ski, and "outriggers" (short crutches with ski tips on them) provide assistance with turns. Like stand-up or "dual" skiers, monoskiers roll their knees from side to side during turns, keep their shoulders square to the fall line, and can reach speeds of up to 70 miles per hour. The U.S. Monoski Association is currently working toward the inclusion of monoskiing in major winter sports competitions.

PARALYMPICS: The Paralympics are sports events for elite athletes with physical disabilities. Although formal sports competitions for physically disabled individuals were organized as early as 1948, the first Olympic-style games took place in Rome in 1960. The Paralympics currently includes twenty-one sports, eighteen of which are also featured in the Olympics, and takes place in the same year and the same location as the Olympic Games.

RACEWALKING: In the sport of racewalking, an athlete's progression of steps must be such that no visible loss of contact with the ground occurs. Race distance typically ranges from 1 to 100 miles, with standard international distances at 20 kilometers and 50 kilometers. The 20-kilometer race for women debuted as an Olympic event in 2000. Elite athletes can reach speeds of almost 6 minutes per mile over 12.4 miles. Milder, noncompetitive variants of racewalking include power walking and speed walking.

RHYTHMIC GYMNASTICS: Rhythmic gymnastics is an apparatus sport in which gymnasts perform on a floor area with a ribbon, ball, rope, hoop, and clubs. Routines are choreographed to musical accompaniment, and athletes may compete in both individual and team events. Rhythmic gymnastics is strictly a women's competition and is one of three gymnastics disciplines included in the Olympic program.

SENIOR OLYMPICS: Governed by the National Senior Games Association, the Senior Olympics encourages a healthy lifestyle in mature adults over fifty. The Summer National Senior Games was established in 1987 and now offers competition in eighteen sports during odd-numbered years; the Winter National Senior Games was established in 2000 and offers competition in seven sports during even-numbered years. American athletes also have the opportunity to participate in games on a state level throughout the country.

SHOT PUT: In this track-and-field event, a heavy metal ball, or shot, is thrown for distance. Competitors rest the shot between their neck and shoulder and push their throwing arm straight to

launch the ball. The shot must be thrown from within a designated circle, and the weight of the ball varies for men and women. Shot put has been an event in the Summer Olympic Games since 1896.

SKELETON: Related to bobsledding, skeleton is a winter sport in which a single athlete races on a downhill ice course. Competitors steer a fiberglass-and-steel sled using only their body pressure and feet as they travel face-first on their stomachs. Athletes reach speeds of up to 80 miles per hour, and winners are determined by the fastest times down the course. Skeleton has its origins in Switzerland in the late eighteenth century and is considered to be the world's first sliding sport. The men's event appeared in the Olympics in 1928, 1948, and 2002, and the women's event made its debut in 2002.

SNOWSHOEING: Snowshoeing is a winter sport in which participants travel across the snow using specialized footwear. These "snowshoes" are racket-shaped frames containing interlaced strips, and when attached to the foot, they displace one's weight and facilitate movement over the snow. Competitive snowshoeing races take a variety of forms, including a 100-yard dash, 1-mile hill climbs, marathons, and multiday expeditions.

SPECIAL OLYMPICS: The Special Olympics provides sports opportunities at all levels for individuals with learning disabilities. World Summer and Winter Games take place every four years, one year before the corresponding Olympic Games. They are the flagship events of the Special Olympics movement, which was founded by Eunice Kennedy Shriver in 1968.

TAE KWON DO: Tae kwon do, which means "the way of kicking and striking," is a traditional Korean martial art in which the hands and feet are used to defeat a single opponent. During the contest, competitors are awarded points for legitimate blows and lose points for penalties committed. Tae kwon do became an official Olympic medal sport for both men and women in 2000.

TRACK AND ROAD RACING (WHEELCHAIR): Wheelchair racing encompasses events of numerous distances and several types of surfaces. Athletes compete on manufactured tracks in events like the 200 meter, the marathon, and the pentathlon as part of the Paralympic Games; however, competitive races also take place on open roads and urban streets. Racing wheelchairs typically have lightweight metal frames with three wheels, and a chair's rear wheels may be "cambered," or angled, to allow for greater speed around corners.

TRACK CYCLING: Track cycling is a type of bicycle racing in which athletes ride specialized bicycles around an oval track. Track, or fixed-gear, bicycles have only a single, large gear; no freewheel for coasting; and no brakes for stopping. Riders use only the pedals to control the speed of the bicycle. The oval track, or velodrome, may be found indoors or outdoors, and the turns of the track are usually banked, or steeply angled. The sport is one of the few to have appeared in every Olympic Games. Women's events in track cycling were added to the Olympics in 1984.

TREKKING: A "trek" is defined as a long and difficult journey, usually on foot. Trekking, then, challenges athletes to traverse natural courses or untouched wilderness for extended periods of time. Challenge events simply require walkers to complete a course within an allotted time, whereas race events test how quickly one can travel the course.

TRIATHLON: Triathlon is a multisport event consisting of a 1500-meter swim, 40-kilometer road cycling race, and 10,000-meter run. The sport was developed in the early 70s by the San Diego Track Club in California and has been a part of the Olympic program since 2000.

TRIPLE JUMP: The triple jump is a track-and-field event in which competitors execute a three-part move: after taking a running start, an athlete hops, skips, and then leaps as far as possible into a sand-filled landing area. The combination of moves is designed to increase momentum with each stage so as to maximize the distance of the jump. The triple jump has been an Olympic sport since 1896.

WAKEBOARDING: Created by a California surfer in 1985, this crossover sport combines elements of both waterskiing and snowboarding. Wakeboarders stand on a single, wide board while being towed behind a motorboat. Advanced riders perform flips, twists, handstands, and grabs; the opportunities for creativity and innovation have made wakeboarding one of the fastest-growing water sports in America.

Biographies

ROBYN BENINCASA: Less than ten years ago, she went to work every day as a pharmaceutical saleswoman. Tired of the humdrum routine, Benincasa decided her athletic passions needed to be integrated into her work. Today, Benincasa is not only a firefighter but also one of the top female adventure racers on the planet, having endured and won both the Raid Gauloises and the Eco-Challenge.

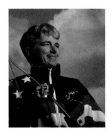

PICABO STREET: An utterance of just her first name conjures up the image of an American athletic icon—Picabo. Never short on charm or guts, she won the gold medal in Super G in Nagano (1998) and the silver medal in downhill in Lillehammer (1994).

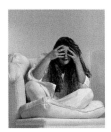

JANET DYKMAN: A two-time Olympian, Janet Dykman has proven herself over time to be one of the most accurate and consistent archers in the U.S. Dykman won a gold medal at the 1995 Pan American Games and led the U.S. to a team gold medal at the 1999 Pan American Games. She has won three consecutive U.S. National Target Championship titles (1996, 1997, 1998) and has been named California State Outdoor Champion thirteen times.

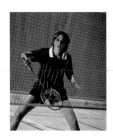

KATHY ZIMMERMAN: A descendant of original Colorado homesteaders, Kathy Zimmerman made a name for herself in USA Badminton's history books. After winning fourteen junior national badminton titles, Zimmerman took her game to the next level. During her college career at Arizona State University, she won the National Championship and was thrice named All-American. Zimmerman is currently on the USA Badminton board of directors.

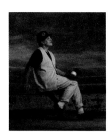

BETTY TREZZA: Fifty years ago she turned the double play, stole home, and legged out the race at first base. Unbeknownst to many, before the WUSA and the WNBA, there was the AAGPBL—All-American Girls Professional Baseball League—and Betty Trezza, Hall of Fame infielder, was there.

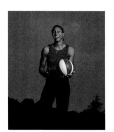

TAMIKA CATCHINGS: A four-time Kodak All-American, Tamika Catchings led the perennial powerhouse Lady Vols to the top of NCAA basketball. Graduated to the pro ranks, she was the WNBA's Rookie of the Year in 2002. Catchings currently leads the Indiana Fever in scoring and steals.

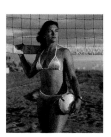

MISTY MAY: Born to an Olympic volleyballer and a nationally ranked tennis star, Misty May had the athletic achievement odds stacked in her favor. But genes don't make champions. That's where gritty determination and old-fashioned defense come in. To date, May (with teammate Kerri Walsh) has dug and sweated her way to the number one beach volleyball ranking in the world.

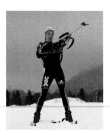

DENISE WHITTEN-TEELA: Sprint a distance through blustery cold on cross-country skis. Stop. Breathe. Now try to grab ahold of your pounding heart just long enough to lift your rifle and get off a shot that demands centimeter precision. Welcome to another day at the office for biathlon Olympic hopeful Denise Whitten-Teela. She is currently on the National Guard Biathlon Team and the US Biathlon Team. As the fastest skier on the U.S. team, she played a key role in the handful of top-ten international finishes the squad notched in 2003.

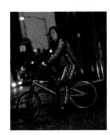

KIM HAYASHI: In the air, she feels at home. It comes as no surprise that in her rookie year as a pro BMX racer, Kim Hayashi absolutely took off. Currently ranked first in the country, the future is looking bright for this Hawaiian-born teenager.

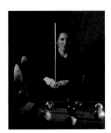

JEAN BALUKAS: At age four she picked up her first pool cue. At age fourteen she won her first women's billiards national title. Today, almost fifty years later, Jean Balukas has lived one of the most illustrious billiards careers in sports history. Her record reads seven BCA U.S. Open titles, six World Open titles, and countless 9-ball and straight-pool crowns.

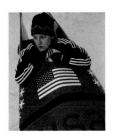

JILL BAKKEN: Entering the 2002 Olympic World Games, no one expected the humble Jill Bakken and brakeman Vonetta Flowers to win—no one but Bakken and Flowers, that is. Pulling off the upset, they were awarded the first-ever women's bobsled Olympic gold medal. After having spent eight years on the national team and pushing tirelessly for women's bobsledding to be included on the Olympic docket, the serendipity was poetic.

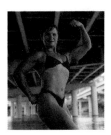

KAREN MILLER: Every muscle fiber in Karen Miller's body is at attention. Called to duty every day for the better part of two decades, these muscles are coaxed into superhero shape. For her physique, Miller was named the World Natural Bodybuilding Federation's Ms. Pro Natural Universe Heavyweight Champion in 2001 and Ms. Pro Natural International Heavyweight Champion in 2002.

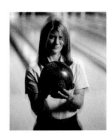

ROBIN MOSSONTTE: When she was six years old, her fingers were too small to fit in the holes of a bowling ball, so she used two hands to launch her dreams down the lane. At nine, Robin Mossontte was competing in tournaments and beginning her ascent to the top of women's bowling. By the time she retired, Mossontte won seventeen titles, was named Bowler of the Year, and was honored in five Halls of Fame.

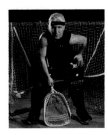

GINNY CAPICCHIONI: The first female player in the history of the previously all-male National Lacrosse League, Capicchioni blocks whizzing bullet shots every day while simultaneously making history. She comes to the New Jersey Storm after an illustrious collegiate career at Sacred Heart University, where she was thrice named Northeast Conference Goalie of the Year.

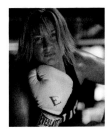

KATHY COLLINS: Kathy "Wildcat" Collins exists at the intersection of core sport and entertainment. Like any true boxer, she takes her training as seriously as her sassy self-promotion. Boasting nineteen professional bouts and four world championship belts, she's got the game to back it all up.

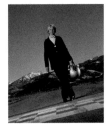

JANET GUTHRIE: "Gentlemen and lady, start your engines!" Those were the words bellowed by the announcer at the Indianapolis 500 in 1977. For the first time in history, a woman racer rolled her car to the starting line and joined the men revving their engines. From that point on, the legendary Janet Guthrie would be known not only for her courage but also for her extraordinary ability to drive fast. From Indianapolis to Daytona, this pioneer cleared a space for women in the sport of auto racing.

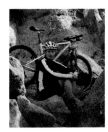

ALISON DUNLAP: "Don't stop pedaling," her dad yelled as a young Alison Dunlap teetered atop her first bike, a royal-blue cruiser with a banana seat. Apparently that advice made an impression. Alison Dunlap is one of the best pedalers in U.S. history. Initially a road cyclist, Alison earned a spot on the 1996 Olympic team. Today, having switched gears, she is the world's cross-country mountain bike champion.

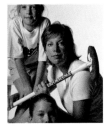

PATTI LANK: There was no shortage of competition for Patti Lank growing up with six siblings. On Sundays, Mom and Dad would take the whole gang down to the club to throw stones, like picture-book Canadians. Continuing in the family tradition, now in the U.S., Lank—a three-time U.S. champion and four-time runner-up—and her husband have taught their daughters the game.

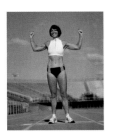

PHIL RASCHKER: There is no timetable for tapping into one's athletic excellence. Phil Raschker is proof. At age forty-seven, she set the Master's world record for the pole vault (11.1). At age fifty, she tore up the track, running the 100 meter in 12.65 and the 200 meter in 25.72. Capturing ten gold medals at the World Veterans Athletic Championships in South Africa, she has become a legend of her generation.

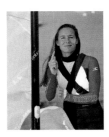

MEG GA!LLARD: In the old boys' club of sailing, Meg Gaillard is an anomaly. Descended from a long line of pioneering female sailors, she has continued the proud lineage of her foremothers. Galliard is currently the top-ranked dinghy sailor in the U.S.

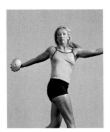

SUZY POWELL: Powering her discus 69.44 meters into the La Jolla air on April 27, 2002, Suzy Powell etched her name into the history books. That throw set the U.S. record and was one of the three times that Powell achieved a top performance by an American in the history of discus.

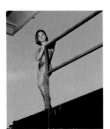

KIMIKO HIRAI SOLDATI: An athlete's drive to achieve is often revealed most vividly in the face of adversity. Kimiko Hirai Soldati, the 2002 World Championship silver medalist, is the ultimate example, bouncing back from scores of injuries with strength and determination. While at Indiana University she was not only the best collegiate diver in the nation but also the valedictorian.

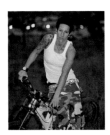

MELISSA "MISSY" GIOVE: Relying on nerves of steel and piercing focus, she has won all the big races—the World Cup, the National Championship, you name it. Throughout all the broken bones and podium finishes, she's remained true to her own strong spirit and head-turning style.

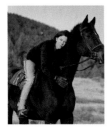

NICOLE TROUSDALE: Nicole Trousdale has thirty-one years invested in her relationship—that is, the one she has with her horses. Forever intoxicated by the power of riding as one with these incredible creatures, she has won countless hunter, jumper, and equitation championships.

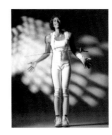

SHARON MONPLAISIR: With three trips to the Olympic Games, Sharon Monplaisir is one of the most accomplished fencers in recent U.S. history. For her unfaltering grace and punchy speed, she was named to both the U.S. World and World University teams.

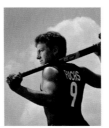

TRACEY FUCHS: In the mid-80s, Fuchs raised eyebrows in the field-hockey community, giving her customary 110 percent for the UConn Huskies and scoring goals galore. Now a fifteen-year national team veteran, she still manages to put the ball in the cage better than most anyone. Having participated in more than two hundred international matches, including the 1996 Olympic Games, Fuchs hopes to help the U.S. squad qualify for Athens in 2004.

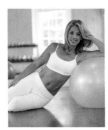

DENISE AUSTIN: An ambassador for the aerobically inclined, Denise Austin is the creator and star of America's longest-running fitness show, *Getting Fit with Denise Austin.* Over the past twenty years, she has established a fitness empire that's brought health to millions of people around the world. Her latest video is entitled *Power Zone—Mind, Body, Soul.*

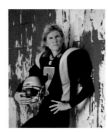

ANDRA DOUGLAS: Who really leads a professional football team? Is it the owner, the general manager, or the quarterback? For the IWPFL's New York Sharks, there's an easy answer: Andra Douglas. Serving in all three capacities, no one is more dedicated to seeing women's professional football succeed.

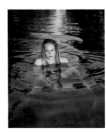

TANYA STREETER: Tanya Streeter plunged into the blue abyss of Providenciales, Turks and Caicos, on August 17, 2002, diving deep beneath the water's surface with nothing to assist her breathing but her will. Three minutes and 26 seconds later, she had reached a depth of 525 feet. A world record had been set, and Streeter instantaneously etched her name into the history books as the first woman in any sport to beat a world record previously held by a man. Her ultimate goal is to hold world records in all five free-diving disciplines.

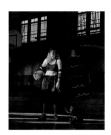

JENI ARMBRUSTER: As a teenager, Jeni Armbruster was a force on the basketball court. Deteriorating vision and eventual loss of sight led her from one outlet of competitive energy to another. Today, Armbruster is one of the top five goalball players in the world. While pushing her team to a gold medal in the 2002 World Goalball Championships, she became the tournament's leading scorer.

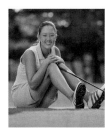

MICHELLE WIE: Thirteen-year-old Michelle Wie shocked the LPGA tour in 2003, making her debut at the Kraft Nabisco Championships. Her 300-yard-plus drives off the tee soar farther than the drives of the top players in women's golf. Beware on the fairway.

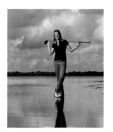

ANNIKA SORENSTAM: Annika Sorenstam made headlines in 2003 when she became the first woman since Babe Didrikson Zaharias (1945) to compete in a PGA Tour event alongside men. It wasn't the first time she made the news. Sorenstam has single-handedly raised the bar for women's golf. The first woman to shoot a 59, she set or tied thirty tour records in 2001 alone. The Stockholm native has five times been honored as Rolex Player of the Year and five times received the prestigious Vare Trophy.

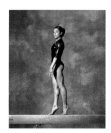

TASHA SCHWIKERT: Like so many great athletes, Tasha Schwikert is a master of overcoming challenge. Deemed by doctors to be destined for a physically underdeveloped existence, she became a world-class athlete—competing regularly by the age of seven. An alternate for the U.S. gymnastics team in Sydney, she was told only days prior to the Games that she would compete. She helped bring the team to the finals, and a year later she won the 2001 U.S. Nationals. She was captain of Team USA as they struggled to an amazing first-ever win at the 2003 World Championships.

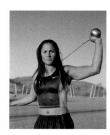

LESLIE COONS: Leslie Coons is a two-time American record holder and three-time NCAA All-America selection in the hammer throw. She spends her days giving back to her sport as a throwing coach at San Diego State University.

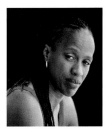

JACKIE JOYNER-KERSEE: During a time when women's sports were expanding at an astronomical rate, she was called the best woman athlete in the world. Winner of six Olympic medals (three gold) Jackie Joyner-Kersee unequivocally dominated the heptathlon and long jump for over a decade. Currently retired from athletic competition, she still holds world records in both events.

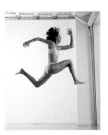

ERIN ALDRICH: In true Texas style, Erin Aldrich likes to go big. Standing 6 feet 1 inch, she can jump a height greater than her own—a height great enough to have earned her a place on the 2000 Olympic track team. But that's not enough for the former Longhorn volleyball standout. Aldrich has her sights set on being a dual-sport Olympian, training with both the U.S. volleyball and track teams.

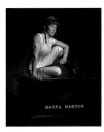

DONNA BARTON: Following in her jockey mother's footsteps, Donna Barton is one of the winningest female jockeys of all time. Retiring after an epic twelve-year career, she won more than one thousand races. To this day she gallops and works horses each morning for her husband, trainer Frankie Brothers, and does Triple Crown commentary for NBC.

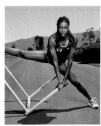

CHITUA "CHI CHI" OHAERI: If you can't find her on the track, try the soccer pitch. In 2002 Ohaeri was the Big 12 champion in the high hurdles and helped the Texas A&M women's soccer team to a Sweet 16 appearance.

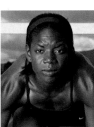

TANISHA MILLS: Tanisha Mills has faith. She has faith in herself as well as something more powerful than she. Her ability to combine humility with tenacity has taken her to the elite echelons of the national track scene. In 2003, she placed sixth in the 400 meters at the U.S. Indoor Track and Field Championships.

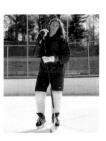

A. J. MLECZKO: As a starting defenseman for the U.S. team, A. J. Mleczko earned a gold medal and a silver medal in the first two women's ice hockey competitions in Olympic history. While a senior at Harvard University, Mleczko enjoyed the most prolific scoring season in women's intercollegiate varsity ice hockey with 114 points.

KELLY MATTHEWS: Skating is in her. She knew it the first time she launched off a ramp. Bruises map the history of her evolution on wheels. When she flies through the air, her grace and aggression are married in perfect harmony. Meet professional in-line skater and pusher of gravity's limits Kelly Matthews. She is considered to be one of the best female skaters competing today, having posted podium finishes at the X Games (1999, 2000) and ASA Championships.

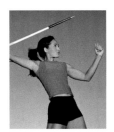

AJA FRARY: Every throw longer, every jump higher, and every length on the track faster than the one before. Aja Frary's promise as a javelin thrower and heptathlete can be seen in her scores. But don't compare her scores to those of others; compare them to her previous showing. At practically every major competition, Frary manages to better her personal record—a true display of the athlete's coveted inner fire.

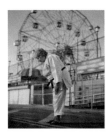

RUSTY KANAKOGI: Rusty Kanakogi isn't just another tough gal out of Brooklyn. She holds a sixth-degree black belt, making her the highest-ranking American woman in the sport of judo. Her success is reflected not only in her belt, but also in her long-time commitment to expanding judo opportunities.

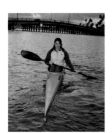

CATHY MARINO BRADFORD: Cathy Marino Bradford is a woman who wears many hats. There's the mom hat. There's the firefighter hat. And, of course, there is her kayaking helmet. A longtime elite kayaker, Marino Bradford competed in the Olympic trials in 1992 and has continued to paddle with the top ranks in her sport.

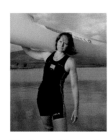

KATHRYN COLIN: Growing up in Hawaii, Kathryn Colin developed a strong connection with the water—a love that has taken her and her paddle to the top. In 1991 she won the U.S. Nationals in flatwater kayaking (K4). Five years later, her boat took first place at the NCAA Rowing National Championships. From 1998 through 2000, Colin's boat was undefeated in the U.S. Now, a member of the U.S. kayaking "A" team, she is training for the K2 competition in Athens in 2004.

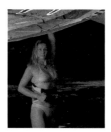

LAUREL EASTMAN: Laurel Eastman flies a kite for a living. It's not what you might be thinking. A professional kiteboarder, she does tricks on a board that runs along the water while propelled by a large kite. Spreading her spirit and love for her sport wherever she goes, Eastman is currently ranked fourth in the Kite Pro World Tour.

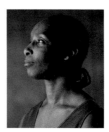

LORETTA CLAIBORNE: She's finished twenty-five marathons, speaks four languages, wears a black belt in karate, and has won dozens of Special Olympic medals for running, including a gold in the 3000 meter and one for a world record in the 5000 meter. Loretta Claiborne possesses a lion's share of courage, achieving what the critics said a partially blind girl with mild retardation would never accomplish.

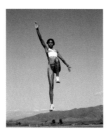

SHAKEEMA WALKER: No one said getting to the top would be easy—even if you're a 6'-tall natural competitor. Shakeema Walker placed third in the National Triple Jump Championship while working three jobs. Her success reflects both natural talent and her willingness to grit her teeth and work for her results.

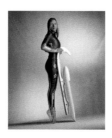

CAMERON MYLER: Widely considered the most successful female luger in U.S. history, Cameron Myler holds six national titles and was a member of four Olympic teams. Retired from the track, she is currently teaching and practicing law and serving as vice president of the U.S. Luge executive board.

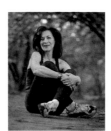

KATHERINE SWITZER: The year was 1967. Using the genderless name K. Switzer, she became the first woman to officially enter and run the Boston Marathon. Since that epic day, Switzer has won the New York City Marathon (1974) and triumphantly crossed the finish line of thirty-four additional marathons.

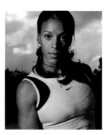

SASHA SPENCER: According to Sasha Spencer, her greatest achievement isn't earning five NCAA All-America awards nor a third-place finish at the USA Track and Field Championships (800 meters). Instead, it has been developing admiration for her mother, who raised Spencer alone after the death of her father.

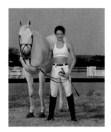

MARY BETH LARSEN-IAGORASHVILI: Growing up playing as many sports as she could find, it's no surprise that Mary Beth Larsen-Iagorashvili became the first American woman to qualify for the Olympic modern pentathlon competition. She is one of the most well-rounded athletes in the world—a four-time U.S. champion in a sport that demands precision and power in a wild array of skills: fencing, horse riding, shooting, running, and swimming. She returned from the Sydney Olympics with a fourth-place finish and has set her sights on Athens in 2004.

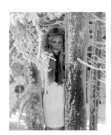

DONNA WEINBRECHT: When there is no place for you, make a place for yourself. And that's just what she did. She became the first-ever Olympic moguls champion. Three Olympic Games, a World Championship, five World Cup titles, and hundreds of wins later, she is the most decorated moguls skier in the history of the sport. Recently retired, she is credited with helping fuel the rise of freestyle skiing in the U.S.

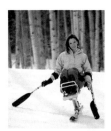

SARAH WILL: Her name says it all. Do you have the will to wake up every morning and compete as though it were your last? Will you risk for the things that matter most? Will you give of yourself so that others may find the greatness that lies within? For twelve-time Paralympic gold medalist Sarah Will, the answer is a resounding yes.

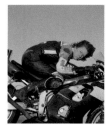

JODIE YORK: Aggressively tipped over, knee inches off the ground, Jodie York rockets around the track on her motorcycle, riding neck and neck with the boys. York is the only woman to win multiple expert production class motorcycle championships at any club in the U.S. In 2000 she finished eleventh in the overall track championship.

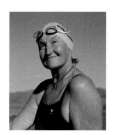

CAROL SING: Swimming began for Carol Sing when she was a child in Mission Bay. Lying belly down in the shallow water, hands sinking into the silty shoreline, she would practice her kicking. Those same kicks powered her training some fifty years later as she swam around the open waters surrounding Manhattan, preparing for a historical swim. At the age of fifty-five, Sing made history, becoming the oldest woman to complete the open-water swim through the Catalina Channel. Two years later, she again made history—this time becoming the oldest woman to cross the English Channel.

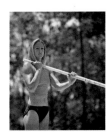

TRACY O'HARA: Soaring precisely $7\frac{1}{4}$ inches into the air, Tracy O'Hara leaped to an NCAA pole-vaulting record. Poised with three National Collegiate Championship titles, she's ready to raise the bar. Next jump? Athens 2004.

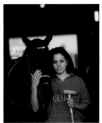

TAYLOR MCLEAN: It was the perfect ending to the perfect story—horses and all. After learning the game of polo in high school through the University Development Program, Taylor McLean chose to enroll at Cornell. Four years and four national championships later, a fierce competitor closes the book on her horseback fairy tale.

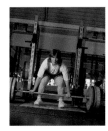

KIM RICHARDS: Hoisting hundreds of pounds over her head, Special Olympics athlete Kim Richards carries both seen and unseen weight on her shoulders. The 2003 New York Female Athlete of the Year serves as both a World Games competitor and a spokesperson for her fellow athletes.

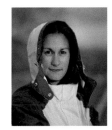

SUSAN ARMENTA: For Susan Armenta, a four-time national racewalking champion, walking is a daily test of pace, discipline, and determination. With an ability to walk faster than most people can run, Armenta set the American record for the 50K in 2002 and is currently training to compete in the 2004 Olympic trials in the 20K.

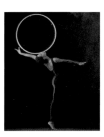

WENDY HILLIARD: Wendy Hilliard is a nine-time U.S. national rhythmic gymnastics team member and the first African American ever selected for the U.S. team (1978). After retiring from athletic competition, she established the Wendy Hilliard Foundation, an organization that provides funding for rhythmic gymnastics programs and associated disciplines.

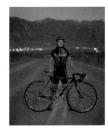

MARI HOLDEN: With legs like pistons, Mari Holden has ridden her way to an Olympic silver medal, five individual time-trial national championships, a world championship, and countless stage races over the past decade. She embraces the team aspect of cycling and has twice been named a member of the winning Tour de France team.

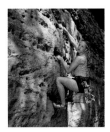

TORI ALLEN: Tori Allen has a remarkable ability to go up. She is not only the Junior Olympic pole-vaulting champion, but also a superhuman rock climber. When she was thirteen years old, she won a gold medal at the X Games and became the youngest female to summit the Nose of Yosemite's El Capitan. Since her epic breakthrough year, Allen has continued to establish herself as one of the top female sport climbers in the country.

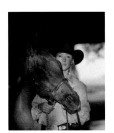

CHARMAYNE JAMES: In the dust and mud of the rodeo, Charmayne James has made a name for herself—the first cowgirl to win a million dollars in prize money. At fourteen, James rode her horse, Scamper, to her first Barrel Racing World Championships. In the twenty years between then and now, she has taken ten additional professional rodeo championships.

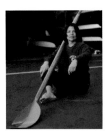

ANITA DEFRANTZ: Anita DeFrantz's evolution in sport has occurred through a series of powerfully rich experiences over the past thirty years. The story began in 1976 when DeFrantz won a bronze medal in rowing at the Olympic Games, becoming the first African American to do so. In 1978 she claimed the silver medal at the World Championships and set her sights on winning it all at the 1980 Olympic Games. Denied the chance to compete, DeFrantz led the protest against the U.S. boycott of the 1980 Olympic Games. For her tenacity and poise, she was honored by the IOC. Years later she became the first African American woman to serve on the prestigious committee.

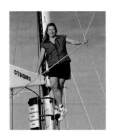

DAWN RILEY: The first woman in the world to manage an entire America's Cup syndicate and one of the only Americans to sail in three America's Cups and two Whitbread Round the World races, Dawn Riley has made gargantuan strides for women in sailing. In 1992 she was a member—the only woman on any team—of the America's Cup winner, *America3*. She has also served as the president of the Women's Sports Foundation.

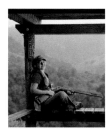

KIM RHODE: Kim Rhode, a student at California State Polytechnic University, is a double trap shooter who won an Olympic gold medal in 1996—when she was just seventeen years old—and an Olympic bronze medal in 2000. In addition, this young shooting star took gold medals in 1998 at both the Cairo and Lonato World Cups, and she competes internationally at skeet shooting.

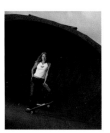

KRISTIN HEASTON: Shot put takes guts, and Kristin Heaston's got them. A star at the University of Florida, she transferred to the University of California at Berkeley in her junior year. Five times named an All-American, she willed her way to two third-place finishes in the past two years at the USA Outdoor Nationals. In 2003 she was both the indoor and outdoor national shot-put champion.

JEN O'BRIEN: Mom by night. Skate rat by day. Jen O'Brien, mother of baby Lotus, was the first woman ever to skate in an X Games contest. She skated in the vert doubles with her boyfriend, Bob Buinquist (aka, "Daddy"). With a handful of first-place big-time-competition performances, O'Brien is boldly making a name for women in professional-level skateboarding.

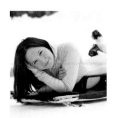

SARAH HUGHES: Her jubilant expression was unforgettable. Turning in the best performance of the day, Hughes captured the gold medal at the 2002 Olympic Winter Games. Five ESPY Awards, appearances on all major TV networks, voted Sportswoman of the Year—all before the age of eighteen.

TRISTAN GALE: Surely the skeleton gods knew something strange was abreast when a little gal with red-, white-, and blue-streaked hair showed up at the Olympic trials and did a 720° at the start. Typical Tristan Gale. Months later, the high-energy dynamo danced on the Olympic podium after winning the first women's skeleton gold medal on her home track in Utah.

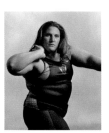

RACHAEL SCDORIS: Rachael Scdoris is the youngest athlete to complete the 500-mile International Rocky Stage Stop Sled Dog Race, a grueling race through remote terrain in thirty-below temperatures. A superhuman feat for anyone—especially a young girl who is legally blind. That race was just the beginning of Scdoris's competitive mushing career. In 2003 Rachael entered the Iditarod, the Super Bowl of sled dog races that stretches 1,200 miles across Alaska.

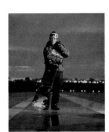

BARRETT CHRISTY: At the age of thirty-two, Barrett Christy is a foremother of snowboarding. She's been there since the start, pushing the sport with soul, grace, and passion. A twelve-time X Games medalist and Olympic team member, Barrett has been respected as one of the best all-around female snowboarders in the world for nearly a decade.

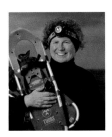

ROSEMARY POETZEL: One look at Rosemary Poetzel's National Senior Games record and it's obvious that this Wauwatosa, Wisconsin, woman gives every event all she's got: first-place finishes in three cycling events, the 5K run, the 100-meter backstroke, and 10K cross-country skiing, plus podium finishes in showshoeing, triathlon, freestyle swimming, and breaststroke.

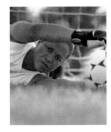

SASKIA WEBBER: Saskia Webber's experience and focus were critical to the WUSA's New York Power. As the team's starting goalkeeper, she was the first line of offense and last line of defense. A ten-year national team veteran, Webber was a member of the 1999 FIFA Women's World Cup championship team.

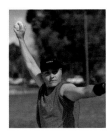

LISA FERNANDEZ: The legend began when she was seven. An awkward Lisa Fernandez spun a dusty softball in her hand and took the mound. From there, history would be made. Countless home runs, scores of no-hitters, All-America accolades, and eventually two Olympic gold medals. Courageously leading the U.S. softball team to the top, Fernandez has left an unparalleled legacy in her sport.

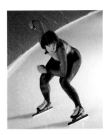

BONNIE BLAIR: With one bronze medal and five gold medals, this world record-setting speed skater started her career off with a sponsorship from her local police department, which helped fund trips and equipment. Decades later, Blair has raced in four Olympic Games and made an unprecedented mark on both speed skating and women's sports by becoming the United States' most decorated Winter Olympian.

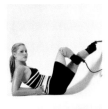

AIMEE MULLINS: Aimee Mullins is an athlete whose everyday performance defies limits. While at Georgetown University, she became the first disabled athlete to compete as part of an NCAA Division I track team. In 1996 she set world records for leg amputees in the 200 meter, 100 meter, and long jump, and she was the only woman sprinter on the U.S. Olympic team to compete at the 1996 Paralympic Games.

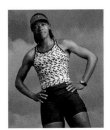

ANGELA WILLIAMS: At age nine, she first realized she could run. In high school, she recorded one of the fastest sprint times in history. One hundred meters in 11.11 seconds. Shaving seconds off her time since her high school days, Angela Williams won four consecutive NCAA titles. Winner of the gold medal at the Outdoor World Championships, her reign has just begun.

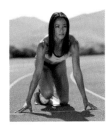

BRENDA TAYLOR: Brenda Taylor knows what it means to work at a dream. Despite suffering two season-altering muscle pulls, she bounced back to win an NCAA hurdling championship in 2001. Despite the rigors of setting records on the track, Taylor graduated magna cum laude from Harvard University. Now eyeing the 2004 Olympic team, Taylor's fierce work ethic refuses to rest.

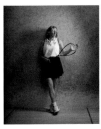

ALICIA MCCONNELL: Alicia McConnell goes down in the chronicles of history as perhaps the best American woman to pick up a squash racket. Energetic, athletic, and forever boisterous, she took to the court like a gritty ballplayer. McConnell dominated the squash scene for much of the 80s, having been ranked in the top twenty internationally during her reign.

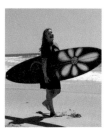

ISABELLA "IZZY" TIHANYI: Picture six-year-old Izzy straddling an old-school surfboard, waiting. She was waiting for the next wave, but she was also waiting for some girls to surf with. When she grew up she took the initiative and created Surf Diva, a women-only surf school in La Jolla, California. Seven years and over 10,000 wave-riding customers later, Isabella Tihanyi has found what she's been looking for.

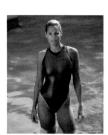

DARA TORRES: If athletic greatness was measured by both outstanding performance and longevity, Dara Torres, the first American to compete in four Olympic Games (1984, 1988, 1992, 2000), would rival a select few for history's top honors. At age thirty-three, she came out of retirement to win two gold and three bronze Olympic medals.

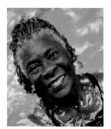

LETTICE GRAHAM: Upon retirement, Lettice Graham decided she wanted to learn how to swim. She was sixty-four years old. Seventeen years later, she has claimed sports as a precious part of her identity. She wakes every morning at 4:00 A.M. to swim laps of every stroke at the pool, do yoga, or perhaps practice for track or the water ballet. A multiple New York State Senior Games gold medal winner, Graham unintentionally redefines the word "athlete" every single day.

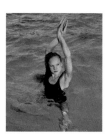

ANNA KOSLOVA: A two-time Olympian in synchronized swimming (1992, 2000), Anna Koslova won nineteen U.S. national titles as a member of the Santa Clara Aquamaids. With two gold medals and a silver at Nationals in 2002, her athleticism and grace continue to promise a bright future.

TAWNY BANH: The moments that defined Tawny Banh as an athlete were those during the 2000 Olympic trials. Facing the excruciating pain of a torn triceps, she had a choice to make: succumb to the pain or fight for the chance of a lifetime. Unwilling to let a dream slip through her fingers, Banh chose the fight. The verdict? Victory in straight sets.

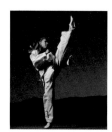

SIMONA HRADIL: Simona Hradil believes in luck. She wears her lucky flip-flops and carries her grandfather's heavy horseshoe to every competition. But Hradil doesn't rely on luck to win. Every bit of her World Cup tae kwon do medal was earned. Like her Czechoslovakian immigrant parents, Hradil possesses an uncompromising vision of success.

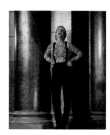

CHRIS EVERT: One of the most decorated players in tennis, Chris Evert has won eighteen Grand Slam singles titles and 157 professional tennis titles, and she has had 1,309 career wins. She won the French Open seven times, the U.S. Open six times, Wimbledon three times, and the Australian Open twice. Dramatically rivaling Martina Navratilova, she helped turn women's tennis into popular entertainment in the U.S.

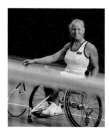

KARIN KORB: With the help of her will and upbeat attitude, Karin Korb's body does amazing things. After being named National Physique Committee's Women's Wheelchair Bodybuilding Heavyweight Champion in 1998, Korb took on tennis. She made the 2000 Paralympics tennis team and the 2000 and 1999 World Cup wheelchair tennis teams and currently ranks among the top players in the world. In addition to competing, Korb spreads her winning energy and positive outlook wherever she goes—most recently to Africa to bring recycled wheelchairs to children with disabilities.

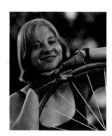

SUE GEORGE: For twenty years Sue George has clipped into her bike with her heart set on beating her opponents across the finish line. She's gotten good at it. On road and track bikes she crossed first at ten Junior National competitions. In college she claimed an individual pursuit national title. Now atop a mountain bike, she seeks to again dominate the Virginia Pro Series. The pedaling saga continues.

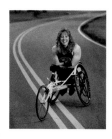

JEAN DRISCOLL: Glowing with humility, Jean Driscoll is the kind of elite athlete you cherish as a hero. She's won the Boston Marathon women's wheelchair division a record eight times, collected two Olympic medals, twelve Paralympic medals, and set numerous course records along the way.

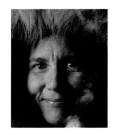

ANN BANCROFT: Born to adventure, Ann Bancroft is the first woman in history to reach both the North and South Poles. In 2001, with polar soul sister Liv Arnesen, she completed the longest ski trek in history while becoming the first woman to cross Antarctica. Through her expeditions and educational enrichment programs, she has dedicated herself to helping other people realize their dreams.

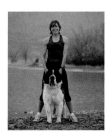

SIRI LINDLEY: It wasn't good fortune that took former world champion triathlete Siri Lindley to the top. Hard-core discipline, regimented training, and a passionate commitment were the lifeblood of her success. A three-sport athlete at Brown University, Lindley developed both her athletic prowess and her mental toughness from team sports. She went on to have one of the most successful triathlon seasons in the sport's history—winning the ITU World Cup, the Aquathlon World Championships, and the World Championships all in one year.

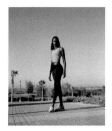

BRANDI PRIETO: Peering down the runway, focus narrow and adrenaline rushing, triple-jumper Brandi Prieto has the potential to make history. But she's not there yet. Like the hop, step, and jump she practices daily, greatness on the track mandates an evolution. Ranked in the top ten in 2002, she possesses the mettle to make it happen.

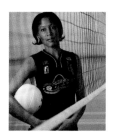

BENISHE ROBERTS: A two-time NCAA All-American, Benishe Roberts led the Long Beach State women's volleyball team to a national championship in 1998. Now playing for the U.S. Professional Volleyball League, the middle blocker was named the 2002 league MVP, finishing first in blocks and hitting percentage, second in scoring, and third in kills. In addition to playing professionally, Roberts has trained with the national team at the USOC training facility in Colorado Springs, Colorado.

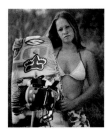

DALLAS FRIDAY: With a playful but focused style, seventeen-year-old wakeboarder Dallas Friday has already made her mark. She's ranked number one in the world in this comparatively young and rapidly growing sport.

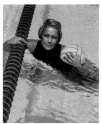

BRENDA VILLA: In 1998, while still in high school, Brenda Villa competed on the World Championship water polo team— the youngest player to do so. Since then she has twice been named Collegiate Player of the Year and has led her Stanford University team to a national championship and the U.S. team to an Olympic silver medal.

CAMILLE DUVALL-HERO: In the world of waterski competition, she's done it all. Camille Duvall-Hero won fourteen U.S. titles in her career, reigning as both the world professional slalom champion and the U.S. overall champion five times. She was named one of the top one hundred female athletes of the century by *Sports Illustrated for Women*.

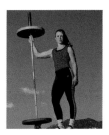

TARA NOTT: The only athlete to train at the Olympic Training Center in three different sports, Tara Nott competed in gymnastics and soccer before making her mark in weightlifting history. At the Olympic debut of women's weightlifting in 2000, Nott became the first U.S. athlete in forty years to win a weightlifting gold medal.

TOCCARA MONTGOMERY: Toccara Montgomery is paving the way in one of women's last uncharted athletic territories—wrestling. Ranked first on the U.S. team (72 kg/158.5 lb division), she won a silver at the World Champion-ships in 2001 and took the gold at World Team Trials in 2002.

Acknowledgments

I would like to thank my husband, Steve Krongard, without whom this book would not have been possible. From the moment I came home late one night enthralled by the one hundred athletes who attended the Women's Sports Foundation's annual dinner, and told him how I wanted to capture what I had seen and heard, he was behind me 100 percent. He gave the idea a name, *SuperWomen*. His belief in me, and his support, friendship, and love, gave me the strength and confidence to venture out and make *SuperWomen* a reality. His devotion never wavered. Our home became Grand Central Station for the book. And in the midst of the mayhem stood Steve, answering my every question, checking the e-mails and contracts, brainstorming photo ideas, writing interview questions, going over schedules, editing photographs, and even making the occasional dinner for an athlete. While I was away, he took care of our son, ran our business, produced *SuperWomen,* and was always there for advice and encouragement during late-night phone calls. He pushed me out the door and gave me a loving, happy home to return to. Steve, thank you, I love you.

I would also like to thank my son, Cary, for his patience and understanding as my time with him was taken away. He helped write interview questions, welcomed athletes into his home, and was my official record keeper. I hope he, too, will gain from the inspirational words held within these pages.

Special thanks to my daughter, Shawn, my little angel, for being all she can be with such strength and innocence.

Thank you to my assistant, Ronnie Smith, for committing to this project with all his heart and soul. He devoted eight months of his life to being by my side as we traveled across the country. He dragged bobsleds out of garages in freezing cold temperatures and waded waist high in mosquito-infested river muck with cameras above his head in the heat of the Texas summer. He started before sunrise, finished after sunset, and drove nonstop from Ohio to New York in July without air conditioning. He always had a smile on his face, and the athletes loved him. He kept me grounded and I am forever indebted.

I'm grateful to Donna Lopiano for seeing this project for what it could be from the very beginning. It was never a question of if we could do it, only of when. Thank you for your commitment to *SuperWomen,* for offering the assistance and dedication of all those who worked on this project from WSF, and for empowering women (myself most certainly included) to attain their dreams.

Also, special thanks to the Professional Photography Division of Eastman Kodak Company for providing film; to Duggal Color Projects for being an early and consistent supporter of this project; to Generant Company Inc. for their generous support; and to Mark Doyle of Autumn Color for his beautiful scans and prints.

I wish to express my deepest gratitude and appreciation for the one hundred athletes who said, "Yes, I would love to represent my sport in your book." To each athlete, who gave to me precious time; who posed with grace and beauty; and who shared her life, dreams, and desires with me, I thank you from the bottom of my heart.

The creation of *SuperWomen* was a true team project. I was honored to have the help of hundreds of people and organizations across America. I would like to thank the following:

The entire Women's Sports Foundation is engaged on a daily basis in helping women in sport. A special thank you to Becky Lane for her hard work and for always being the person I could turn to; to Yolanda Jackson for helping to identify and contact the athletes; to Marj Snyder for her behind-the-scenes support; and to Sarah Murray for writing the bios.

At Bulfinch Press, Betty Wong for her guidance, expertise, patience, and warmth; Jill Cohen for believing in *SuperWomen;* and Alyn Evans for keeping the printed page beautiful.

My agent, Coleen O'Shea, for her perseverance and for finding Jill.

My designer, Laura Lindgren, for her elegant design.

My sister, Mindy, whose generosity has been astonishing; my best friend, Carolyn Jones, for always being there; my incredible parents, Flossy and Paul, and my brother, Ben Buren; Evy and George, Nick and Joshua Franco; and Betty Krongard.

Joe O'Donoghue, the Ice Man, Ice Fantasies Inc., Brooklyn, New York, for providing Sarah with ice.

My assistants, who worked incredibly hard for very little pay: Christina Aceto, Gretchen Hoffman, Anne Raftopoulos, Flannon Jackson, Cheryl Humbert, Whitney Mosello, and Jessica White.

Hair and makeup artists Robert Farber, and Christie and Mili Benigno.

Dear friends Cynthia Anderson; Jonathan Pite; Catrine Turillon; Nancy Loden; Barbara Alpert and Michael Kaufman;

Michael Bader and Margo Duxler; David Merzin and Anastasia Portnoy; and Pete and Reine Turner.

Teachers Jay Maisel (for the inspiration) and Eve Arnold (for being my very first role model).

Suppliers Sarah Oliphant; Alan Abriss, Alkit Pro Camera; Ken Horowitz; and Mamiya America Corporation.

Coaches Tom Cray; David Eldridge; Kip Flanik; Randy Huntington; and Jeanne Johnson.

Parents Amy Beth and John Hughes; BJ Wie; Darla Friday; Ed Zimmerman; Jerry Scdoris; and Shawn & Steve Allen.

New friends Anne Bleiker, Professional Rodeo Cowboys Association; Alan Strachan, Director of Hockey, Lasker Ice Rink; Ernie C. Reed; Steve Wright and Kim Jackson, Killington, Vermont; Rob Bartley, Director of Golf, Seaview Marriott; Eric H. Allain, Director of Club Operations, Lake Nona Golf and Country Club; Gene Walker, Verizon; and Greg Sellentin and his sled dogs.

Athletes Cathy Sassin; Sarah McMann; Marilyn Fierro; Cathy Hearn; and Regina Jacobs.

—Jodi Buren

The Women's Sports Foundation would like to gratefully acknowledge the hard work and total team effort of everyone involved in creating *SuperWomen*. We would especially like to thank Jodi Buren, whose dedication and perseverance was instrumental in getting the project off the ground and in keeping it running; Coleen O'Shea, our literary agent, who provided a sound and level voice always, and the wonderful people at Bulfinch Press— Jill Cohen for believing in the book and offering her full support, and Betty Wong, whose vision, good humor, and patience was always appreciated. The Foundation would also like to recognize the work of our own staff members involved in this endeavor: Project Manager Becky Lane, Ph.D.; writers Sarah Murray and Vanessa Schnaidt; Corporate Relations Specialist Jennifer Butler; Athlete Services Staff Yolanda L. Jackson, Nancy Laroche, and Jason Young; and Chief Program and Planning Officer Marjorie A. Snyder, Ph.D.

Additionally, this book would not have been possible without the generous support of Rolex ᴿᴼᴸᴱˣ and the following individuals. Thank you. We hope you are as proud of the result as we are.

—Donna Lopiano

We would jointly like to express our appreciation to the following:

USA Sports, including Jerry Kokesh, US Biathlon Association; Tom LaDue, USA Bobsled and Skeleton; Kelly Walker, USA Cycling; Steve Butcher, USA Gymnastics; Heather Ahearn, USA Hockey; Mary Ann Monty, USA Luge; Seth Sylvan, US Tennis Association; Jill Greer, USA Track and Field; Steve Locke, USA Triathlon; Paul Soriano, USA Volleyball; Eric Velazquez, USA Water Polo; and Gary Abbott, USA Wrestling.

U.S. Olympic Training Centers, including USOC Training Center in Chula Vista, California: Faith Triggs and Amy Flug-haupt; USOC Training Center in Colorado Springs, Colorado: Carla O'Connell, Peggy Manter, and Cecil Bleiker; and USOC Training Center in Lake Placid, New York: Stephanie Ryan;

Ladies Professional Golf Association: Mindy Moore.

Racegirl BMX League: Kim Fisher.

Special Olympics, New York: Rosemary Bruno.

Agents Paul A. Herschell, Sports Unlimited; Susan Zarambo, Yourexpedition; Z (Zaynab), The Familie; Sue Dorf, International Management Group; Shana Martin; Lloyd Frischer, SFX; Peter Raskin, CSMG Sports; Sigmund Morawski; Frankie "G" Productions (Frank Globuschutz); Kathy Thomas, International Management Group; Dave Popkin; Tami Olsen, Evert Enterprises/IMG; Tom McCarthy, Progressive Sports Management Inc.; Linda Kanner, Management Plus Enterprises Inc; Valerie Foster, Jackie Joyner-Kersee Boys & Girls Club; Rachel West; Michael Spencer, Ego Sports Management; Evan Morgenstein, Premier Management Group; Kim Fisher; Danielle Rausch, Wilhelmina; Ray Flynn; Jeanne McNulty-King/2X Inc.; Seth Mayeri, SFX; Emanuel Hudson, HS International; Paul Streeter; and Sue Rodin, Stars and Strategies Inc.

The following institutions and all the people associated with them for allowing us to use their locations: National Senior Games Association, Norfolk State University, Norfolk, Virginia; Colorado School for the Deaf and the Blind, Colorado Springs, Colorado; Pacific Athletic Center, El Monte, California; Hall of Fame Billiards, Brooklyn, New York; Intrepid Sea-Air-Space Museum, New York, New York; Pettit National Ice Center, Milwaukee, Wisconsin; Center Circle, Rahway, New Jersey; Germantown Academy, Fort Washington, Pennsylvania; Academy of Boxing for Women Inc., Huntington Station, New York; California Yacht Club, Marina Del Ray, California; Boca Raton Resort and Club, Boca Raton, Florida; Torrent Falls Bed and Breakfast, Campton, Kentucky; Hansborough Recreation Center, New York, New York; Stanford University, Stanford, California; Woodlands Athletic Center, Woodlands, Texas; Guillermo's Squash Club, Colorado Springs, Colorado; Oxley Equestrian Center, Cornell University, Ithaca, New York; Lasker Ice Rink, Central Park, New York, New York; Cumberland College, Williamsburg, Kentucky; Oak Tree Gun Club, Newhall, California; Friedman Center, Cornell University, Ithaca, New York; University of Houston, Houston, Texas; Valencia Lanes, Newhall, California; University of Southern California, Los Angeles, California; Vail Mountain, Vail, Colorado; Killington Mountain, Killington, Vermont; Seaview Marriott Resort and Spa, Galloway Township, New Jersey; Mitchel Athletic Complex, Long Island, New York; Gymcats, Henderson, Nevada; International Swim Center, Santa Clara, California; Willow Springs International Raceway, Rosamond, California; Denver Athletic Club, Denver, Colorado; Lake Nona Golf and Country Club, Orlando, Florida; Arthur Ashe Stadium, New York, New York; Soho Studios, New York, New York; and Aspen Sports Car Club, Aspen, Colorado.

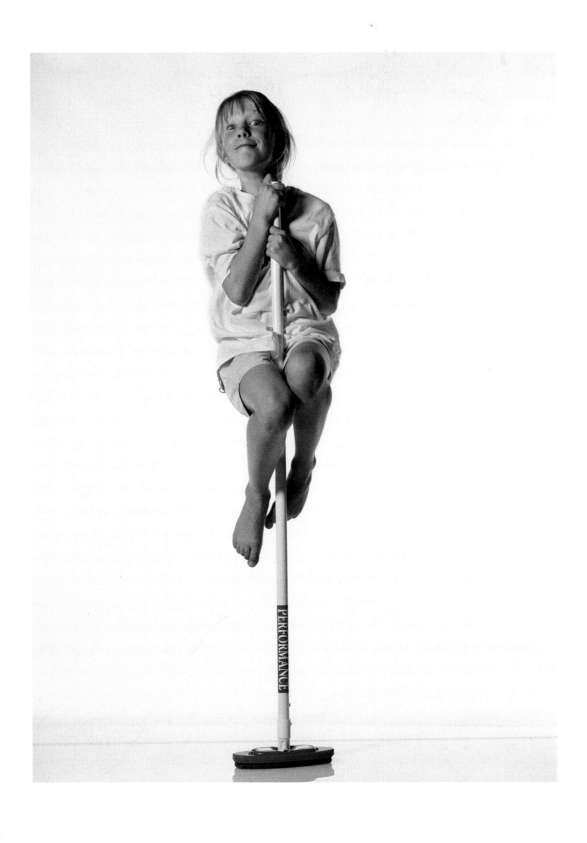